A LONDON

SAFARI

A LONDON SAFARI

WALKING ADVENTURES IN NW10

ROSE ROUSE

AMBERLEY

First published 2014

Amberley Publishing
The Hill, Stroud
Gloucestershire, GL5 4EP

www.amberley-books.com

British Library Cataloguing in Publication Data.
A catalogue record for this book is available from the British Library.

ISBN 978 1 4456 4450 9 (paperback)
ISBN 978 1 4456 4459 2 (ebook)

Typeset in 10pt on 12pt Sabon.
Typesetting and Origination by Amberley Publishing.
Printed in the UK.

To my mum for the simple things.

CONTENTS

Acknowledgements	10
Introduction	11
First Impressions	17
Pre-Dawn Walk	23
The Spirit of the Wild West	26
Creative Junctures	33
THE WALKS	
WALK 1: Looking for Willesden Hippodrome Without Google	39
WALK 2: A Sea of Hair	47
WALK 3: An Ex-Gas Meter Reader's Perspective	53
WALK 4: All Eyes on Egypt and the Black Madonnas	60
WALK 5: Pubs (A Few Old Ones)	68
WALK 6: Mean Fiddler Mogul Vince Power Returns	72
WALK 7: The Tattooists' Tales	79
WALK 8: When Rose Met Louis	85
WALK 9: Madame Curly Takes Me on a Food Tour	93
WALK 10: Mr Mash Up	100
WALK 11: An Anti-Gun Crime Activist Tells It Like It Is	104
WALK 12: Being Amused by Scouse Raconteur, Alexei Sayle	109
WALK 13: The Man Who Makes Art and Cuts Hair	117
WALK 14: Sparkly Bras, Cockroaches and Little Brazil	122
WALK 15: The Heady Delights of Willesden Junction Station	127
WALK 16: The Philosopher	136
WALK 17: Reggae, Reggae, Reggae	143
WALK 18: Mother's Day with the Salvation Army	149
WALK 19: The Sex Tour (a Walk with a Tantric Goddess)	155
WALK 20: A Militant Modernist Visits Stonebridge	163

WALK 21: Not Donald the Duck 169
WALK 22: What Is It With the Art in Harlesden? 177
WALK 23: Prison, Paraplegia and Roundwood Park 181
WALK 24: A Batty Night Out at the Welsh Harp 187
WALK 25: One Hell of a Somali Woman 192
WALK 26: George the Poet and His Marvellous Mother 198
WALK 27: Sweetland 207
Harlesden and the Ripples Outwards 213
Notes 219

Cities give us collision. 'Tis said, London and New York take the nonsense out of a man.

Ralph Waldo Emerson (1850)

The life of our city is rich in poetic and marvellous subjects. We are enveloped and steeped as though in an atmosphere of the marvellous: but we do not notice it.

Charles Baudelaire (1845)

So I think if any of you need to convince brainwashed whites about the very real dangers of multicultural society up close and personal, then take them to Harlesden.

White Pride World Wide Forum, post entitled 'Mine and GF's Safari In Harlesden' (2009)

Acknowledgements

Thanks to the people of Harlesden for allowing me in, and making me laugh, question and want to see more of your fabulous undergarments. Special thanks to my son Marlon and my partner Asanga for encouraging me on and to my agent, Laura Susijn, for believing in this project when no one else did. More praise to Faisal Abdu'Allah, Leroy Simpson, Louis Theroux and all the Harlesden Town Team for all your efforts to improve the neighbourhood. Lastly, thanks to Malcolm Barrès-Baker for casting his expert eyes over the final draft.

Introduction
by Louis Theroux

One of the occupational hazards of being on television is that strangers try to recruit you into supporting causes or contributing to projects that are dear to their hearts but have no special meaning for you. Some years ago I received an email message from Rose Rouse, a Yorkshire-raised former music journalist and chronicler of the music scene in the eighties. Rose now had a blog entitled 'Not On Safari in Harlesden', consisting of walks she took with the famous and the not-so-famous around the gritty and litter-blown area of NW10 in which she resides. She asked if I'd be willing to go on a walk with her.

I looked at the blog. There was a funny encounter with the comedian Alexei Sayle – he and Rose seemed to rub each other the wrong way. Another walk featured the Irish music impresario Vince Power, owner of the old Harlesden venue the Mean Fiddler. He reminisced about his days of trying to make it in the live music business, and recalled a time when the folksinger John Martyn puked over the front row.

I politely declined Rose's offer, but not without a sense

of guilt. The guilt derived from the fact that I too live in Harlesden and since moving here in 2001 I've grudgingly – and in a small way – taken it on as a project, as many of us do who live here; it's an area that could use a little help. And so when Rose asked again, I caved. A few weeks later I found myself face-to-face with the diminutive cheerleader of NW10 in a local café – a place which (in true Harlesden style) also sold cut-price mobile phones.

In her book Rose mentions that she wears a 'bejewelled headfeather'. She refers to herself as an old punk rocker. Another important fact about Rose is that she once did a pop-up dance project in which she and some friends were filmed grooving at unlikely locations around Harlesden and Willesden Junction, in a way that was a little embarrassing. In fact, Rose's willingness to risk embarrassment is one of her assets as a journalist. She belongs to a category of cultural savants who enjoy grappling with the modern world and who are determined, as a point of principle, to be open to new experiences, even if the price of those experiences is some momentary embarrassment.

There is also still something of the music journalist in Rose, only now her critical gaze rests not on Frankie Goes to Hollywood but on the shop-fronts and byways of an unglamorous suburb. She is the blogger-laureate of Harlesden.

On that first walk Rose and I ended up visiting a hotel in nearby Stonebridge, an area with a reputation for gun crime which used to have a number of high-rise council blocks. The hotel had always seemed desolate when I drove by it on my way to and from the North Circular, a place for lost alcoholics to drink themselves to an anonymous death. But inside it turned out to be surprisingly cheery, recently refurb'ed, a stopping place for builders on local jobs.

After that I checked on Rose's blog from time to time, especially if I was away and wondering what was going on in my old manor. Now it is a book, with Rose *on* Safari in London. A wise move in my view; *not* being on safari is like telling someone *not* to think of a pink elephant.

Harlesden is a funny old place. We loyalists use words like 'vibrant', 'exciting', 'exotic' and 'cosmopolitan'. But the truth is you could just as easily say 'maddening', 'dispiriting', 'dreary' and 'disturbed'.

It is plagued with crazed driving and clogged traffic, abandoned mattresses and little plastic bags of rubbish spilling out of bins. The high street 'offering' is heavy on betting shops and pound shops and odd multi-purpose places that offer 'global money transfers'. It is a fragmented polyglot chaos of Irish pubs and West Indian takeaways and Polish delis; weeds that sprout out of the facades of the elegant old buildings; mini 'casinos' full of slot machines; grime and decay; and very occasionally a background sense of menace, often on the 18 bus and the top floor of the 220, as though a fight is about to break out.

But, as with so many things in life, Harlesden's negatives turn out to be positives when rightly considered. Its noise and chaos are part of its indomitable 24-hour energy. There is disorganization but there is also a crazy quilt of cultural offerings: churches, nightclubs, late-night hairdressers. There are stores and emporia selling everything under the sun. And the people are a microcosm of the world, hailing from everywhere – Africa, Asia, Eastern Europe and South America. Harlesden is both villagey and, in some ways, the most cosmopolitan place imaginable.

I came to Harlesden almost by accident. I was renting a flat in Shepherds Bush close to the BBC, at what I thought was

the tail end of a property boom. It was 2001. I figured it was time to buy but I was conscious of having missed the boat on finding bargains in fashionable areas. I tortured myself with the idea of how much cheaper everything would have been a year before. One day an estate agent took me on a short drive from Kensal Rise, where I was looking, up the Harrow Road to a tree-lined avenue of grand old Victorian homes standing in faded splendour. Each house cost roughly the same as a flat in Shepherds Bush. Welcome to Harlesden, last bastion of un-gentrified Zone 2. It was rough at the edges, but I liked the idea of seeing past the surface of a place into its true potential. Harlesden had 'good bones', as they sometimes say in property circles. I had an old friend who lived in the area and he vouched for its qualities. I made an impulsive decision.

A little later, having moved into my house, I discovered I was now living in Britain's 'gun-crime capital'. And my old friend moved to a village outside Bristol.

I've been in Harlesden ever since (with some breaks for travelling), rooting for the area, in the spirit of a football supporter whose club won some trophies in the early 1900s and now languishes somewhere in the lower divisions. It may seem ridiculous to think we can play in the premiership, but some of us still dream.

A few months into my stay a house over the road underwent renovation. I smelled gentrification in the air. Then I found out it was being chopped up into seven studio flats – the dreaded 'multiple occupancy'. A small gang took up residence on the corner of the street. The McDonald's on the high street closed. I'd never heard of a McDonald's closing. It felt ominous. God forgive me, but I was excited when Superdrug moved in: a recognizable high-street chain, it seemed to represent the green shoots of some kind of come-

back. A Subway and a Specsavers followed. If Harlesden was our team, these were significant player signings.

But something else happened. I started to make friends and learned the habits of enjoying Harlesden as it is, getting to know the shops and the people.

Harlesden and I still have our on days and our off days. The off days usually involve litter or news about local crime or absurd stand-offs taking place outside the house with drivers shouting at each other because our street is too narrow for two cars to pass in. But Harlesden also has moments of grace: on sunny days at the café in the park, during the World Cup with the many Brazil supporters out in force, on church days with the amplified preachers on the old traffic island ... It reminds me of when I lived in New York: an insomniac district of noise and traffic and dirt, with people from everywhere striving for a new life; a mosaic of ethnic enclaves occasionally making something beautiful.

Rose has recorded many of those wonders in these pages. She has introduced me to local landmarks I've seen many times but didn't know. The street drinker, George, who wears a dress and paints murals – the industrial secrets of Old Oak railway yard deciphered by one Ian Bull – the vanished pubs, now housing blocks and Portuguese cafés – stars from the Reggae scene of the seventies ... She has decoded the area for me. In the process she has performed an alchemical act, taking a suburb that is nothing much to look at and imbuing it with a wistful poetry.

One of my favourite passages comes when Rose visits a huge derelict building – a notorious eyesore – on the borders of Willesden Junction and Park Royal. She describes the rubbish around it as being like 'a polluted sea'. 'An office block,

it has been attacked by urban marauders. Burnt, broken, covered in graffiti – it is nevertheless somehow amazing ... When something or someone is broken open, there is always the opportunity for beauty. It's hideous, dystopian and falling apart but there's something gloriously wonderful about it. Like Detroit now. Like the Road. Like me when I was breaking up with the father of my son. The decay almost radiates in its slow dying.'

Harlesden isn't dying. But the point about seeing beauty in abandoned buildings and lost objects still stands.

Some may wonder of the relevance of any of this to those outside Harlesden, or Brent, or London. But, like it or not, Harlesden represents something bigger than itself. It is a petri dish of what is happening – in less concentrated ways – across Britain. If we can learn to love Harlesden, it's a promising sign for us all.

First Impressions

Park Parade, my local row of shops, is a telling introduction to Harlesden: there's the chicken/kebab shop, Caledonia, which was the 2009 scene of the afternoon November stabbing that ended the life of twenty-year-old Antony Parkes; All Eyes On Egypt, a bookshop that puts forward the black-centric point of view, sometimes lurches towards conspiracy theories but also magnificently promotes talks like 'The Angry Vagina'; a Brazilian seamstress who goes by the inimitably holy name of Victory Divine, and is also a pastor; Johnny's hairdressing and tanning salon, Paraskevas (he's a grey bouffant-coiffed man-about-town who came over from Cyprus thirty-five years ago); the newsagent run by Danny that also, weirdly, sells boxing gloves (it turns out his family in Pakistan make them), which are used in the local boxing clubs; the Nigerian internet shop; the Portuguese restaurant called O Bombeiro (oh, what a name – O Fireman); a mysterious and quite posh shop called Janie Lightfoot Textiles; the Royal Oak, an Irish pub built in 1892 – the original building went back to the 1830s and was a stop for the first omnibus going from Harrow to the City; a funny little shop called Cash For Clothes where you can literally sell clothes by the kilo; and that's not everything ...

Harlesden is a one-off, but also a mirror and a microcosm of what is going on in cities and towns all over Britain. It is everything that diversity creates. It's exciting with an edge that is missing from, say, Suffolk, or even Kensington and Chelsea. An urban cacophony that defies description, a feast for the senses. 'Big Up Harlesden,' declares twenty-three-year-old George the Poet who was brought up on the hardcore St Raphael's estate and went to Cambridge University, and it's true, it's time to. All those yardie and gang tales have flavoured the Harlesden stew but they no longer define it.

Harlesden has more hair shops, ones selling real hair in the guise of wigs and weaves, and more fresh fish shops – boasting sea creatures that never turn up on the counters at Sainsbury's – than anywhere else in the country. There is also the reggae connection in the form of the ever-present Hawkeye and the recently re-opened Starlight; Scandals and Mister Patty with their famous Jamaican patties; and O Tamariz, the best and friendliest Portuguese cafe with delicious *pastéis*. And then there is its compelling history, from the now destroyed but formerly grand Willesden Hippodrome, which opened in 1907, seated 3,000 and is now a boxy Job Centre Plus, to punk bands the Clash and the Slits (who played in the seventies at the Misty Moon, then at the Coliseum, a flea pit), to the epicentre of rock'n'roll that was Vince Power's Mean Fiddler (where musicians like Billy Bragg, Nick Cave and even Roy Orbison played in the eighties), to the horrific shootings and killings that escalated in the late nineties and 2000s.

This part of NW10 is one of the most diverse places in Britain. Forget Brixton or Hackney, welcome to the pulsing heart of Harlesden. It's an ever-changing, fascinating mix-up

of post-war immigrants: early layers from Ireland, Jamaica, Pakistan, India and Cyprus, later ones from Afghanistan, Sri Lanka, Columbia, Portugal, Brazil, Poland, Somalia and more, not forgetting the new media types. Harlesden is a place that shines with its own nitty-gritty light and spirit.

Non-gentrified and possibly non-gentrifiable (M&S left in 1984 and never came back), it has an atmosphere reminiscent of the Wild West. New and old, eclectic and taboo, poverty and invention, religions and irreverence – they all rub up against one another in an amazing array of different colours, foodstuffs and attitude. I come from a village in Yorkshire; for me, Harlesden is heaven because it breathes with such breadth, because its rhythms are unrecognisable and because so often it puts me not only in touch with my curiosity but also my ignorance. Blimey, there is so much that I don't know.

For many years, I lived off Portobello Road. In fact, I was a fully fledged W11 bohemian with a flower in my hair and rebellion in my footsteps. When I moved to Harlesden, the flower stayed but I was a little bit lost. A kind of reluctant pioneer – in terms of straying from the 'Bella' – I felt myself in alien terrain, even though it's only ten minutes away by car. After a while I became aware that I was merely toe-dipping when it came to Harlesden. I went to the bank, to Harlesden Fresh Fish and occasionally to the best supermarket in the world, the irrepressible Way 2 Save with its oodles of black, kidney and butter beans in huge sacks, rice of all denominations except brown and an incredible selection of olives. On so many levels, I was a Harlesden virgin. And a coward.

I was also a travel journalist, as well as a rock 'n'roll one, who had had enough of press trips and the hamster wheel

of finding stories. It sounds pretentious and arrogant, but I'd been to Mumbai with Boy George; I'd interviewed Pete Townsend in New York accompanied by a male-only drinking crew of hacks; singer Terence Trent D'Arby once took me home in his chauffeured car, then followed me in only to discover my partner looking after my sick four-year-old son; I'd even ended up having a suite in an art deco hotel for a week in Rio and only writing 500 words at the end of it; I'd also fortunately failed to kill the horse I was leading through the Sierra Nevada on a trek – and finally I realised that I was feeling a longing to be local and stay at home.

When I started walking and talking in Harlesden during early 2010, I was apprehensive. I was scared that Harlesden in its rough finery wouldn't want me interfering with its underskirts. Would this middle-class, white, middle-aged woman be accepted by Harlesden? I knew I wanted to be more part of this community, and I had a plan, but it was far from foolproof. I remember walking down Park Parade on the November afternoon after twenty-year-old Antony Parkes had been fatally stabbed in the leg, blood still visible on the pavement and shocked loving messages from his friends and family in a pile with the bunches of flowers still in their cellophane. I already knew Harlesden wasn't for the faint-hearted, but this made it even more evident. It also made it even more important to venture forth.

My plan was to simply walk and talk with as many different people as possible. The idea was that these walks would become a kind of interview in motion, and that walking through this urban landscape would spark more tangential conversations than a static one. I wanted to welcome the unexpected and also a bit of verbal pugilism. After all, Harlesden is known for its famous boxers, Audley Harrison

and James De Gale. I wanted to invite debate, occasionally heated debate, on to these lively and sometimes troubled streets.

I had questions, puzzles and bits of unsolved trails of information. The questions would all lead to more questions and that was a vital part of the quest. I wanted to become a street detective. Writer and somewhat reluctant psycho-geographer Iain Sinclair describes himself 'stalking' the streets of Hackney; I see myself in a similar pursuit. But he writes about having walked those streets so often that he feels they accept him, whereas I am a neophyte in this respect.

As soon as I started walking, I started discovering. A Somali woman, Amran, with a gorgeous smile, failing kidneys and a husband who had been killed in Somalia fifteen years ago, tells me she sometimes goes for a box of chicken in Sam's down the High Street at 1 a.m. 'Yeah, Harlesden's not so violent these days, it feels safe enough for me to go out then.' I'm shocked by her late night habits. She's just about to tell me about the difficulties of meeting Somali men in London, when I bump into Sue Saunders – who had a daughter at the same primary school as my son back in the nineties – eccentric, poet and now, it transpires, gas meter reader. At a later date, we go on a walk together that is one of my favourites. Oh, the joys of street-combing with Sue. Her wit, her sexy stories.

And then there was finally getting through to Louis. Neighbour, Harlesden Town Champion, Theroux was proving hard to pin down. I emailed his agent. He prevaricated. Finally, Louis himself replied: 'I don't think I can help you.' Within his 'No' I was able to detect a chink of a 'Yes'. I persevered. Eventually, he caved in and we had a remarkable

walk, which included a visit to a Victorian hotel, situated in the midst of the formerly high-rise, and now low-rise, Stonebridge Estate – also formerly known for its crime rates. Louis and I ended up pretending to be a couple looking for a room together. It was quietly hilarious.

And then, there was/is Leroy Simpson. Although he's the chair of the innovative Harlesden Town Team – they (and Brent Council) are responsible for the regeneration of the centre in terms of roads and traffic – at first sight, with his missing teeth and less than smart appearance, he looks like a vagrant. However, we got on like a house on fire and he's soon telling me his dreams for Harlesden, among which a bistro with waiters figures largely. Leroy is sometimes a man from another era. He also dreams of making his parents – both came over from Jamaica at the end of the fifties, his father worked for Ford and his mum was a nurse – proud of Harlesden. The HTT are active and trying to change Harlesden for the better. After many consultations and meetings, the regeneration is in action. Spruce it up, give it some pride. The question is: deep down, is Harlesden willing? Philanthropist and Oxford-dweller Serena Balfour is hovering around the edges with her US Charitable Trust, which is supporting local young people in getting work, but who knows what will happen. What will the renaissance of Harlesden look like?

Recently I've been reading indefatigable rural walker Robert Macfarlane's book, *Old Ways: A Journey On Foot*. In it, he poses two questions that we should ask of any strong landscape. 'Firstly, what do I know when I am in this place that I can know nowhere else? And then vainly, what does this place know of me that I cannot know of myself?' Harlesden is a fierce, non-pretty area. These questions are

also with me as I walk this wild city landscape. The walking is about going out and admitting my ignorance, but it is also about going in. As George Eliot reminded us, landscape 'can enlarge the imagined range for the self to move in'.

Walkers often walk to out-stride their sadness. From the eccentric nineteenth-century multi-linguist and camel rider George Borrow to contemporary writer Sara Maitland, they tend to be depressives who seek the temporary release of pace and motion. Country paths seem to assuage their pain, but what of this NW10 asphalt? I don't find myself seeking solace but rather looking for stimulation, for interaction, for dialogue.

Pre-Dawn Walk

6 a.m., 8 February 2010. The sun rises at 6.58 a.m. It's still dark but illuminated by street lights. The sounds are the birds and they are loud. I think they must be blackbirds and I get irrationally disappointed when I see rows of pigeons later. Somehow, there's no romance in pigeons singing. If a blackbird is Frank Sinatra, a pigeon is that bloke on *X Factor* who used to be a dustbin man.

I've got my son Marlon and his girlfriend Tania with me. Both twenty-four and film-makers, without their cameras, they bring only their curiosity. 'It reminds me of coming home from clubs,' says Tania, referring to the past. Mario, my ex and Marlon's father, says later, 'What, you went out before the criminals get up?' It's teetering on the edge of bad taste, not to mention safari-ism.[1] I can't help laughing.

I'm surprised by just how many people and cars are around. At the bus stop in Wrottesley Road, I go up to a woman and ask her where she's going. She looks alarmed

and is on the verge of ignoring me. This almost-darkness embraces ill intent – by me, a middle-aged, middle-class white woman. This is a new role for me. 'I'm a pastry chef,' she says eventually. 'I'm going to Liverpool Street.'

I perceive differently in this inkiness with neon moments. I see a ramshackle house with a little wooden balcony in Park Parade that wasn't there before. It appears like a ghost from the Louisiana bayous. Further down, the words 'we pay cash for gold' beam out of the front of a pawn shop in red lights like a so-bad-it's-good version of a Tracey Emin.

Over the road, Saj's Supermarket is open but I'm not sure if it's just opened or has been open all night. I ask one of the young men who is bringing out yams and plantains. 'We're open 24 hours,' he says. A man wearing a long sarong type garment round his waist hurries by. 'Where are you going?' I say trying not to be too aggressive, my new pre-dawn etiquette.

'To the mosque,' he says. We guess that he's Somali. I didn't realise that there were any mosques here until I spoke to my newsagent, Danny, a few weeks ago. He mentioned that he sometimes pops into the mosque on the high street.

'Shall we follow that man?' says Tania, only half-jokingly.

A few days ago, Marlon and Tania observed what they thought were Maori women coming out of a boarded up building, Park House, in Manor House Road. We go and have a look. There is a tangle of satellite dishes perched outside a window on the second floor and a light. People are obviously in residence but there's no indication of who they are.

Rounding the corner, I can't help smiling at an unusual sign in a shop window. It announces boldly, 'Here photos come alive, here legs come to dress' – and they do. This is

Wrights[2], the extraordinary shop that sells Italian lingerie – including sexy pirate outfits by Donna, not to mention baby doll Santa costumes – as well as photographic equipment, watches and all manner of gadgets. It's such an Irish concept, except it's not Irish. The couple who own it are Indian/Kenyan. Perhaps it's the powerful influence of The Shawl nearby, a very Irish pub.

I remember the story about Salpetrière Hospital in Paris, where a neurologist called Jean-Martin Charcot conducted experiments on women suffering from hysteria. At one point, they were put in wards near epileptics, and they too started experiencing fits. Those Irish who came over to work here from the 1840s onwards on the railway brought with them the expectancy of their own crazily mixed up shops. Not for them the one-dimensional. Many years later, Wrights has fulfilled this dream, and it is far from the only place.

Deliveries of Guinness are just arriving at The Shawl. Meanwhile, Craven Park Road is heaving with mighty lorries carrying waste plastic and highway maintenance equipment. Unbeknownst to me, this is very much the hour of industrial passage. These secret rituals have obviously been going on for years as I hunkered down under my duvet.

Another man appears in a sarong-like *ma'awis*. We turn off the main road into a back alley. It is dark for the first time and a little bit scary. The buildings suddenly look grimier; there are bits of newspaper blowing about like Harlesden versions of tumbleweed as we tentatively follow this gentleman. Finally, at the end of the alleyway, we turn a corner in silence. There it is, in what looks like a garage. There are rows of shoes at the doorway and all we can see are disappearing heads and a row of clocks showing the different times for prayer.

We've made our discovery, so we scurry back to the main road. A cleaning machine – one with two swirling brushes – is nudging us off the pavement. Bus stops and cafes are filling up. It's getting lighter. We've missed dawn. The sun rising over Willesden Junction is not our lot today.

It's wet and cloudy and it's time for us to go back to bed.

The Spirit of the Wild West

When I moved to Harlesden there was double-parking in my street. Double-parking in London. Outrageous. Visitors were astonished (not too big a word) by this blatant lack of rules in such a normally over-regulated capital city.

That spirit of anarchy, that feeling that everything is on the edge of imminent meltdown is part of Harlesden's charm to me. Make no mistake, there is serious poverty in NW10, but there's also an uprising of energy and a determination to be different that's a kind of happenstance. Can the momentum of determination and the randomness of happenstance co-exist? I think so. No one's had a big plan; the tumbling of cheap rents for shops and the different waves of immigrants have all contributed to this beautiful mayhem.

And then there's Obioma. She's the manager at our local Santander. An over-assertive but, I discover later, also kind Nigerian woman who was so concerned about the state of London schools that she sent her eleven-year-old son back to her parents in Lagos to make sure he got a good education. Oh dear, London. At first, I found this information shocking – could our schools really be worse than those of Nigeria? – but now I realise there are lots of people who

send their children back to more traditional institutions in their former home countries. And it isn't just about the education, it's about peer groups. When I asked Obi what she thought of Harlesden, she gave a sparky laugh, the sort you reserve for a punch line. 'Harlesden has the spirit of the Wild West about it. Everyone does their own thing.' I know what she means.

There's also a very tall gentleman called George who has long, untamed white locks, a big bushy white beard and a proclivity for drinking special brew. He often wears women's long skirts or a kilt. Yesterday, he was out in a multi-coloured, large-checked shirt, a black lace skirt and some fetchingly geeky spectacles. A street-drinker who is wont to make declarations from the bible he usually carries, he also has an air of nobility about him. However drunk he is, he never loses this upright dignity. I know where he lives on Wrottesley Road; its surrounding wall has been covered in psychedelic colours and images, presumably painted by him. Apparently, he used to be a doctor and then his wife died. It's a sad tale and yet he somehow epitomises Harlesden, while she, in turn, embraces him. He's always around, no one bothers him and he bothers no one. And he speaks to a lot of people. He's a gentle presence despite the tragedy that ebbs forth from him.

Take a look back in history to 1880 and a black-and-white photo shows the Royal Oak Tavern and Railway Hotel (now Royal Oak) with its expansive windows, rather gorgeous Georgian exterior and grand hanging gas light outside. The road is empty except for a delivery cart, and so unbelievably wide. It looks as though the Lone Ranger might turn up any minute. And the pub itself looks more modern than its Victorian successor with its gothic twirls.

In the late nineteenth century, Harlesden was a hotbed for cheap house builders because, being then in the parish of Willesden, it was not subject to London's strict planning regulations. Anarchy still reigned – along with open drains, until a sewage system arrived in 1871.

With an archivist's glee, Malcolm Barrès-Baker – a marvellous academic who resided until very recently at Brent's Willesden Library – happened upon a passage by Welsh supernatural writer, Arthur Machen, in *The Inmost Light* and sent it to me. Written in 1894, it reveals Machen's view of Harlesden as a place of little consequence in an era when it was supposed to be in its middle-class heyday. Oh la la.

'Harlesden, you know, or I expect you don't know, is quite on the out-quarters of London; something curiously different from your fine old crusted suburb like Norwood or Hampstead, different as each of these is from the other. Hampstead, I mean, is where you look for the head of your great China house with his three acres of land and pinehouses, though of late there is the artistic substratum; while Norwood is the home of the prosperous middle-class family who took the house "because it was near the Palace", and sickened of the Palace six months afterwards; but Harlesden is a place of no character. It's too new to have any character as yet. There are the rows of red houses and the rows of white houses and the bright green Venetians, and the blistering doorways, and the little backyards they call gardens, and a few feeble shops, and then, just as you think you're going to grasp the physiognomy of the settlement, it all melts away.'

'How the dickens is that? The houses don't tumble down before one's eyes, I suppose!'

'Well, no, not exactly that. But Harlesden as an entity disappears. Your street turns into a quiet lane, and your staring houses into elm trees, and the back-gardens into green meadows. You pass instantly from town to country; there is no transition as in a small country town, no soft gradations of wider lawns and orchards, with houses gradually becoming less dense, but a dead stop. I believe the people who live there mostly go into the City. I have seen once or twice a laden bus bound thitherwards. But however that may be, I can't conceive a greater loneliness in a desert at midnight than there is there at midday. It is like a city of the dead; the streets are glaring and desolate, and as you pass it suddenly strikes you that this too is part of London.'

What sacrilege! 'A place of no character' – Machen should be here now and see just how ridiculously characterful it is. But that is the transformation, the wheel of middle-class, staid and white, round to diverse, unpredictable and sometimes hellish.

Zadie Smith describes this arc in NW London. She's talking about Kilburn and Willesden, but it could just as well be neighbouring Harlesden. 'Ungentrified, ungentrifiable. Boom and bust never come here. Here bust is permanent … In the 1880s or thereabouts the whole thing went up at once – houses, churches, schools, cemeteries – an optimistic vision of Metroland. Little terraces, faux-Tudor piles. All the mod cons! Indoor toilet, hot water. Well-appointed country living for those tired of the city. Fast-forward. Disappointed city living for those tired of their countries.'

I know I'm only an immigrant from Yorkshire but I'm not sure everyone is disappointed. Despite the hardship, I see the positive energy and the endeavour. Suresh, my incredible

(he gives me a hand whenever I'm in car maintenance need) neighbour and mechanic – a couple of years ago, a crowd of neighbours turned out for him at Brent Town Hall on a Thursday afternoon to counter the council's plans to shut his home garage workshop down and we won – is quietly triumphant. From Gujarat (he's tellingly a Patel), he's a community star; he helps everyone.

Harlesden is mentioned in the eleventh-century Domesday Book. It was a Saxon settlement on a well-watered woodland clearing on a hill; its name comes from Herewulf's Tun (or farmstead) because it was farmland for centuries. A brick and tile works is mentioned in the fifteenth century, and by the nineteenth century it had become a prosperous middle-class village with villas and farms (although Arthur Machen would argue that it lacked character).

One of the dominant figures in the nineteenth century was George Furness, who dwelt with his family (he had a tragic family history, with three of his children dying in infancy) at the terribly posh Roundwood House, which eventually gave its name to Roundwood Park. Furness sold the park to the local council. The house itself was sold after his death, and in what local historian Cliff Wadsworth calls bluntly 'an act of civic vandalism', the council knocked it down. When I first arrived in NW10, I used to wonder about the street names around me – Furness, Palermo, Ancona, Spezia, Odessa. Turns out they come via Mr Furness, who was both a benefactor and a public works contractor (he organised engineering and drainage projects), often overseas in places like Palermo and Odessa. My own road was named after a benefactor to All Souls College. The college owned lots of NW10 land, including Elmwood Tennis Club (which I belong to), and are sadly just about to sell Kensal Rise

Library, which was opened by no less a figure than Mark Twain. It was closed by Brent Council but is still the subject of protests, as well as the location for a truly heroically long-lasting pop-up library run by eighty volunteers. All Souls are trying to get rid of the site now and at least one property developer has plans for predictable luxury flats and a small area for a library hub. Hundreds of angry residents want to keep it as an arts building and are wonderfully vocal and active on this front. I hope they triumph.

There has been another more disturbing contributor to the sharp edges of Harlesden – young men who are willing to use guns and kill each other. In the early 2000s, national newspapers were splattered with words like 'Yardie' (lasted for a few years, peaked with the murder of seven-year-old Toni-Ann Byfield and her father, then gradually disappeared), 'UK murder capital', 'Harlem' and 'drug gangs', and often they were talking about NW10. It got worse before it got better. Between 2005 and 2007, Operation Trident investigated forty-eight shootings in Brent. Ten were fatal and led back to Stonebridge and Church End, the estates that were at that time in New Labour transition from brutalist tower blocks to post-modern low-rise. The Detective Inspector declared that it had been 'all out war at that time' and put those particular murders in that era down to differences between the Kensal Green-based Mus Love and the Stonebridge Gang. 'They were dealing in crack cocaine,' he declared. 'Stonebridge was a series of concrete blocks with walkways between. It was difficult for police to get in and out. It was rife with drug dealing and violence.'

I walked round Stonebridge – formerly tower blocks, now sparkling exteriors and pervasive pine board, low and friendly, with the architectural emphasis on both inclusivity

and difference – with Michael Saunders, an anti-gun crime activist from the British Londoners' Business Community who believes in 'community unity'. This translates as bringing together fathers, mothers, aunties, uncles and grandparents with the young people in ongoing meetings. Here, the mother of a young person who has been shot can sit next to a father who has a son who's in prison for murdering someone. That way, it all gets up front and personal; that way, people, and what's happened to them, can affect each other.

Saunders blames the gun and violence trends on MTV and rap videos. And if you google Harlesden and rap, there are some pretty offensive local videos, hideous verbal attacks on neighbouring gangs. One is called 'Fuck St Raphs', stuff about spraying bullets at people – all the usual disaffected venom.

Local rapper K Koke, who comes from a Greek Cypriot family, had in fact just signed to Jay-Z's label Roc Nation and was about to break out of Harlesden when he was charged with attempted murder – a twenty-seven-year-old who'd just been playing football was shot in the back at Harlesden station – in 2011. Eventually, Koke was acquitted and is back rapping but the other two, apparently part of the Stonebridge Thugs (one of whom was only sixteen at the time and is Koke's cousin), were convicted.

But things have calmed down. Faisal Abdu'Allah – Harlesden's funkiest barber and artist – tells me he was literally losing clients all the time to bullets. 'I wore one suit to six funerals,' he said, 'so in the end I threw it away because I thought it was bad luck. I think the situation has changed. I think the people involved in drugs and crime are wising up. They're not driving flash cars and they're not kill-

ing people that owe them money; they realise that if they're dead, they're not likely to get their money back.'

Like I said, Harlesden has a certain kind of spirit, and it's a defiant one.

Creative Junctures

If you read about Harlesden, it is inevitably referred to as 'vibrant'. The subtext is dirt, little money and under-privilege. Vibrant in this case is like the much-debated cultural muddle of exotic. Only vibrant is active, and exotic is passive. It's often white people like me – although, confusingly, people often find me exotic – who find the unfamiliar exciting and a little bit dangerous. The unfamiliar is what the waves of different immigrants – Caribbean, Brazilian, Afghan, Pakistani, Portuguese, Polish, Somali etc. – have brought with them in foods, clothes, culture and religion, as well as their bodies and how they look.

Part of me wonders if the shadow side of Harlesden somehow enables the light. When Leonard Cohen sings about 'the crack that lets the light in', I think he means the crack in the blues, the fracture in the despair, the tiny aperture where opportunities can happen. Harlesden is not a pleasant land of frothy shops and glamorous eateries. But there is Leroy Simpson who leads an inner city version of the Vicar of Dibley in his Harlesden Town Team. They may be finding their torturous way to the light.

However, Harlesden does have a certain perkiness, a lack of conformity, a tendency to surprise. Because high street chains perceive this neighbourhood as undesirable and therefore don't come – Alexei Sayle wanted to know if there was a Starbucks and I had to cheerily dismiss his

latte imaginings – there is a freedom (from Boots, Costas, Orange etc.) that means individual shop owners rule (the joys of Planete Brazil with its bikinis, Blue Mountain Peak with its scores of yams and giant Jamaican avocados, or the Shop with its quasi spiritual air-sprays that de-demonise your flat).

In that way, Harlesden is a paradise of localism. Amid the horror of Cash Converters, pawn shops, and chicken/kebab takeaways (the blues), there are the bursts of sunlight in the shape of the Jam Down Bakery, a family-run pattie shop, Avant Garde (owned by the oh-so-funky George with its traditional yet groovy Italian men's clothes, from checked caps to dapper tweed jackets) and Hawkeye. Which reminds me, Prince Charles called into Hawkeye in 2007, did a bit of a skank to 'Good Thing Going' by Sugar Minott and declared enthusiastically, 'I don't think I have enjoyed myself so much for a long time going down a high street and popping into one or two shops. I'm sorry I couldn't go into a few more.' Perhaps we should get Charlie back to promote the High Street.

But Harlesden is also home to another much more remarkable phenomenon: urban mash-up craziness. Philosopher Robert Rowland Smith noticed it while we were meandering together and was instantly enlivened. It's all about madcap junctures and startling juxtapositions. The significance is in what is birthed from these meeting places. 'The Afghans next to the Jamaican takeaway, the gym with a church in the adjoining room, Bang community radio being run in the same building as Santander,' he said, 'these are the creative junctures where life really happens.'

And I do really feel that.

Initially, I came across this kind of incredible urban mash-up craziness or eclecticism bordering on commercial

schizophrenia at Wrights, which is my favourite Harlesden shop. It's the one with the lingerie and the cameras and the watches and so much more, the one where I bought the stockings with black tie-up bows at the back, which I bought as a 'hen' present for my friend, Jake (a woman).

I delighted in inviting my fellow flâneurs to sample Wrights, but not all of them were as keen as me.

Alexei Sayle, who's been solidly married to Linda since something like the seventies – millions of years, anyway – looked alarmed at the thought of outré lingerie and obviously felt his shy and retiring Marxist roots were about to be poisoned. I had much more luck with poet/eccentric/ex-gas meter-reader/bon viveur Sue Saunders, who reported that she'd bought her young husband a riveting Babydoll calendar there with the intention of focussing his DIY skills. Louis was quietly bemused but ultimately unconvinced by Wrights. Sorry, Nancy – no adventurous sexy pirate outfits for you. Of course, tantric goddess Kavida was captivated not only by the thongs – she bought a very tiny flame-coloured one – but also by the fabulous sixty-something Indian couple who run it.

Quintessential urban mash-up craziness also happens at the Harlesden Centre. Locals think of this building as a nightclub because it housed Dreams (now NW10), as shown in the 2001 docu-soap 'The Heart of Harlesden', where young women in diaphanous tops and bottoms 'wined' for Britain, but in fact, it is so much more.

For years, I've been overly fixated on these upstairs windows that hover enigmatically above Iceland because they often bear impossibly clashing signs. So I'd got the nightclub bit – queues of young people on Saturday nights – and then up popped a tatty banner with 'Dominion Church of

Christ', and finally another advertising a gym. My mind went into overdrive. How did a nightclub, a gym and a church co-exist?

When I finally made it through the front doors, there were more possibilities to contend with. It's run by Nigerian Kola Williams, who is large, difficult and often described as a local gangster – by himself especially, which must be telling! Fortunately, he's funny too.

The building is cavernous and ramshackle. The latter quality is also a Harlesden speciality. Kind of raw architecturally, with a certain attitude. As well as a church, the same room – it has the only good wooden floor – doubles up as a salsa studio. As well as the gym downstairs, there is a kick-boxing ring upstairs. And Kola has lofty ideas for that space. Yoga. What about yoga for body builders, I suggest, looking at his biceps? Could start a new trend.

Down the road, Faisal is a masterful example of urban mash-up craziness. Yes, yes, yes. This is where the life is. I feel invigorated by these fabulous junctures. Faisal also has the grooviest barber's shop in Harlesden – pervasive white decor, white and red uniform shirts, clients like boxer James de Gale and rapper Gappy Ranks – and the downstairs acts as a gallery/workshop for Faisal's art work, i.e. photos, screen prints and film installations. And there is synergy. Often his clients' stories turn into his work.

Just down the road is Willesden Junction, the railway station on the right. How does this qualify? Because it is a junction as well as a juncture. Because there's a lot of weird unexpected urban 'shit' going on in this station and beyond. It's a huge place. Because of the old and the new, the industrial, the bleak and the beautiful all being mixed up together inextricably. Because there's an Everest of rust

at the rear – old fridge compressors, apparently – behind the myriad wire fences.

Railway enthusiast – as opposed to train-spotter; be careful – and goth-like, middle-aged pixie Ian Bull shows me round the craziness. Lots of history standing in seductive ruins next to the new and functional. A massive broken-windowed 1909 (arts and crafts, no less) transformer building – they were manually levered in those days, hence the windows – rises behind the dull, windowless contemporary transformer bunker. When I walked with Bull, there was still an old going-back-to-the-1960s signal box at the back too. It had these distinctive wooden finials as decorations. Like an adjunct to spinning, they were church-like. Sadly, that signal box has been dismantled. Tragically, there is no Cornelia Parker to re-assemble it.

And so it goes on, mixtures and melanges that have this unacknowledged creative potency. Eruptions from the streets, unheard-of combinations, alluring commercial follies – all this higgledy-piggledyness that clashes together and somehow creates this tangle of new life.

Looking for Willesden Hippodrome Without Google

This was going to be a search for air raid shelters with author Nick Barlay. He flunked out – a water pipe problem. Anyway, I was pissed off because he had cancelled twice. I hate people who cancel. He walked the London section of the A5 for *Time Out*, so I thought I'd get a few tips. Too bad, I'll go on my own.

In the meantime, I'd been looking at a map of Harlesden from the 1830s, which had various more recent buildings added. I tried to imagine where the Willesden Hippodrome – which, as I've mentioned, opened grandly in 1907 – would have been. I knew it wasn't there anymore, but where had it been? I decided to refrain from consulting Google, and try to find someone who knew. By talking to them. Novel, I know.

The Willesden/Harlesden references are going to be eternally challenging. Harlesden used to be in the borough of Willesden, before Brent was created in 1965 and absorbed them both; hence a variety of theatre and station location-confusions endure. Willesden Junction – you may not know – is actually in Harlesden. And so would Willesden Hippodrome be, except it doesn't exist anymore. When it

did, it was in Willesden. But now it doesn't, its absence is in Harlesden.

Outside, the puddles have iced over, a light glaze. The skies are grey-feathered. I stand at the end of my road (is it in Kensal Green, Harlesden or Willesden?) and mull over the idea of hanging out there one day and just chatting to people about Harlesden.

I cross over Wrottesley Road – on that 1830s map, it's a marginal presence in one corner, but you can see the trees lining it and I know it was the leafy, muddy and privately owned Green Lane at the time – and pass Leah's flat. Before Christmas, I went on a search for Leah and found her – on Valentine's 2009, her boyfriend stencilled our pavements with amazing heart words to her, like concrete poetry – by putting a poster up on nearby trees. *Who is Leah? A writer wants to know.* The wrong Leah rang, but eventually the right one rang too. Sadly, we've yet to meet up. I want to hear her love story. In the last text, she said she'd had a tough Christmas. I still hope to get hold of her.

On my way to find the site of Willesden Hippodrome, I suddenly decide that I'm actually going to talk to people. Have conversations. Interact with strangers. I want these walks to be happenings too! It's an old-fashioned word, I know, but I like it. And it's a community venture. I'll ask them what they think of Harlesden.

I'm on Ancona Road and a young man approaches me wearing headphones. I enquire if I can ask him a few questions. He's very willing. Turns out he lives in Doyle Gardens with his parents. Doyle Gardens is in Willesden postcode-wise, Kensal Green if you're flat-hunting, and Harlesden, if you live there. He's twenty-four and a police officer. The first person I encounter is a young, out-of-uniform policeman!

In Hillingdon, he says, where it's more affluent and easier to police than here. He smiles a lot, a confident smile. 'My mum came over from Kenya when she was three,' he says. 'My dad is Indian.'

Rav did a degree in politics and joined the police when he was twenty-one. He loves it. How strange, I think; I would never have imagined students of politics joining the police. More the opposite – more the protesters. Maybe that says something about the contents and lecturers of politics these days. He says he's in the reserve TSG, the territorial support group or riot police. He seems liberal; he claims he would like to see them open up their methods to public debate. 'We've been issued with embroidered numbers now for our epaulettes,' he says innocently revealing the results of the furore around Ian Tomlinson's death during the G20 protests; the officer who pushed him over was not wearing an identification number. The video footage, filmed by an American hedge fund investor visiting London, showed this state of police undress very clearly. And apparently the ensuing publicity has had an effect. Embroidered numbers, which can't 'fall off'. I check later with the Met press office and it's true.

What does he think of Harlesden? 'I think it still needs more money investing. My police friends who work here have to deal with gun crime all the time, and even talking to someone at night is difficult. They have to have a few cars come out together because the threat of possible aggression is so great.'

Who would he vote for in the 2010 election? 'I think I'll be voting for Cameron,' he mutters. 'We need a change. People are worried about immigration and I think that will come out as we get nearer to the election date. The BNP

have already started the debate.' Did he watch Nick Griffin on Question Time? 'Yes, he was awful,' he says. It's a relief to hear him say that.

'Did you know they're changing the boundaries in Brent? Basically it will be the Labour MP, Dawn Butler, who is at present in Brent South, up against the Liberal Democrat MP, Sarah Teather, who is in Brent East at present.' I didn't know this. I like Sarah Teather, I say, because every time I see her on Question Time, she is so well informed and sensible. He agrees. 'Yes, she's a great local MP. She comes and talks at the Willesden Hindu Temple. She even knows some Gujarati. I like her because she travels by bus and walks around the constituency.

'Oh, I think I will vote for Sarah,' he says finally. Phew, that was a turn-around.

I pass the wall that still has 'I love u Leah. With all my heart' stencilled on it. I'm envious. When's someone going to do that for me?

And there's the Rebirth Tabernacle. Then there's the green, very green, Max's barber shop where Rav had just had his hair cut.

Before I know it, I'm walking next to a woman who's wearing a cream scarf over her head and limping. I ask her if she lives in Harlesden? She has an incredibly open face. 'I do,' she answers. 'I'm in Ridley Road with my two daughters. My son has left home for University.'

Amran is from Somalia and has been here for fifteen years.

Does she feel welcomed by us, the British? 'Yes, I do. My husband was killed in Somalia when my youngest daughter was only two – she's seventeen now, and I'm forty-four.' I can't help myself asking – what about other Somali men? Fortunately, she laughs – she's got a robust one – and

responds, 'It's difficult. They might go back and get killed. And if I ask which tribe they're from, it sounds as though I want to marry them. It's worse in Somalia now than it was fifteen years ago. It is a country that is being torn apart. I have family there who are just waiting to die. We women are strong, we're the ones who are left to suffer, but we're also the ones who stand up and say "no more".'

Oh, she is so warm and honest. I can't believe how trusting she is. We've walked up to Harlesden House now, which is where the Job Centre is, and a number 18 bus approaches. 'I have to get it,' she insists. Do you work? I ask. 'I can't, I have kidney failure. I'm on my way to an appointment now.'

At this point, I decide to walk back down the road again and see if I can find anyone who's heard of the Willesden Hippodrome, because I know it used to be somewhere near here. I see a man who has the inherently exhausted look of someone who's worked at this furniture shop for too long. 'I've been here for twenty years,' he sighs in an Irish accent, 'but I don't know it. Let's ask my colleagues.' No, nobody has a clue.

I cross the road, wander over to the top of the stairs that run down to the long walkway leading to Willesden Junction which opened in 1866. It's one of those urban moments. I stand – I never stop here ever because I'm always in the momentum of being on my way to somewhere – and gaze across the vast tangle of railway lines, the open skyline marked with cooling towers, and now clichéd graffiti tags. Fresh, Snag.

I feel a tap on my back and look round to see Sue. I haven't seen her for years. In fact, she's a poet who's wonderfully eccentric; the last time I saw her she was pasting original pages of Mrs Beaton's cookbook on her ceiling. So

what is she doing in this uber-blankety green jacket, wielding a strange machine with numbers on it?

'I've become a gas-meter reader,' she explains. 'In fact, I was just reading the meter at the used car lot when I heard a woman's voice politely asking about the availability of Somali men in this area. I didn't realise it was you, but then I recognised your style.' We discuss the wonderful view from these steps. The sheer, industrial extendedness of it. Of course, her daughter Eileen, aged twenty-one, has just bought a puppy – they went to the Isle of Sheppey (yes, the Isle of Sheppey) last night to get it and spent all night in bed with it, so Sue hasn't slept. I tell her what I'm doing with this project, and she says how much she loves beachcombing.

Beachcombing? I think she must mean streetcombing. I know that she will be a fantastic person to walk with in Harlesden. I promise to ring her very soon.

I walk back up Harlesden High Street, past Café Brazil and closed-down nightclub, the Lodge. It was groovy for a year a two, but couldn't keep going. It's looking very abandoned now, with a closure notice pinned to the door. I have recently taken in that it was called the Lodge because in the nineteenth century, the Grange Lodge used to be nearby. A little further up the hill, I look across the road, and there is Harlesden House, an unappealing nineties brick building. It's a Job Centre Plus now, but I can imagine the Edwardian Willesden Hippodrome standing there. Was it, I wonder?

I'm looking for some more people to ask. I see a couple of older men, but they start speaking what sounds like Polish. Then, I see a grey-haired, bespectacled woman coming towards me. She could have lived here a long time. I ask her. 'I came here,' she points to a flat at 150 Harlesden High Street, 'just after I got married in 1969 and have been here

ever since. My husband was Irish – he used to get up at 5 a.m. and travel around.'

Perfect. Does she know where Willesden Hippodrome was? 'Yes,' she says, faltering, 'it was down there on the left, next to the bus stop. It's a block of flats now.' That's strange, I think, because that's not the side of the road I've seen it marked on the map. But she is certain, so I try to believe her. I walk down and there is Paddy Power, the bookmaker's with what turns out to be new build block of flats above it. Deeply unattractive and too small a site, I would have thought, for such a big theatre. However, I've never been into a betting shop. I push open the door. All men.

I go up to the bloke in the green clothes (yes, it's all part of Paddy's Power) and ask him. Unsurprisingly, he doesn't know. He tells me to go and ask some of the old-time locals. A large man with a grey beard and a Rasta hat, another more Chinese-looking Jamaican and their friends. 'No, I think it used to be a wine bar,' says the Chinese Jamaican.

'Why do you want to know?' says the big man with the Rasta hat who turns out to be called Charlie. He's rather good-looking with a lot of flirty sparkle. Forget the Hippodrome. I think he might be a good lead for one of my future walks. What does he know about dancehalls? Harlesden has always been big on reggae. 'We used to go to Burtons in Cricklewood,' he says, 'but mostly to private shabeens. I know who can help you, Roy at Hawkeye Records up the road – tell him I sent you.'

I say it's the first time I've been inside a betting shop. 'You'd better leave,' he roars with several twinkles, 'you might get tempted.'

Post-walk google – I look up the address of the old Willesden Hippodrome; it's 161–163 High Street Harlesden.

Ah ha, Paddy Power is at 120. My hunch was right, it's not the same place. There's a piece in Cinema Treasures that has a picture of it – it's huge, and so grand. Wow, the photo shows a different Harlesden – lots of ladies and gentlemen in their finery when Harlesden was posh, at the turn of the nineteenth century. It was where Harlesden House is now, the home of the Job Centre Plus. The Willesden Hippodrome was opened by one Walter Gibbons as a music hall/variety theatre. Designed by the most prolific turn-of-the-century theatre architect, Frank Matcham (I went to Blackpool a couple of years ago and he designed the Grand Theatre and the Tower ballroom there), it had a 30-foot stage and eight dressing rooms! In 1927 it became a cine/variety theatre. Then it was closed in 1930, taken over by ABC and opened as a cinema until 1938. Finally, it re-opened as a music hall/variety theatre, but was bombed in 1940 by German bombs.

According to former resident Steve Jones, the interior was damaged but he remembers children swinging from balcony to balcony on a long rope and treating the roof as an extended playground. He says it was finally demolished in 1957.

And what was on the site of Paddy Power? Harlesden Cinema Theatre opened in 1911, turned into the Grand Cinema in 1928, and re-opened with an art deco façade. It closed in 1957 and was converted into an Irish dancehall. Later it became a nightclub called Top 32 Club, then Angies. Finally, it was a snooker club. That was demolished in 2003 and rebuilt in 2008 to house Paddy Power and those flats.

WALK 2

A Sea of Hair

Today, I'm walking with twenty-one-year-old June Mckenzie. Having recently graduated from Westminster University with a degree in journalism – she's the first one in her family to go on to further education – I met June before Christmas at my ward meeting run by the local police. I was there because of the burglaries in my road; she was there because she wanted to help stop the gun crime.

'I can't see it stopping,' she said, sounding frustrated. 'Black on black crime is complex. I did my dissertation on how it is portrayed in the media. I want to be involved. I know a lot of young men who are in that world. I don't know what to do, but I want to do something.'

A few months later, I met up with June outside the famous John Line's butcher's shop in Harrow Road, which without fail has long queues. 'We've always bought our meat here,' she explained. 'It's cheap and good. It's a family tradition with us.' She lives with her grandfather round the corner. 'If it wasn't for my grandparents, my life would be very different. I might have been a single mum or in prison. In many ways, they brought me up. Sadly, my granny died nearly two years ago. I still miss her – her death has affected me physically and mentally.'

Just before we said goodbye that time, June asked if I'd heard of Shawn Callum. 'My friend is the mother of his baby,' she explained, showing me a photo of the good-looking twenty-six-year-old with shaved eyebrows. 'He was shot and killed last year leaving a private party at Stonebridge Primary School.'

Why? 'He wasn't involved in drugs or gangs, but that is how the newspapers portrayed him. He was innocent. The papers never portray black youth as innocent bystanders,' she said passionately. 'The trial is very soon. My friend is nervous about whether the person who has been charged will be prosecuted or not.'

By the time I see her this time, the twenty-one-year-old who was accused of the killing has been found not guilty. Not enough evidence. June is upset. Her friend is beside herself. They feel that the killer has been set free and that the legal system has failed Shawn – and them.

But I don't want to just focus on June and who she knows in that way, so I'm getting her to take me on a hair tour. She spends a lot of time on her hair and Harlesden is big on hair. Plus I really know nothing about this world of add-on hair.

We meet at the telephone box at the junction of Wrottesley Road and Harrow Road. It's 6.30 p.m. Bless her, June's taking this hair tour very seriously. She's even changed her hair for me. Last time, it was long and straight. This time, it's back in a kind of ponytail.

'I'm wearing a lace,' she explains as though I'll understand. Oh dear, I'm already baffled.

Does she mean a wig? 'No, we call it a lace, it's stuck on to the front of my head,' she says. 'It's glossy and long. Women like Beyoncé wear them. But I also wear weaves when I'm

not wearing a lace.' And how much are they? 'I get two packets of weaves for £60 and they last about five weeks. But laces cost between £150 and £200 for real hair and might last a month before they start getting itchy.' Oh, the fine art of laces. Which incidentally are sort of wigs. I'm astonished. She spends this much money on her hair!

We cross the bridge at Willesden Junction station and pass Jet Set on the left. It's a strange little club, which at this time has the words 'Dine and Dance' up there too, but I'm pretty sure that there's no dining going on. 'There was a shooting there too,' she says. 'That DJ was shot outside, he has to have round the clock care now. He was trying to be a peacemaker for another guy. I know Craig Robertson, who did it. He was only seventeen at the time. I grew up with him, my granny would always cook for him – he loved her mutton and rice. I was totally shocked at what happened.'

Our first stop is Faisal. Today, the shop is packed with assistants and customers – from toddlers to thirty-somethings.

I talk to Ben, who is having a razor cut. How often does he come? 'Every three weeks,' he says, 'and I've been coming for 10 years. Since it started, in fact. I pay £12 for a fade.' Then there's a nudge from the barber. 'Oh, it's a skin fade, not a fade,' he re-informs me.

We wander past a Brazilian hairdresser's, which only has one customer. It's nearly 7 p.m. 'I'm not being rude,' says June, 'but you never see that shop full.' Then a bar and restaurant called West Coast. Does she go there? 'Well, I went a few weeks ago for the after-party of a funeral, but I wouldn't normally go. They're not my sort of person. They're too arrogant for me.'

As we pass the Job Centre Plus – in other words, the former site of the Willesden Hippodrome – June makes an

admission. 'You're going to think I'm mad,' she says, 'but I'm not. Last week, I spent an hour and a half leaning against that tree and in that time I counted 160 young women and prams going to the Job Centre Plus. They looked angry and disillusioned. But I felt enraged. So many of them are getting benefits and flats. That's why some of them get pregnant. I felt disgusted. I don't want to be part of a culture that is like that. Young girls can do so much with their future! Why waste it? Babies are a blessing, but I don't believe in bringing poverty into poverty.'

Sometimes, it feels as if June is carrying this burden – that's how she sees it, the boys without fathers, the girls who are obeying a certain unwritten 'babymother' law – all herself. It's the opposite of what she wants for herself or them. I can feel her passion and fear rising simultaneously. 'In my culture, to be poor is to be bad,' she says despairingly, 'that's why easy drugs money is so attractive.'

As if on cue, we pass the Christian bookshop fittingly called The Rock. We pop in for solace. Books like *Everyday Jesus Healing Wounds* with a sticking plaster on the cover, pink prayer books for girls, a bible especially for brides, and special sort of soft mints with stripes ('You get those in Jamaica,' says June), as well as flowery Jesus bags. It's an old-fashioned shop, which I could imagine finding in a suburb of Kingston. Yes, Kingston, Jamaica.

Next door is what I think is a skincare and shampoo shop. But we go in and there it is. A sea of hair. Hair in packets hanging everywhere, wavy, fiercely curly, straight, startlingly blonde, brown, black – all manner of hair, both real and not real. I've never seen so much hair in one place. They're made by companies like Remi and Milky Way. I knew about the hairdressers and barbers shops in Harlesden, but until this

point I had managed to totally miss out on the hair shops. This is hair for sale en masse. Of course, real hair is more expensive. And June wants real hair.

The slight, thirty-something man selling the hair is Afghan. Another customer called Edith – she's wearing a pretty brown and blonde lace, I'm an expert now – has come from Harrow on a hair mission. 'There are twelve hair shops in Harlesden,' she explains. 'I might keep a lace in for three months but then it will get uncomfortable. That's what's happening now. I'm getting ready for the weekend with my boyfriend and I want to give my head a rest so I'm looking for a wig, a long wig.'

I can't believe how many hair shops there are in such a small area. Again I'm stunned at the effort and money that goes into these women's hair. I say so. Loudly. 'Yeah, we put hair first and health second,' giggles Edith, who works in the City. 'It's our life, and we are willing to go the extra distance. My boyfriend is English and he's still getting used to it.'

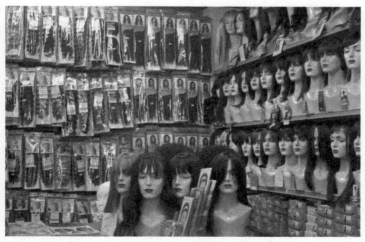

A sea of hair at one of Harlesden's famous hair shops.

Why oh why? 'It means they can have a different hairstyle every day,' explains the doe-eyed shop owner, who says his family have been in the UK for fifteen years, and now have a lovely big house near Finsbury Park. He might work in Harlesden but he doesn't live here. The hair business is evidently good business.

In the meantime, the 'girls' are admiring each other's laces. Edith is sporting the eye-catching blonde and brown one, while June has a rather more demure black one. 'That one is too over-the-top for me, it's too much,' says June, meaning Edith's one. 'I couldn't wear that at work.'

It's fascinating that she is so disapproving. Hmm, do I hear the murmurings of a hair war?

'My granddad will be back from Jamaica in April – he goes there in the winter,' says June, 'then you'll find him in the Misty Moon[1] up the road at this time in the evening.'

Did she ever go to Dreams nightclub? 'Yeah, I went when I was young, like fourteen,' she says, 'but I wouldn't go now. Did you see what those girls were wearing to Dreams in *The Heart Of Harlesden*?'

'Yep,' I reply, 'almost nothing, and the camera was constantly focussing on their behinds, often barely covered behinds.'

'Oh, I couldn't believe it,' she says. 'The girls would arrive late at like four in the morning just to make an entrance. They liked to think they were stars. It was all a status thing.'

It's 8 p.m. as we walk past the rest of the hair shops, hairdressers and barbers. Most are closing. June just pops into one to check how much it would cost to have a ponytail. No, not that kind of ponytail. 'It's a way of grooming the hair to the side,' she says.

Evidently, I've still got a lot to learn ...

WALK 3

An Ex-Gas Meter Reader's Perspective

Streetcomber, poet, artist, mother and gas meter reader Sue Saunders has been sacked since last time I met her. She's wearing tiny teacup earrings, striped tights and sneakers with silver laces and immediately launches into telling me about the precious street bounty she has collected in the past. 'I've got a bird table in my garden that I found down Tubbs Road,' she laughs. So we decide to go down Tubbs Road. Just like that.

I hadn't known that Sue had been wearing her green uber-blankety outfit (in other words, gas meter reader uniform) for three years. 'Yes, I loved it,' she says wistfully, 'the freedom to roam around, to investigate basements and the backs of buildings. Just me and my meter reader.'

As we gaze at a church, which announces itself as 'OPEN DOOR Ministries, Church of God Prophecy', I'm beginning to become aware exactly how much of an asset it is. To walk with an ex-gas meter reader, that is. 'I always thought Open Door was rather an ironic name,' comments Sue dryly, 'because I could never get into the building.'

So we try the door at the back. It has a bell marked 'Please ring for attention'. 'I would always look at those words,' she

says in her rather wistful, haughty tones, 'and think, "Oh yes please, I love attention." If only my husband would put in a bell like that in our bedroom.' But this particular attention fails to materialise and we move on.

Only moments earlier, Sue had been telling how difficult it is for her to find a job again. Then she drops a little bombshell. 'They put me on a register for professionals because I told them I have a degree from Cambridge University,' she says, 'but I've never been a professional. I don't want to waste their time.'

Ah ha, I think, degree from Cambridge. I didn't realise that either. Sue is such an amazing mixture of contradictions. She reminds me of another era. The seventies, when students went to study what they fancied, not what career they thought they should go for. I have an ex-boyfriend, Jerry Tidy, actually, who studied Latin and English and then became a car mechanic in the US; another friend, Simon Farr who became a Maoist while he was at art college, then worked on the Underground for eight years. Jerry still works on cars, but they are Alpha Romeos in Virginia, while Simon is an artist who paints portraits in Suffolk.

Sue's leading me round a corner. 'It doesn't have a sea view,' she says, 'but it leads to the backs of the businesses that are on the High Street and there are some interesting alleyways.' I'm always thrilled to go somewhere totally new and I've never walked down here before. Clifton Road looks onto Willesden Junction and there's an impressive warehouse-type of building at the end. 'You'd really like it in there,' declares Sue knowingly, 'there's a flat up there that's rather modern and fascinating.'

We investigate the alleyway on the left, which takes us to the back of the shops. 'I'd think of myself as Jodie Foster

in Silence of the Lambs,' says Sue, now leaping around as though she has a fake gun in her hand, 'when I came down here. I'd be creeping around in the darkness. People don't get how hard it is to actually locate meters especially in businesses.' It's true, it had never occurred to me. At that very moment, she spots an invitingly open back door, which looks very dodgy indeed. The way to it is strewn with mattresses and discarded magazines, plus it is decidedly water-logged.

I'm not sure I'm so keen on this particular excursion. But Sue is enchanted. That's all part of her fantastic allure. So I join her. We step into the darkness and I become aware that we have found the downstairs club area of Jet Set. 'I would sometimes wander up the road to find cigarettes at night,' she says, 'and I'd find myself ordering a whisky here.'

Sue obviously has a perambulatory late-night existence. By the time we're back on Tubbs Road, she is telling me more about her night-meanderings. 'There used to be an old snooker hall up the road,' she says and I think she must mean where Paddy Power is. 'One night, I had an amazing time. There was a big gypsy bloke and a black jockey who kept bursting into tears because he'd got caught up in drink and drugs and missed out on a successful career. They ended up taking me to Lakeleys, a drinking club in West Hampstead, which is where I met my husband a while later. On the way home in a mini cab, the gypsy kept telling me that we would never meet again and that he knew this because he was a gypsy. But I still didn't give him a kiss.'

By the time we get to Station Road, Sue admits she's been tempted by the interior of the Victorian Willesden Junction Hotel and wanted to go there and dine, but the desire has sadly diminished since it has become the Brazilian and

decidedly meaty Amber Grill.[1] 'But look at these original tiles,' she says, pulling up the front mat. 'They would make a great photo.'

I suddenly feel drawn towards Harley Road, which I've never walked down and which looks distinctly unpromising. The railway lines are on the left within a huge industrial complex. Neither of us are sure what goes on here. I'm expecting endless nondescript houses, but suddenly I notice a girl's face wearing a hijab on the wall. A row of faces painted in dramatic black and white. Boys, girls, serious, threatening? What do their expressions tell us? It turns out to be a 2008 art project funded by Brent Council called 'Girls and Boys' (note order), which is questioning the negative stereotypes that we have about teenagers. Great idea. Shame it is hidden away down here, although it is brilliant to discover and the first bit of public art in Harlesden that I've actually liked.

Sue spots a bloke in a green uniform munching away on a park bench. 'He's probably a street cleaner,' she says, going into uniform expertise, 'having his elevenses. That is one of the problems about working outside; you have to find somewhere to eat. In winter, of course, I used to seek the comfort of a cappuccino in a café. Actually I used to get given food all the time. Especially loaves, then I'd have to carry them around with me all day. But people were being so generous – I couldn't refuse.'

We stand by a metal fence and admire the gigantic yellow industrial equipment that looks as though it's about to clamber across the landscape, like a stray rollercoaster that has wandered off from the Pleasure Beach. Then I notice a discarded crutch just through the fence. 'I'm such an optimist, that I would look at that and assume that a miracle

had happened,' she says. 'But you see that plastic ghost-like model, that's the sort of thing I would pick up in my street-combing. It would give meter-reading a poetic dimension. I once opened a meter and found a lion inside and imagined I was in Narnia. I'm always writing bits of poetry. Sometimes, I have written on the backs of maps, then forgotten and thrown them away by mistake.'

As if summoned by our resident poet, the heady sweet smell of biscuits wafts over us. It's the McVitie's factory. 'I once wrote a poem about real success being about having the freedom to take in that smell, rather than the safety of working in a bank,' she says.

A sign appears on a wall above the railway lines. It declares, 'Prepare To Meet Thy God'. I have to admit I am unprepared.

There's a Caribbean Cultural Centre on Minet Road where Sue recommends the woman who works there as a good chatterer. 'But not today,' she says, 'otherwise, we'll never get away. I used to go to read the meter and then she'd engage me in a lengthy discussion, which I found very difficult to extricate myself from.'

On Acton Lane, Sue explains that she actually relished meter reading for businesses, and that no one else wanted to do them because they took so long to find. 'We didn't have a target because the managers knew how hard it was,' she says, 'which was perfect for me because I could wander with impunity. But I was very good at it.' It seems wrong that they sacked her. She is obviously so ideally suited to the profession.

She strokes the lichen on top of a garden wall and explains that it's called golden haired lichen. We pass a shop further up called Fix Up Good, which has the mystifying sign 'Acc/

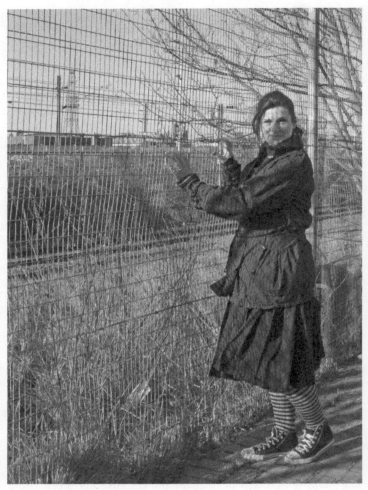

Sue Saunders, mistress of eccentricity.

clo/toil' on it. Another language. In fact, I wouldn't have noticed it if she hadn't pointed it out. 'What does that mean, do you think?' asks Sue. I've no idea, but she has already worked it out. 'I think it's accessories, clothes and toiletries, but it's not exactly the most attractive of abbreviations, is it?'

We pass Connaught House, obviously a grand Victorian abode in its day. It has black wrought iron at the front and a veranda. 'I was delighted when I found out that it's owned by the family of one of my daughter's friends,' she says displaying her penchant for grandeur in design at least. 'Eileen has visited and she says it's just like being in *Little House on the Prairie* when you sit on the veranda.' I can't help myself mentioning that thirty years ago, I (with Jerry, the Latin scholar and car mechanic) lived for a short time in a plantation house that was in New Orleans' ninth ward – the area that was hit so badly by Hurricane Katrina – and it had a similar veranda. And, of course, a couple of rocking chairs. Is this veranda one-upwomanship? Probably. Unaware in a delightful way, Sue gasps in wonder at the thought of me in New Orleans.

We manage a quick stop at Wrights to admire the skimpy lingerie and the strangely attired models. Sue is unabashed in her appreciation. She had purchased a sexy calendar for her younger husband. Would he similarly purchase a portrait of a hunky young 'stud muffin' to motivate his wife? 'Oh no,' she says, having spent a few minutes examining a 'naughty' lighter for women, 'he'd never think of that.'

All Eyes On Egypt and the Black Madonnas

Apparently, there are around 500 Black Madonnas – a black version of the Virgin Mary, who various scholars suggest is a pre-Christian mother figure with the goddess Isis as an ancestor – scattered around Europe, and three of them are in Harlesden and Neasden. The Black Madonna is also said to teach us to embrace our dark and light sides, our negative and positive characteristics. Very much my kind of woman, in this case.

But instead of visiting two of these local Black Madonnas – the priest at the Catholic Our Lady of Willesden Church in Harlesden is on his day off – I find myself at a book shop called All Eyes On Egypt on Park Parade that has been intriguing me for some time. Is it the home of a mysterious cult? I must be following the Isis thread instead.

I'm greeted by the very spirited Amsu Re, who happens to look like Eddie Murphy.

He sparkles and crackles with preacher-like zeal, but I can't help noticing that he's a bit of a laugh. 'People are robots,' he says in an American accent. 'They don't want to know the truth or talk about the deceptions. This shop is about education.'

A few weeks ago, I saw a poster on the window of the One-Stop Jerk Chicken shop in the High Street, advertising a talk entitled 'The Angry Vagina', which was taking place here at this shop. 'Oh yeah,' says Amsu Re, 'the author, Queen Afua, was over from the US so we launched her book *Overcoming the Angry Vagina* here.'

Queen Afua advocates natural remedies and the health of the womb. In other words, don't let the medical world intervene and remove wombs when it's not necessary. She's also concerned that young women 'don't give themselves away too easily'. Originally called Helen Robinson, she's now an African queen. I love the idea of re-appropriating names in this grandiose re-positioning manner. I want one myself – maybe not African, but more appropriately Celtic. Similarly, Amsu Re was probably born with a name like Colin Walker but has become the vastly more mysterious and Eyptian king-like Amsu Re.

Queen Afua – a holistic practitioner who's worked with Stevie Wonder and Erykah Badu – asks a vital question. Is your vagina happy or angry? Or more appositely, is your spouse's vagina happy or angry? She also makes suggestions of ways to increase vaginal contentment to men and women. And watch out, because she has hinted that her next book could be *The Angry Penis*.

There are pictures of Bob Marley, natural oils, soaps, posters of black women and men who fought against slavery and for women's rights, and then there are those of sports stars like the magnificent Mr Bolt. All Eyes On Egypt seems to be about inviting Afro-Caribbean people to become more aware of the richness of their culture. A re-education.

Mercifully, Amsu – who tells me he was born in Paddington but later brought up in one of the towers at Stonebridge,

before he and his family went to live in the US – has great entertainment skills as well as passion for his subject. 'You know why Usain Bolt can run so fast. It's because Jamaica is where all the rebel slaves went,' he says, simultaneously comical and serious, 'so they had already learnt how to run away from their owners.'

And Egypt is African and the cradle of civilisation. 'The word Egypt means those with brown faces,' he explodes, 'and ancient Egypt included North and South America.'

Mmmm, did it? And then, he adds more. 'Did you know that John Hanson was the first black President of the US in 1781, forget Barack Obama?' he says in an authoritative fashion. There are photographs of this black 'President' around the shop, but later I check out the facts around this assertion and discover that John Hanson was more probably a white merchant, which is what white history recalls, and the black John Hanson was a nineteenth-century senator who promoted the relocating of black people to Liberia. This seems to be a photo of the latter, as photos weren't around until the 1800s.

So truth takes strange turns at All Eyes On Egypt. I agree with their premise – redress the status of Afro-Caribbean people in history – but advise caution on some of their wilder shores. Amsu Re, despite being charming, committed and fun, has a conspiracy theory edge to him, which is a step too far for me personally. There are books about Jay-Z being a member of the Illuminati, the Moorish Paradigm and much more.

However, it makes me smile to see one of their posters is the Pope kneeling in front of – guess who – yes, a Black Madonna in Poland in 1999. 'Yeah, you see, even the pope respects the Black Madonna,' he grins.

He also shows me two photos of black women from the early nineteenth century in the US. 'This one is Harriet Tubman,' he says, 'and she escaped from slavery but went back to the plantations to rescue another seventy slaves using something called the Underground Railroad which was a system of safe houses. She was an abolitionist and suffragette. The other one is Sojourner Truth who was also a slave who ran away. She was the first black woman to take a white man to court and win the case. She managed to get one of her children back from a slave-owner.'

At home, I read about these heroic women and when the text says 'born into slavery', I feel instantly moved by what that actually meant. They were incredible women. And Amsu Re? 'I've seen a lot of unjust things,' he says finally. 'You can make a choice in life and I try to be a better person.' I believe him.

There's a sign above one of their doors saying 'Hold On To The Rope'. What does it mean? 'Stay firm,' he says, giving one of his ever-ready smiles. 'Don't give up.'

The next morning – yes, this is a walk in two parts – I'm off to find a Black Madonna. I'm straying a little out of Harlesden into Neasden – actually the parish of Willesden – to St Mary's Church.

St Mary's – C. of E. but high church, 'anglo-catholic', as they say – is an unexpected pleasure. I walk down past Roundwood Park and up to Church Road. Over the bypass and next to a big roundabout, I come upon an unexpected vista. Suddenly, the urban surroundings melt away, and there is St Mary's looking as though it is still set in a village. Yes, a village.

A place of worship has been here since AD 938 and it is the ancient shrine of Our Lady of Willesden. Pilgrims came

Eddie Murphy doppelganger Amsu Re.

from far and wide to visit 'The Black Virgin of Willesden'[1] and the well to which miraculous powers were ascribed.[2] By 1475, drunkenness and gambling were reported. In 1538, Thomas Cromwell stripped the church of its carvings and the Black Madonna was burnt in Chelsea.

I push open the heavy fourteenth-century door and the scene is comical. It's a Saturday and one of the parishioners has a pink feather duster in his hand. Suddenly, the vicar sweeps in and kisses one of the altars on his way. Singing, incense, Hallelujahs and communion all follow. I try to keep up with the delightful mixture of stalwarts. My eye wanders over to a plaque, which commemorates Cyril Verres Davis, the first black churchwarden here from 1985 to 2000.

At the end of the service, the vicar, David Clues,[3] shakes my hand. Immediately warm, friendly, witty and urbane, he oozes confidence and obviously adores his job, his congregation and his church. He reminds me of the Cameron/Clegg tribe with a bit of Ben Bradshaw thrown in. And it turns out that he is also a Lib-Dem councillor, the only one in this ward to be re-elected. Also, it later transpires, a controversial one.

'Come and have coffee with us,' he says, shunting me deftly into a backroom which takes me back in time to the 1960s in an institutional way. In fact, it reminds me of my own childhood Yorkshire village church. 'You'll have to be brave, they all like to talk a lot,' he says. Obviously, he doesn't know me. Like a perversely young father – he's in his forties, they're all older – he tells them to be nice to me.

They are, of course. There's a lot of bustling going on – staple guns at the ready for programme work – because they are in full preparation for the annual pilgrimage next week. 'Oh, it's great fun,' says local historian, Roger

Macklen who informs me that he started off as low church and has ended up high. 'Pilgrims come all over the country, there is a procession and balloons,' he adds. I actually do wish I could attend.

There's a flurry of excitement as I ask about the oldest part of the church, and Steve, an ex-engineer, who's been a member of this church since 1972, leads me to the other end. 'Look at this pillar,' he says proudly. 'It's from the twelfth century and was discovered in 1872 during some renovation work. You can see this was originally the outer wall before this extension was put on to make the church bigger. In 1800, there were 200 people in Willesden and by 1872, there were 20,000; they needed more space in the church.'

Finally, David stops running around and sits down. He's a bit of a media whore vicar. He likes the limelight and doesn't mind admitting it. He's theatrical in a charming way. 'I'd heard about St Mary's because of its soup kitchen,' he explains, 'which was fantastic and happened every night. But last Christmas, we sat down to eight turkeys and there was only one homeless person. Other places had opened up similar provisions so we called it a day. We suffer here geographically – there used to be streets of terraced houses but they were all pulled down. Now we've got a bypass and a roundabout, but not so many people. We always keep the doors open because I believe we are a valuable place of refuge and solace.'

At last we come to the Black Madonna moment. There amid all the finely carved nineteenth-century sculptures sits the Black Madonna and Child. It is a bold, modern, primitive piece of religious sculpture. Baby Jesus stands on his mother's knees with his arms outstretched in a gesture that is surrendered, trusting and welcoming. Funnily enough, it

reminds me of the major arcana tarot card, the Sun. In the nineteenth-century Rider Waite pack, a child rides naked on the back of a horse – it is a powerful image, which urges you to trust the universe and not to fear it.

'I'm tremendously proud of our Black Madonna,' says David. 'It was commissioned in 1972, and a woman sculptor, Catharni Stern, carved it out of lime wood. They were uncertain political times and I think its solidity gives reassurance. Pilgrims do come to visit and also take holy water from the well. It's very special to us.'

This Black Madonna looks decidedly out of place here. She's got solid peasant woman limbs in a church that is full of slender carved figures. No one knows what the original statue was like – Thomas Cromwell had it burnt – only that it was in black wood (and some think it was candle soot-blackened) and covered in silver plate. But people still come to worship her here.

Pubs
(A Few Old Ones)

There are a couple of asides to this tale. Firstly, a minor miracle happened to me last week. I was in a rush. I went to the Santander cash machine, performed the usual card thing, and crossed Manor Park Road to go home. Three minutes later, it dawned on me that I'd left the cash behind. Yes! Left the cash lying there ready to be picked up by all and sundry. I didn't even have time to panic; I turned back and there was a woman with a big smile approaching me with £40 in her hands. Gasps all round of thanks and incredulity. A singular act of kindness, in Harlesden. I radiated faith in humanity for the rest of the day.

The second aside is more apposite to the story. I invited Malcolm Barrès-Baker, a rather grand, non-booming-but-looking-like-he-would-boom gentleman then working at Brent Archives to look at pubs with me. He's rather charmingly of another era, when manners and politesse were uppermost in the 'English' way of being. Anyway, it was Malcolm – this is typical, I'm sure – who sent me that tract (mentioned earlier) from Victorian author Arthur Machen's supernatural short story *The Inmost Light* to read beforehand, because it mentioned Harlesden in a surprisingly

negative way when it was meant to be an era of poshness and style. Oh, what an arcane delight this experience is.

Malcolm Barrès-Baker and I had arranged to meet inside the Royal Oak. I've only been inside once before, searching for an alcoholic boyfriend who had escaped from my alcohol-free home to pursue his own vision of how life should be. It was 5 p.m. and this charismatic drunk was on a bender. His focus on beer was unwavering. I couldn't persuade him to leave.

Today, Malcolm is already ensconced with half a pint and his archive photos. Malcolm illustrates just how upscale Harlesden was in 1900 with a photo of a garden party in Roundwood Park, the women in flouncy long dresses and the men in top hats and tails.

He also mentions the 'original' (i.e. 1892, because this is a Victorian re-build) tiles in the hallway, so we venture out there to take a look at the Parliamentarian trooper hunting for the fugitive King Charles II after the Battle of Worcester illustrated on these painted ceramics. 'They're excellent quality,' intones Malcolm in his own unmistakable way. Posh, too.

On the subject of 'poshness', Malcolm remarks that there are oodles of old photos and photo postcards of Harlesden in existence, many more than Willesden. I'm surprised. I'd always assumed that Willesden was richer than Harlesden because there is so much printed coverage of Willesden. 'Harlesden was actually posher than Willesden,' says Malcolm, getting into the vernacular.

Ah ha, I really didn't know that.

And these picture postcards, why are there so many of them? Because the ladies and gents of the area would send them as a way of thanking their recent hosts for tea. 'Remember, in those days,' says Malcolm, 'you could send a card in the morning and it would arrive in the afternoon;

there were two post deliveries a day.' Postcards, letters – they were the texts *du jour*. Instantly, I want to re-create the sending of postcards and letters in this way, the romance of the postal delivery.

Before stepping out on to the High Street – which is rather a daylight shock for Malcolm who is used to being hidden away in bookdom – we discuss the contemporary (this being entirely the wrong word for the Royal Oak style) open plan bar. 'In many ways, it's not helping pub trade,' says Malcolm, 'because before with a public bar and a lounge one, at least pubs could attract different sorts of drinkers. These days, it's all-in-one and much more limited.'

We stare up at the sign outside.[1] 'What's wrong with that?' says Malcolm, who has a degree in history and a post-degree in Greek classical archeology. I haven't a clue. 'Well, they've put an image of Charles I in the middle of the oak tree, when the king who hid in an oak tree and inspired the name Royal Oak was Charles II.'

We appreciate the mosaic of an oak tree on the side of the building. All gold and green – it is artfully constructed and also from 1892. Looking up is a vital constituent of these walks. 'Gladstone said always travel upstairs on the bus if you really want to see London,' says Malcolm helpfully.

The block of buildings next door, including this version of the Green Man – the first one was built before 1778 – was constructed in 1907, and is pseudo-Dutch, which I've never noticed before. The Green Man has curved gables and even a turret at the side. Malcolm is keen on the architecture and distinctly excited by the turret, which he didn't notice on the plans.

But why Dutch? 'It's a style called Anglo-Dutch or Pont Street Dutch,' he explains. 'From the 1870s some British

architects wanted to break free from the Classical and Gothic styles and began imitating late seventeenth- and early eighteenth-century domestic architecture, which was strongly influenced by the Low Countries.'

He stares across the road and declares that the various Somali shops over there had once been a pub too. The Elm Tree. Again, I wasn't aware there had ever been a pub there. Afterwards, I find a photo of it, and this building looks a bit more modern than The Royal Oak – maybe the 1920s.

We walk back along the High Street and Malcolm points out a blue sign on the buildings opposite Iceland; it says 'You May Telephone Here'. Not any longer, of course. A vestige of a usually invisible past. Ghost trails.

We arrive at the newly refurbished Way 2 Save and focus our attention on the other side of the road. 'A pub called the Anchor & Cable used to be there,' says Malcolm, 'which existed in 1670 and it was rebuilt in 1888 and called The Crown.' This building has serious flounces and flourishes; it almost thinks it's in a gothic horror story. The more I look at it, the more I see. Additions. Balustrades, terracotta rosettes, grotesque heads, mock Tudor black stripes. There's quite a lot going on. Earlier, during archive picture time, Malcolm showed me a photo of the trade token used at the original pub. 'There wasn't enough small change in seventeenth-century England so tokens helped,' he explained. 'On the back you can see the initials of the husband and wife who ran it.'

The last words in this mini pub tour have to go to the caustic Mr Wadsworth, local history supremo. He writes in his history of the pubs: 'In the 1990s, the Crown suffered one of the worst examples of re-naming: someone felt it would do better under the title "The Rat And Carrot".' Not surprisingly, it didn't.

Mean Fiddler Mogul
Vince Power Returns

It's a beautiful spring day and a huge, silver Lincoln is sweeping – in that hushed wide way that only old American cars can – into the eyesore Plaza car park. It contains Vince Power, who was literally a powerhouse in Harlesden for many years. Well, twenty-three years to be exact. He used to own the Mean Fiddler – an all-important music venue on the High Street, now closed down – which became the Mean Fiddler Group (Jazz Café, the Forum, Reading Festival, the Grand and many more), which he sold in 2005 for £60 million. Not that he's retired; at this point, he had VPMG[1] (Vince Power Music Group) that owned the Bloomsbury Ballroom and the Pigalle Club (now both sold), and ran Hop Farm Festival (which he managed to lure the likes of Prince and Paul Weller to play at but had to cancel in 2013) and Benicassim Festival in Spain. However, Vince is never down and out.

As he gets out of his stylishly unfashionable car, I remember the reputation that precedes him, that he's some sort of Svengali Irish gangster. But the stocky, stubbly chinned man who pats me on the arm in an affable gesture of friendliness seems much softer than that.

'You're the reason I first came to Harlesden,' I say, 'because I used to review people like Billy Bragg up here for Sounds.' He laughs the sort of unassuming chortle that is pleased that he should have that kind of influence.

Before I know it, Vince is opening a very green[2] metal door to a new-to-me alleyway in the High Street. 'We used to own the whole block,' he says, 'but this was the box-office and entrance down here.' There is a tangible poignancy about this alleyway for Vince. It's neglected and run down. And it was here that his music venue empire began in 1982. On his website, he's justifiably called 'The Godfather of Gigs', but here he is looking watery-eyed about the past.

'I recognise those doors,' he says, pointing to the old entrance, now locked and scruffy. 'We bought them from a chocolate factory in Scrubs Lane – you could still smell the chocolate on them. I know this place so well because I built it. It does make me sad, looking at this building now – it had such soul and such spirit, but like the old Marquee is no more, you just have to move on. Van Morrison, Johnny Cash, Paul McCartney, John Martyn, Dr John, Christy Moore and many more all graced this stage. I had to wage a one-man war in order to get people to come to Harlesden. But I was so determined, I did manage to get them. It was the beginning of my business. The money from here paid for Subterania, the Jazz Café and all the rest to start.'

We walk a little further to the old stage door at the back. 'I remember standing out here with musicians,' he says, 'on summer's evenings. One night, country musician Dwight Joachim was having a fit of nerves before going on, so I was out here trying to persuade him to perform. He did go on in the end.'

Vince is standing next to an old street lamp, also painted green, which is quite odd in the middle of this alleyway. 'We

restored it,' smiles Vince, revealing his inner DIY spirit. 'It was originally from the nineteenth century.'

Apparently it used to be a dodgy drinking club owned by boxer Terry Downes before Vince bought it. 'It was hard for them to get a license,' he explains, 'so it was illegal. There were a lot of heavy gangsters who used to come here then. A couple of bodies were found in this alleyway at one point. I bought it in 1981 because I wanted to turn it into a honky tonk bar. I used to go to Nashville so that inspired me. I loved country music, so it started just doing country but soon broadened out.'

Back in the eighties, John Martyn was supposed to play at 10 p.m. one night. 'He came on at 12 p.m. and was promptly sick over the front row of people. I had to give a lot of people their fivers back,' he says with humour.

My own strongest memory of the Mean Fiddler was going to a Sun Ra – out there, inspired jazz singer, musician and controversial cosmic philosopher – gig. I'd never seen so many people as his Arkestra – I think there were thirteen – on the tiny stage. Sun Ra was wearing something on his head that resembled an extra-terrestrial hair net and I kept thinking he looked like Ena Sharples (from *Coronation Street*) on acid. It was 1990. They played music which startled and amazed in equal measure. It was one of those extraordinary gigs that takes you out of the present. He was to die aged seventy-nine three years later, but he was truly dancing to the beat of his own drum.

Back on the High Street, Vince surprises me by saying that he actually came over from Waterford in Ireland to Harlesden when he was sixteen in 1964, on his own. He was one of eleven children. He has a much longer relationship with Harlesden than I thought. 'I lived in a back room of the

house of a Jamaican woman who treated me like her son,' he says. 'It was very unusual for someone Irish to board with someone Jamaican in those days. But I loved it.'

It turns out that he met his first wife who was also Irish when he was eighteen, also in Harlesden. 'At the 32 Club,' he says, which was in the building before Paddy Power, 'which used to be opposite the Royal Oak. We got married in the big Catholic Church, Our Lady of Willesden, up Acton Lane. We were very young, both still eighteen; my mother came over from Waterford. It was just what you did. We had three children before I was twenty-one.'

As we verbally go back and forth between the present and the past, we're also observing the High Street. 'In the sixties, it was upmarket here,' says Vince. 'There used to be a Marks and Spencer's here in those days. Employment was easy, so everyone had money from working in the factories round here. But I must say it is very lively here still, much more so than Kilburn High Road which is my shopping area now.'

At this point, we're just passing plantain and Scotch bell peppers piled up high outside a halal butcher's, when a guy with his long grey locks in a ponytail shouts out to me because he sees I have a notebook. 'Are you from 'Elth and Safety?' he calls out.

'No,' I reply, horrified to have been mistaken for someone from the council. For goodness sake, I have a bejewelled feather in my hair. What is the country coming to? Traditionally, a notebook in hand translated as a journalist, now it's Health and Safety? Oh, the poverty of reference points.

We go back to talk to him and his friend. It turns out that both he and Vince have bad backs! What on earth is going on with these men? They exchange supportive back care tips

while I chat to Ronald, who says he volunteers with young people in the area and lives in Rucklidge Avenue, the same road as singer Sabrina Washington's parents.

By the time we reach the newly re-opened Library, Vince has to sit down because of sciatica in his leg. Later, he tells me he has a gym in his house and a visiting yoga teacher. Evidently, he's not using their services on a regular basis.

'First of all, my wife and I lived in a room in Bramshill Road, then we moved to a beautiful house in Stonebridge Park. In the sixties, there were some wonderful houses there but they were demolished to make way for the tower blocks. I know because I demolished some of them. At that time that's what I was doing,' he explains. 'There was nothing wrong with the original houses, but I do remember how excited people were at the idea of getting new bathrooms and kitchens – they couldn't wait for those blocks. But those tower blocks destroyed the community. I have been up there and had a look at the new developments and they've done a good job.'

Vince points in the direction of Stonebridge and explains that there was an Odeon cinema just up the road, a 'fleapit' that became the Roxy Theatre in the seventies – not to be confused with the more famous Roxy in Covent Garden. But Sham 69 and the Clash played there (there is an album called *Live at the Roxy Theatre* which came out in 1978), and the Sex Pistols were meant to be there on their cancelled Anarchy tour. And various sound systems were there. Oh la la. I was under the impression that the Roxy Theatre had been at the Coliseum cinema, which is now the Misty Moon pub. I was wrong.

In fact, back in the sixties and seventies, it was people moving out of their houses that created work for Vince's

new business. 'For fifteen years, I ran a second hand furniture business,' he says. 'The main shop was in Kilburn High Road. I was good at making money. I just liked picking my wits against another human being and getting twice as much as I paid for whatever it was.'

That's quite a contrast with 2010. Hasn't he gone posh these days with his Berkeley Square Ball, his Bloomsbury Ballroom and his Pigalle Club? 'You can't make me posh,' he exclaims in a jokingly serious way as we walk back. 'You can't pimp me.'

But what about his gangster image, he's definitely got a reputation? 'I think it came about because I used to do lots of support gigs for the Guildford Four and the Maguire Sisters. All of them were innocent. Because I did those gigs, people assumed I was an IRA member. I've always been political and left wing but I've always been against any kind of violence. I did a lot of the Red Wedge gigs in the early nineties, and everyone like Hank Wangford came and celebrated at the Mean Fiddler after the 1997 Labour election victory.'

It's 5 p.m., and we're at the bar at the Misty Moon ordering a tea and a coffee. Very rock 'n' roll. At sixty-two, Vince has eight children and seven[3] grandchildren; he's been married three times. 'I think when I split up from Alison, my third wife, I did reassess my life and wonder what I was doing with it. It was five years ago and that's when I sold the business. I wanted to do something new. But I'm no good at doing nothing, so I ended up finding some new venues and festivals. I've just announced Bob Dylan is playing at the Hop Farm, a one-day festival in Kent. It's in its third year and it's back to basics, there are no VIP passes. Everything became too inflated. I was guilty of it too. Now I'm interested in everyone being treated in the same way.'

He briefly had a mid-life bachelor crisis and acquired a penthouse in Paddington, but now his feet are back on the ground and he's back in a family house in Willesden. His youngest children – thirteen, fifteen and eighteen – visit for a couple of days a week. He's single and he admits somewhat mistily that he definitely prefers the family unit as a way of living.

And what does he make of Harlesden these days? 'Well, there was a time in the nineties and early 2000s when young people were shooting each other here and everyone assumed it was a terrible place. But I never thought that. For me, it was always a family place, and I think it still is.'

Fittingly for the gentleman he shows himself to be, he gives me a lift home in the Lincoln. Not since multi-millionaire publisher Felix Dennis[4] sent me home in his chauffer-driven silver Rolls Royce have I arrived home in such style. But that's another story.

At home, a friend of my son's, on hearing who I've been out with, says, 'Oh, isn't he that heavy gangster guy?'

So the old image is still working. I get the impression Vince quite likes it.

The Tattooists' Tales

Today, I'm in pursuit of 'Hanging In Harlesden'. When I first began tracking down my neighbourhood, I came across a film on You Tube, which came with the warning 'If you have an aversion to hooks, blood and heavy French accents, do not watch'. I definitely have a squeamish – I have been known to faint when injected – response to hooks and blood, but I watched anyway. It involved a tattooed, pierced young man being hung up on huge hooks, which penetrated his skin. For pleasure. It was scary, incomprehensible and compelling all at the same time.

It's been in the back of my mind to find out what was going on and why. And I've walked past Krazie Needles, a tattoo studio in Station Road, a few times now. So I decide to start here. I was half-thinking that these 'hangings' must be going on at their premises. It's the middle of the afternoon, a safe time to visit! I enter the shop, stroll past the dozens of possible body illustrations – from comic-book-voluptuous women to hands in prayer and cars – and enquire at the counter.

'Do you know anything about "Hanging In Harlesden"?' I ask, as casually as I can muster. They – there are two male

tattooists in attendance, but apparently they do have female ones too – shake their heads in unison. We don't do anything like that here, just tattoos and piercings,' smiles the first one, who I later realise has quite a large tattoo of a bee on the side of his bald head and is called Krazie (or Chris), funnily enough. 'I know they go on though, but it's more underground.'

What is it all about? 'Technically, they're called body suspensions,' says Danny, who's actually in the middle of working out how to transfer a pink-haired beauty he's found on the internet onto Krazie's arm. 'The insertion of the hooks causes a rush of endorphins, the participant gets high and possibly has an out-of-body experience. It's a spiritual thing, a very personal experience. I've heard people say that it's about being on your own in that state with nothing else going on; you get into a meditative state. At that moment, nothing else matters. Fakirs used to do it, and it was part of an important ritual for Native American Indians.'

In the meantime, my gaze is wandering around their studio. Of course, there are the gothic fake skulls and bones embedded in black on the welcoming wall and the heavy metal bands roaring in the background, but suddenly I notice that one of their display cases is actually a coffin. 'Yes, it's a real coffin with glass instead of a lid, and we've got corn snakes living inside,' says Krazie, ever-friendly and informative. I wander over to take a look, and there they are – one red one, and one beige one curled up together with, naturally or unnaturally, a skull just below.

Tattoos, these days, are boringly *de rigeur*. Not just Beckham – even Sam Cam has got a swallow one. 'Yeah, they're like fashion accessories,' says Danny. 'People don't think enough before they have them. They forget that they are permanent.'

What about the old-fashioned ones like hearts and daggers? 'Well, there was the trend for Celtic ones, then tribal ones, then all the Sanskrit writing, but funnily enough the old-fashioned hearts and daggers are making a comeback. But the colours are much better these days so they are improved. There's a lot more information out there now so people can make more informed choices. We get people coming in and wanting portraits of their children on their skin.'

Now I ask a stupid question. It's my prerogative. I am aware that in my head, I think of tattoos and white rather than black skin. So who are their customers? '95 per cent of our customers are black. This is Harlesden. Everyone thinks that tattoos don't show up on black skin, but of course they do. All the rappers like 50 Cent are covered in them.'

Down at the far end of the studio, there's a sign that says 'Don't ask me for fucking stars'. The Krazie duo are comedians. They're referring to Rihanna and her star tattoos. 'They come in and want exactly what celebrities have,' laughs Danny, 'and that's our response.' I guffaw as well, because I noticed recently that artist Douglas Gordon has also got stars. But I suppose his are bigger, more arty, or something. Anyway, they do do stars, they just enjoy complaining about this blatant lack of tattoo imagination.

How many tattoos does Krazie have, I wonder? 'I started when I was fourteen and I'm forty-three now,' he says, 'so I must have over a hundred. They were old-fashioned, but now they're panthers, spark plugs and women.' Not forgetting the worker bee, which happens to have a syringe, that is entering one half of his shiny head. 'That's me injecting art into myself,' he explains helpfully.

Hovering over our heads is a framed photo of a tattooed

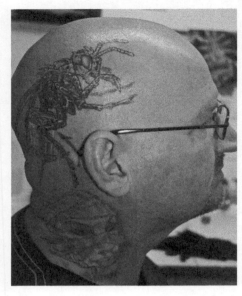

Kris, or Krazie.

arm, which announces 'Misfit'. There's a lot of banter flying around about exactly this notion. So although I think tattoos are terribly fashionable and very conventional these days, Danny and Krazie still seem to consider themselves tattooed outsiders. 'Employers still think as though they're in the Dark Ages,' says Danny. 'To them, tattoos mean trouble-maker or cheap. When in fact, tattoos don't make you a different sort of human being.'

What do people spend? 'Well, the cheapest one is £20, and then you might get people who want Beckham sleeves; that will take much longer and cost hundreds of pounds. A body suit is the most comprehensive piece of work,' says Krazie. 'That might take forty hours and they'd have to keep coming back, but we don't get many of them.'

And what about women tattooists? I'm surprised in a good

way at the ferocity of Danny's reply. 'There are not enough,' he exclaims. 'They don't get enough opportunities, and they don't get enough credit. We need more women. Sometimes women customers come in here and you can see they're uncomfortable around all these men. It would be great to have a studio of all women tattooists where they would feel at ease.'

Forty minutes ago, they had no idea I was on my way to meet them. They have been unbelievably accommodating, kind and humorous. As I leave, Krazie says he has a mate who's been suspended on hooks – large fish hooks, as it happens – and he's going to ask him if he's heard about anyone doing suspensions in Harlesden. So the puzzle of the 'Hanging In Harlesden' may still be solved.

As I leave, I have a look at their photo books, crammed full of arms with gentians, shoulders with horses, backs with whole scenes from the roof of the Sistine Chapel. Tattooing is changing. Last time I was close to the tattooing scene was when poet and novelist, Joolz Denby – married to New Model Army's lead singer, Justin – took me on a tour of Birmingham tattoo studios and showed me her own Celtic decorations. At least they weren't stars!

I'm standing outside taking photographs of the window when a man appears at my side. 'I like that,' he says, pointing at a display photo of a woman's back covered in a black hibiscus, 'but I always wonder – what happens when you're seventy?'

A conversation ensues that includes the pros and cons of body modifications. Chris – another Chris, as it happens – and I agree that cosmetic surgery and botox are wrong, foolish and ridiculous, creating a strange group of Joan Rivers' alien clones. Not to mention Madonna-stretch.

But Chris and I beg to differ on tattoos. I'm not against

them – as opposed to being actively for them – because there's such a long history of body ornamentation, and tattoos seem to be on that aesthetic continuum. They are not a youth-seeking modification, rather an aesthetic one. However, Chris is not convinced.

Then I discover what Chris is attempting to do. Yes, folks, Chris – in his office in the Acton Business Centre – is re-inventing the trifle! 'The first one is called "Oh George",' he says, with his chest slightly inflated, 'with layers of cream, chocolate and raspberry coulis. I'm trying to make an ironic version of St George's flag.'

A trifle representing contemporary Britain, and the inventor is black. Outside a tattoo studio. This could only happen in Harlesden. I really love it.

When Rose Met Louis

I've known for at least the past five years that the ever-so-quizzical and now apparently sexy – the other day, a twenty-something data designer told me that the gig audience her friend had been part of the previous evening was a sea of Louis, which was a very desirable thing – documentary maker Louis Theroux was a neighbour of mine. Not close close, but I had spotted him at my local newsagents, Sweetland – Danny's place. And I'd heard that Louis was a member of the Neighbourhood Watch in my area. Gosh, that last sentence sounds like the conspiratorial tones that Louis uses in his films.

So for the past few months, I've been trying to persuade him to walk with me, via his agent and emails. At first, he declined. However, he declined in a way that made me think that he would eventually agree. He took a typically 'Louis' softly, softly approach. 'I don't think I can help you,' he wrote, indicating to me that there was at least a small part of him that thought he could.

I persisted in a slow, lightly determined manner. A few weeks ago, he relented, always finishing his emails with 'Best Regards' as though he is deliberately adhering to a

time warp. I suggested we meet down Park Parade. He had other ideas. 'Dora's Delights,' he wrote, 'at 9.15 a.m.' The delightfully named Dora's Delights was a new café that had recently opened right next to the Jubilee Clock.

And there he is, reading *The Sun*. That's a surprise. Initially, I nearly fall into a seductive trap. Louis, of course, starts to ask me questions about myself. I suddenly hear myself talking about The Face and interviewing Jimmy Boyle, the sculptor dubbed in the 1960s Scotland's most violent man, and have to stop myself. He's seducing me into thinking I'm the interesting one. It would be easy not to find anything out about Louis.

It's all a bit polite at the beginning. He's lived here for nine years; he'd like to be even more active locally (he's pretty active already; he's the Town Champion[1] and he was out on the streets earlier this year promoting the shop locally campaign); he talks about the negative press that Harlesden attracts, the regeneration project, the Keep Harlesden Clean campaign and the local shops.

'I do try to shop locally,' he says. 'I've become a bit of a mango snob since living here. There are at least three different types, including honey mangos.' And then, there's his list of good local fishmongers and restaurants.

Does he get recognised here, I ask? 'Less than elsewhere,' he says. 'For instance, my Polish neighbour Ryzard has just got back from a trip home. He got really excited because he'd seen me over there on TV – he hadn't realised what I did before that. A lot of people in Harlesden are watching their own national TV by satellite so they wouldn't see me.'

It soon becomes clear that Louis' head really is full of questions. He is wont – as we see in his TV documentaries on everything from medicating children in the US to inter-

viewing the inmates of San Quentin prison or sex workers in Nevada – to ponder possibilities endlessly. He has been accused of being faux-naïve, but I experience him as just eternally wanting to find out more. 'I am curious to know,' he says uttering one of his favourite phrases, 'how the demographics evolved here. It was posh, wasn't it, at the turn of the century, so how did it change?'

I explain badly about the railways, then the industrialisation – for instance, the McVitie's factory – then the arrival of cheap housing for workers. And the departure of the middle-classes in the 1920s and 1930s. Later, I read that Louis has a first in history from Oxford University. Oh, the satisfaction of not even getting an O level in it and being able to lecture Louis!

But before long, we're on to shopping again. Louis reckons – is he right? – that Harlesden is the only place in London where you can buy black beans in a tin. I do like his quirky adherence to such little known 'facts'. Apparently, he – he has two young boys, Albert and Frederick, and a wife called Nancy – cooked a Nigella dish last night which included one of those remarkable tins of black beans, plus Thai fish sauce and lime.

We talk about shops like Harlesden Fresh Fish – the fish shop that is closest to me, which is owned by a large Afghan gentleman – opposite Iceland, when Louis demonstrates one of his most charming attributes. 'I worry about the shops in the week,' he says and I think he genuinely does, 'they might be busy at the weekend but they're almost empty in the week.' There's something deeply okay about a man who worries about the livelihood of his local shopkeepers.

I'd planned to take Louis on a walk to Stonebridge. I wanted to know what he thought of all the architectural

changes. But he had a slightly different idea. 'Have you ever been to that hotel up there?' he says eagerly. 'I'm curious to know what goes on there. Who stays there? Why do they stay there?'

In fact, I have been meaning to go to this Victorian hotel with its fancy wrought iron. Right in the middle of Stonebridge estate – and its disappearing towers – stands this vestige of another era. It is weird, out-of-place, faintly ridiculous. The Stonebridge Park Hotel was built to cater for the professional classes that inhabited the villas near here in the late nineteenth century.

And so we're walking at last. Past Subway and, of course, Wrights – 'What's all that about?' he laughs – and the old Mean Fiddler. 'I read your piece about Vince Power,' he says, 'but he can't really be soft can he? He runs nightclubs and music venues.' Afterwards, I think about this and decide that actually he can be soft as well as tough. Do people have

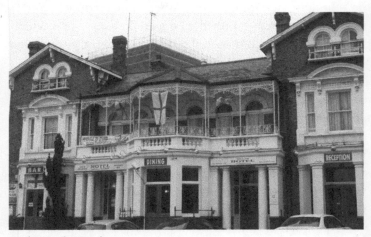

Bridge Park Hotel.

to be either one or the other? The questions are evidently infectious.

Now we're outside another fresh fish shop window in the High Street and we witness a crab moving. It's still alive. 'Do you think that's cruel?' he asks. I turn the question back on him and he's not sure. There are a lot of different fish – from parrot to sea bass – on display here. 'Can you name many of them?' he asks. I don't think I can. These constant questions make me aware of what a permanent state of inexactness I live in.

Outside the library, a little group has gathered waiting for it to open. Our communal gaze is immediately drawn to a couple of shaven-headed men who are sitting on the steps and falling slowly and drunkenly into one another in a very intimate way for 10.30 in the morning. Of course Louis, the documentary maker, isn't a teensy bit phased by staring at them for quite a long time – way past most of my comfort threshold. 'It's funny, they look as though they are cuddling,' he says. And they do. 'They're probably Eastern European,' he adds.

He points to Odeon Court – a row of bland, 1990s houses, like Barrett homes. Of course, it's where the Odeon, which originally opened in 1937 (and later the Roxy Theatre), once was. 'I find myself lamenting the demise of the Odeon,' says Louis, admitting a kind of longing for a lack of change, 'but I do have neo-phobic tendencies, so I just have to stop myself.'

I can feel his neo-phobic tendencies almost constantly. They settle in the relentless pondering and the almost comical grimace that so often appears on his face.

As we look down Hillside and onto the new Stonebridge estates, I ask him if he's ever thought about doing a

documentary on Harlesden. 'I've thought about it,' he says, 'but it's good to keep work and home separate. There are so many questions that I haven't asked about Harlesden in the nine years I've been here that I would have asked in the first hour out on the street with a camera crew.'

The strangely out-of-place Stonebridge Park Hotel is before us now. Only it's changed its name to the Bridge Park Hotel, obviously because Stonebridge has too many crime connotations. It has wrought iron balconies and a feeling of distant grandeur turned into nouveau tackiness. We push open the door and somehow Louis transforms into his documentary-maker self. Newly assertive, he takes the lead.

'Can we see a room?' he asks, and he won't take 'No' for an answer when the blonde and perhaps Eastern European receptionist informs us that the rooms have yet to be cleaned. Suddenly, I'm in a situation where Louis and I are pretending to need a room together. Well, he asks to see a twin one which would cost us £60 for the night.

In the meantime – while we wait to see whether we will be allowed in – we survey the reception area. There's a huge, Argos catalogue-type chandelier, a souvenir display case and lots of brochures about Paris and Wembley, then some decorative nineteenth-century posters. Louis is bizarrely impressed and incredibly enthusiastic. He's come alive in some way that wasn't there earlier.

'Someone has obviously spent some money on this hotel recently,' he says. 'There's a feeling of it being taken care of. It looks clean and looked after.' And he says it quite a number of times. 'Am I going overboard?' he asks. He is.

Finally, we triumph. We wander down back corridors crammed with kitsch pictures of elephants, storks and crying women with peculiar little words of wisdom. For instance –

'To Be Happy, We Must Not Be Too Concerned With Others'. 'That's odd, isn't it,' he says, and I agree it is very odd.

The room is small and unremarkable. Louis is far better than me at making small talk about this frankly unimpressive twin room. 'Do you have non-smoking and smoking rooms?' he asks as though he is making a vitally important enquiry. I can tell he is enjoying himself. It's the thrill of the chase of 'the genuinely odd in the most ordinary setting' that drives him. I'm not sure how odd this is, though. 'I think I can smell smoke,' he observes in a detective-like manner. The receptionist concurs but adds that it probably is from a few nights ago rather than the previous evening.

On the way back, we look out of the back door on to one of the two remaining Stonebridge tower blocks. Confusingly, it has scaffolding around it. We're fooled into thinking that they are re-furbishing the façade. My son puts me right when I get back. 'That's because they take it down bit by bit,' he explains to his yet-again-ignorant mother.

As we walk away from the Bridge Park Hotel, I wonder aloud about the dramatic changes in architecture around here, and whether the low-rise buildings will encourage more community and less crime. 'I think Le Corbusier said something like "we shape our buildings and thereafter, they shape us",' he says, showing off now.

You were sounding rather anti-smoking back at the hotel? 'No, I'm a smoker,' he smiles. 'I smoke about three cigarettes a week.'

At this point, he produces a shopping list on the back of an envelope and we end up at the Blue Mountain Peak, Harlesden's best known Caribbean supermarket, searching out very English ingredients for the Theroux family dinner. But Louis is unabashed. 'Can you see the broccoli?'

he says amid the mountains of yams and cassavas. I can. But definitely not the crème fraiche. Oh, and he has a very cute shopping bag with him! With lots of pink and a little dog.

'I'm so glad we went to that hotel,' he says seeming genuinely pleased.

'Why?' I laugh.

'Because now I can speak with authority about it,' he explains.

Hilarious. Why would you want to? 'Well, it would make a great place to disappear in,' he adds tellingly. 'Haven't you wanted to totally disappear?'

Ending on a series of questions seems only right and proper after an encounter with Louis ...

Louis shopping at Blue Mountain Peak with that cute bag!

Madame Curly Takes Me on a Food Tour

This is a bit bizarre. I'm walking with a friend for the first time. And we're in a bit of a 'wow' place. Writer Monique Roffey has just been shortlisted[1] for the Orange Prize for fiction with her sensually evocative second novel, *White Woman On A Green Bicycle*, which is based on her family who moved to Trinidad in 1956 just before it became independent; as she says, 'it's a big deal, I didn't get reviewed nationally, and now this.' She has recently moved from Harlesden to Kensal Rise.[2] They may have less than a mile between them, but it is a million miles from the noise and the glorious collision of cultures to the quiet, middle-class and leafy.

Monique is also my first co-walker to have planned her own walk! She's taking me on a Jamaican and Trinidadian food tour. I disrupt her plans temporarily by suggesting we rescue some guerrilla planting that I've noticed. Guerrilla gardeners – committed humans who take voluntary digging action onto public wasteland – have planted cowslips and pansies in an area of urban deadland on Manor Park Road. Unfortunately, they haven't planned how these flowers will survive. They are wilting badly.

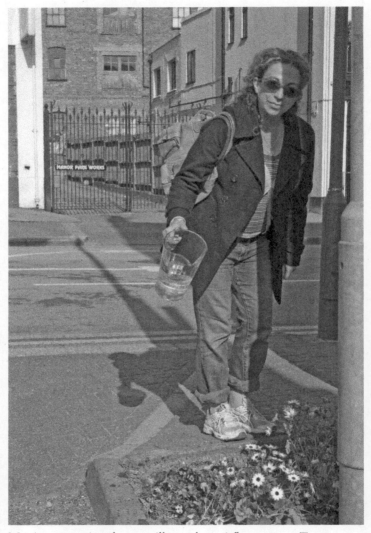

Monique watering the guerrilla gardeners' flowers near Tesco.

The staff at the Misty Moon are bemused that anyone cares enough to ask for water. But the barman mentions he's seen yet more recently planted spring flowers under a tree nearby. Monique gives those thirsty pansies and cowslips temporary relief.

Our first stop is the Jam Down Bakery, which I've never visited before. For twenty-eight years, it's been a traditional Jamaican bakery and takeaway. Mon used to be a regular. 'If I couldn't be bothered to cook on a Sunday,' she says, 'I'd pop round for their jerk chicken and rice 'n'peas. It was the perfect solution. The food here is so well-cooked.'

We've ordered a mutton meatloaf. It's lamb encased in bread. Very tasty and very meaty. It is a sexy mixture despite there not being a vegetable in sight. And the bread is sweet, delicious and filling. 'I would often come and get one, and give half to Mr Campbell[3] who begs every day outside the HSBC bank,' she says. 'I'm rather fond of him.'

The shop is pure Jamaican kitsch. Lots of biblical scenes in frames and a clock surrounded by red plastic flowers. There's also a handwritten notice promoting their Mannish Water. What is Mannish Water? I wonder. 'Do you remember that Rolling Stones album called *Goat's Head Soup*?' says Madame Caribbean Expert. 'They'd just visited Jamaica and obviously had some Mannish Water; it's great soup which is made of goat tripe.'

'And good for your daughter,' adds the gentleman behind the counter, evidently alluding to the apparent menstrual pain-assuaging aspects to this soup.

Mon is then tempted by the callaloo. 'It's a soup made from dasheen bush, dasheen is a root vegetable with green bush, and you add okra to it,' she says, referring to the Trinidadian dish. When it appears Jamaican-style, it's

actually not soup, but green leaves fried with salt fish. Very salty, very tasty. 'In Trinidad,' she says, 'we have callaloo, but it's not like this. This isn't dasheen either – our soup is slimy with okra, pork knuckle and cream of coconut. It's like drinking a swamp. We also do a stewed chicken with brown sugar – you will have tasted that at my house.'

Next, we're outside the Afghan-run Bilah Halal butchers shop and she's squeezing the avocados. 'These are Pollock avocados, they're so big. My mother wouldn't accept anything else,' she says. 'We used to have them in our garden.'

And these yams and cassavas? 'In Trinidad, we call all those roots, blue food or provisions,' she says. 'It's complicated, but the Africans who came to Trinidad came as enslaved people and they adapted their food to what was available there. But the plantains, they're always better the blacker they are. That means they're ripe.'

Mon's picked up a fresh bunch of thyme and she's pointing out the bottles of Green Seasoning as well as all the tins of condensed milk. 'Thyme and Green Seasoning are the basis of Caribbean food,' she says, 'and condensed milk appears all over the place. I have a theory about cow's milk and humans not being supposed to drink it. Why should we?'

I hear the familiar tones of Mr Campbell. 'Have you got a pound?' he says, in the insistent tone I've heard so often. He's known locally as 'Poundman'. A year or so ago, he was asking for two pounds, but as a result of the global financial collapse, Mr Campbell seems to have reduced his expectations.

Mon starts to ask him questions about his life. 'I've been coming here for twenty years,' he says. 'I come down from Wembley on the number 18 bus. But I used to live here at

Stonebridge Park'. We don't get much of the story before his 'pounding' starts again.

Next we pop into Ali Baba, that serves part Arab and part Indian food. 'I'd come in and have a lamb kofte kebab and watch Al Jazeera,' she says. 'I'd catch what ex-BBC news reporter Rageh Omaar was up to.' The owner has apparently gone to see his family in Iraq for a holiday.

Norman's, the hairdressers, was also a frequent haunt. 'I'd get a cut for £10,' says Monique. 'I have frizzy hair and it is tricky. There is always the danger of getting a frizz ball, which is like having a huge hairy dog on your head,' she says. 'You have to have a grooming routine. I plait my hair when I've washed it but it's also down to hair products. I'm wearing it out today because I've found some good products. It's interesting because black women probably look at my hair and wonder what the fuss is about. White women with frizzy hair are pretty much left on their own to deal with it.'

Incredibly, Mon has two close friends who also have frizzy hair. They bond over hair care. In fact, I've never really talked to her about it because I've got straight hair. I'm not a part of her curly set.

Now we're walking down Nicholl Road past Our Lady of Willesden. And Mon is talking about her Harlesden experiences. 'At first it was really exciting,' she says, 'and my two flatmates and I totally embraced it. We'd have shopping expeditions to Way 2 Save. It definitely has the best olive and feta counter in London. They also have a brilliant selection of juices from cactus to coconut water. Matthew once went out for a pint of milk and didn't come back for two hours. He was lost in food choice.' Interestingly, she says 'at first' here, because what she means is that after three years in Wendover Road, which attracts a constant stream

of street drinkers and drug-takers, she was ready to move to a quieter area.

Mon also had an infamous – as in it has appeared in many tales around the table – altercation with be-suited, militant members of the Nation of Islam who were wont to gather at the Jubilee Clock[4] on Saturdays. 'They wouldn't sell me one of their newspapers,' she says. 'They said it wasn't for people like me. I replied, "You mean white? Or a woman? How do you know I'm not black?" We had a row. But the one who was in charge must have had a word with this particular guy, because they next time I passed, they offered me one. But it was too late.' One of her defining characteristics is that she is not afraid of conflict or of defending vociferously what she thinks is right and proper.

Now we've arrived at our final destination – the Trinidad Roti Shop.[5] I have to confess that I've never had a roti. As it happens, Mon has never made it to this shop. The Jam Down Bakery was too near to her former flat, and she couldn't quite find the motivation to make the trek up here to her homeland food shop. However, she is now getting excited at the prospect of a roti. 'Boneless chicken, pumpkin, and spinach, channa, and no pepper,' she orders. 'And a grape solo. In Trini, we ask for sweet drinks not soft drinks.'

She's laughing about the nature of Trini food, in that it's often high in sugar and fat. Not to mention fried. 'I only have to look at a roti,' she erupts, 'and I pile on the pounds.' The roti arrives and it's that rich mixture of chicken and vegetables wrapped in a roti skin which is like a thin version of Indian naan bread. '45 per cent of the indentured work force in Trinidad were Indian,' she explains, 'while the other 45 per cent were African, so that's why we have a mixture of their cuisine. Rice'n'peas is African, roti is Indian.'

In the meantime, Mon has noticed that there's something called doubles on the menu. 'Oh, we have to have one of those,' she exclaims. 'When you come to Trinidad, that's what you will have for breakfast.' What is it? It's a fried piece of dough called a *bara* with *channa*, or chickpeas in a curry sauce. It's good, but it is very fried and it tastes like afternoon food to me, little Englishwoman that I sometimes am.

And there's always the pepper question with Caribbean food. Plenty pepper or slight pepper? In other words, do you want hot chilli pepper sauce with it? And Mon doesn't. 'I struggle with spicy food,' she says, surprisingly.

Pig foot souse and goat curry, they're all on there. But where do they get the goats, I wonder out loud? 'From farms in Ireland,' says the gentleman behind the counter, who informs us that he is actually from Grenada, 'but they taste different to the ones at home. Those goats live on the rocks and don't eat anything that grows on the ground. That makes all the difference.'

Tucking into her roti, Mon is impressed. 'That's what I know to be a roti,' she says, nodding her head. 'You should see the ones they serve at Notting Hill carnival, they're tiny. I grew up on this food. The best street food in Trinidad is from St James.'

The shopkeeper concurs. But where is St James? 'It's a red light district in the Port of Spain with a very lively street culture. In *White Woman On A Green Bicycle*, George goes to pick up a prostitute there. They have the best rotis in Trinidad.'

So at least I'll know where to find rotis, as well as the red light district.

WALK 10

Mr Mash Up

It all started with Oxford philanthropist Serena Balfour. There were plans for a Harlesden Hub,[1] which her charity was going to create for the Harlesden community via this huge building that languishes over Iceland. I went to a cocktail party there in 2012 – except it was wine and crisps – and heard all the promises and hugely expensive, architectural intentions. Old what's-his-name, the architect, David Adjaye, was apparently in line for the multi-million pound conversion.

However, we found ourselves among the billiard tables and rudimentary bar that were the pre-hub Hub. And truly posh (bit of an obsession, this posh stuff, but she is the niece of the Earl of Marlborough) Serena introduced us to local man-about-club, Kola Williams, obviously her man-on-the-ground.

Nine months later, I'm passing by the same doorway and there he is, handing out postcards with gym information. I introduced myself. The Serena Balfour connection was obviously off. The Harlesden Hub too. A couple of weeks later, I arrive at the Harlesden Centre, rather than the Hub, to meet Kola. Immediately, I commit a multicultural faux pas.

When will I learn? I address him as Kola, when in fact the pronunciation is more like 'collar'. 'Cola,' he informs me, acerbically and culturally sensitively, 'is what you drink.' There's a little laughter in there too. Thank goodness.

Kola is a bit of a one. Big, Nigerian, flirtatious, obtuse, and extremely vague about his personal details. For instance, he refuses to tell me where he lives. I've no idea why. But obviously not in Harlesden. Dreams Nightclub for under-twenty-ones is what this building is famous for, or infamous for. Ten years ago. Loads of noisy, energetic young people. The girls baring their bottoms, the boys with bottles of Kristal. Lots of bad publicity. But Kola maintains that it all gave the wrong idea and there was very little trouble there. Now it's rented out as the NW10 club.

It is an incredible building. Big, with huge potential, but a little rundown at the moment. And so Harlesden, in that marvellous crazy mash-up collision way. There are the billiard tables, the club, a gym, a church, the Dominion Church of Christ[2] and a boxing/kick-fighting ring upstairs. Kola keeps talking about community, but I get the impression that he's a bit of a feisty loner.

He talks off the record about Serena Balfour, and it's obvious that they did not get on in the end. According to him, Serena had her idea about what needed to be done but she didn't actually understand the community and their needs. More cultural insensitivity, this time hers, apparently. And Kola is adamant that he was not going to sell his soul for the money.

This is funny, because beforehand someone in the neighbourhood tells me they have the impression that Kola is 'all about business and money.' But he flatly denies this. In fact, he talks about his involvement with 'Not Another

Drop'[3] with pride and shows me thank you letters from the students at Newman Catholic College where he gave a talk on values.

I'd say The Hub idea has had an effect on Kola though. He's talking about widening the community aspect of the club. It needs a new name. He means it's perceived as a mainly Afro-Caribbean community centre but he's keen to widen the remit. A fifty-something musician called Robert turns up, and it turns out they're going to have a rehearsal night for different rock musicians. Kola is eager to show me pictures of a Somali party that took place there recently.

And then there's the church. A room with floral curtains, a drum kit, and two golden chairs – it's spectacularly unexpected. I'm confused. What is the Dominion Church of Christ? 'Well, a pastor set it up,' he explains, 'we gave the room and they found the congregation.' Sounds like Harlesden in the 1850s with its tin chapels. I wonder aloud where this church originated. Kola once again gets culturally defensive, as though I'm asking a racist question. Anyway, he mutters that it's Pentecostal. The holy spirit is obviously active on a Sunday morning down here. And it sounds like the church members give Kola a hand around the rest of the building, as well as having their own celebrations here. They do seem to be this community.

Upstairs is in semi-disarray. The showers and toilets are half-done. There is a kick-boxing ring and lots of mats. Kola tries to explain to me about Greco grappling and to be honest, he doesn't get far. Apparently some Polish young men come up here and do that. Then there's a young man who's also a singer – Kola is very proud of his two-second appearance on You Tube – and a fitness instructor who uses it.

But Kola – who is into boxing, although does not look particularly fit – has surprising aspirations. He mentions yoga classes. I'm stunned. He's thinking of even doing yoga himself. 'As we get older, we need to be flexible,' he says seriously. 'I was thinking of doing some yoga. Blokes like me need to start doing yoga.'

Kola is persistently as prickly as a hedgehog under attack but he's also funny. He's insists that Tamara, who volunteers on reception, goes and gets some ginger biscuits. He loves ginger biscuits. This is his cute, cuddly bear side. Kola with a K.

I'm looking across at him – he's standing by the front desk – there's a bamboo plant behind him and there's a massive hole just above his head. I point it out. He laughs and says he was hoping that he was tall enough to block it out. There was a leak and he had to make a hole to get to it.

He'd also like to point out that he's not difficult, he's wary. He still won't tell me where he lives. I suggest that it'd be great if he collaborated with the Harlesden Town Team, and the rest of the community. Why is he so determinedly alone here? After a few blusters, he agrees. There's the Love Harlesden Day – why doesn't he get involved? 'I don't disagree,' he laughs. 'I'm agreeing with you.'

I think this is a good time to depart, on a note of agreement. He insists on a cuddle. I think we're getting on. Not sure how long it will last. He refuses to be photographed but promises to send me one. We'll see ...

An Anti-Gun Crime Activist Tells It Like It Is

I hadn't been up to Stonebridge Estate – formerly referred to as 'a festering sore', 'third world', and notorious for terrible problems with crack, guns, gangs and fear, now the scene of a £225 million New Labour, award-winning regeneration scheme – for a couple of months, since I went with Louis on the quirky hotel trip. And I notice the last of the anachronistic sixties tower blocks is down. I'm here to meet anti-gun and knife-crime activist, Michael Saunders.

Michael – known locally as 'uncle' – founded the British Londoners' Business Community (which is a curious name, but I assume they didn't want to focus on black or white and did want to sound business-like, although confusingly it has nothing to do with business) in 2009 in order to tackle gangs and gun and knife crime. The idea is to get the mothers, fathers and grandparents involved with each other, as well as with their young people and what they are doing.

In fact, two years ago, Saunders found himself being challenged to do something by a friend's twelve-year-old son, TJ, whose mother had stopped him going out to the park because she was frightened that he would get hurt. 'He'd already watched his elder brother get depressed when one of his friends was shot

dead,' says Michael. 'So TJ wanted to know when we, the older people who were moaning about it all the time, were going to get up and do something. So four of us, my old friend, Lasana Fulu, TJ and his thirteen-year-old sister, Sheneisha founded BLBC. I was aware that the mothers had already been active with marches like 'Not Another Drop' and we, the men, needed to get up off the sofas and be more proactive.'

Saunders – who was born in Kilburn and is back there now, but who lived in New York for thirty years and says he has learnt what not to do around these problems from the US, as well as what to do – blames MTV and the influence of rap culture on the behaviour of young people here. 'Whether they are black or white, they all want to be like Jayz or 50 Cent,' he says, 'and that is giving them distorted ideas.'

I'm not sure it's that simple although, obviously, a middle-aged white (or Caucasian, as Michael would say) woman who was brought up in a Yorkshire village may not have all the answers. But the pressure of poverty on parenting, the failure of schools, feeling alienated in a society that doesn't support them would also seem responsible. We agree that education, discipline through sports, and community action can help change the situation.

Has the new Stonebridge – old towers down, low rise and family terraces in place – helped? 'Yes, yes, yes,' he says, 'now it is like a community here. It's not so institutionalised. Look, now people see each other in the garden, it's not anonymous-living any more. It's made a hugely positive difference.'

And the police do now have access? 'I lived in this estate in '77,' he explains, 'and they were big flats with great views, but the buildings were all interlinked which meant young people could evade the police very easily. That doesn't happen now.'

Two teenage boys go into a house nearby. Michael shouts 'hey' to them in that 'we hang out together sometimes but you know I'm on your case' kind of way. BLBC has a slogan, which is FUBU – 'For You, By You' – and is about individuals in the community realising what power they have in their own hands. 'The estate has changed over the last ten years,' he says, 'but there is still a problem with young people. Right now, there's trouble between Stonebridge and the estate over the A406 called St Raphael's. It's even worse because there are families who have relations in both areas. Potentially, that means there is the chance that one family member might unknowingly injure another family member by mistake, just because they live at the other place.'

That's crazy and sad, I opine. 'That's the reality,' he says as we walk towards a football pitch. 'Young people are influenced by their peer group. But we hope that getting the parents and young people in one room together will have an effect. Parents and relatives can pass on positive moral messages to their children. Mothers often know their son's friends, and they can influence them if they're altogether in the same sitting room having a conversation. They respect people they know well. That is the first port of call.'

Right in front of us, there is a lot of football action going on, training with small kids up to teenagers. Meanwhile, Michael admits that there is a lot of resentment towards the Somalis who have arrived over the last decade. 'Young people who were born here don't like that Somalis are getting given flats,' he says. 'There is a perception that the Afro-Caribbean community came here because they were needed to do jobs and so they paid their taxes, and their children and grandchildren should be looked after.'

I'd heard from my son that there was tension but I didn't understand what was going on. Now, I'm shocked, but not shocked. The Somalis are refugees. This is the sort of perverse logic that leads to second generation immigrants joining the English Defence League. And the vicious circle of 'not enough for us' that comes out of Britain, every time we have an austerity situation.

'We teach them what respect really is,' he says as we reach the sports club entrance. A hundred or so young children are playing football with older mentors. 'Super is the man here,' he says introducing me to an avuncular, kind-faced gentleman who's hiding a bundle of locks under his hat. 'He can tell you on another occasion about what else is going on with the young people here. It's important that we get to the young kids, so then they form a network where potentially others will step in if they start falling off the tracks.'

Michael says BLBC identify the alpha males and females in the community and work with them. 'They are often older and have the influence, they're the leaders and they persuade the others. So it's important to have their ears. They influence the peer group. And peer groups are so significant to teenagers.'

And parents? 'Parents only have so much influence,' he says. 'They might be on your ass from time to time but they don't see everything.' Hmm ... I disagree; I think parents can play a bigger role and should. I know I have with my own son. I remember the time when he was mugged in a humiliating way at fourteen, and he wanted revenge so badly. I argued and argued that revenge was not the answer. In the end, he did understand.

I wonder how Michael formed his ideas on youth and crime. 'When I was in New York, there was this young boy with an AK47 on the street,' he explains. 'I asked him what he was doing and why. He said it was my fault. I was in my late thirties. He said that my generation hadn't put the struc-

tures in place to look after that age group. I remembered that. I'm trying to help but I know it's not going to change completely in my lifetime. We're just sowing the seeds.'

Michael says he's walking me out of Stonebridge, but we seem to be walking back in again. I sneak a look at the desolate site where the tower block behind St Michael's nursery was. Last time I was here, it was still wrapped up and be-scaffolded. Now, there is bare terrain. It feels momentous, even though these changes have been going on for a decade. And I'm not in favour of pulling down all the grey sixties housing estates – some could be refurbished. But these had to go.

I'm not quite sure how we managed to get on to the subject of Obama – it was probably the lack of positive male black role models in the UK – but I couldn't help myself. 'Shouldn't he be called mixed race rather than black?'

Michael makes a sort of whooping noise like a wild dog caught in a trap. 'No,' he cries, 'Obama is black. If he went anywhere in the world, they'd say he was black. The US constitution says that anyone with an eighth of black genes is black.'

But he is mixed race, I insist. 'That's just being politically correct,' he counters. 'And it's different in the UK. Here I grew up with white kids in Kilburn listening to Manfred Mann, but over in the US all my neighbours were black.'

Manfred Mann! So you mean it took moving to New York for you to feel black? He laughs. I like to think he's admitting I'm right.

As we walk down into Craven Park Road, Michael's mind turns to his supper. Red snapper, it seems. And mine turns to his hairwear. A blue cloth that reaches down his neck. 'It's a do rag,' he says in that US do-dew way, 'I wear it because I don't want to comb my hair, and if I take it off, my hair will be fine. It's a black hair thing.'

Being Amused by Scouse Raconteur, Alexei Sayle

Ah, punctuality. Alexei – comedian and actor, formerly of 'Ullo John! Gotta New Motor' fame but now acclaimed author – is ascending the steps at Willesden Junction just as I arrive at the top from the other direction. Excellent timing.

I'd invited him to walk with me because I'd read a piece he'd written declaring that he writes in the morning, and then takes a bus or train to an unknown destination, and walks home to Bloomsbury. I thought I'd divert him to Harlesden for the afternoon.

White bearded, almost benign-looking and smaller than I imagined. I tell him later about this unexpected lack of height, to which he quips, 'Oh, people usually think I'm not as fat as they expect.' I give him the choice of a right along the High Street into Harlesden or a left and down Scrubs Lane, then along the Great Union Canal before turning right towards the main drag. 'I do want to experience Harlesden,' he says, 'but it would be good to see a bit of urban countryside first.'

I'd read somewhere that he was going on tour again as a stand-up? 'No, that was a mistake,' he says, huffing as

opposed to puffing, 'I'm doing a reading of my new memoir, *Stalin Ate My Homework*, and a Q and A at the South Bank in summer. That's what the papers should have said. It was actually selling better before that stand-up stuff came out.' That's a good sign, I suggest, in terms of his more recent career as a novelist. I guess that he gives good reading – unlike the majority of writers who are, of course, not performers. 'Yeah, I always say to them, just because this has been good, don't expect others to be. They'll be shit.' Ever bolshie funny – the Scouse thang – he sets the tone for this walk.

On the left, at the start of Scrubs Lane, I laughingly point out an unappealing office block that calls itself somewhat hopefully the Chandelier Building. 'Yeah, it reminds me of another hideous building in Camden which called itself The Red Lobster,' he observes, 'and helpfully they put a picture of a red lobster on the side, as if that could remove the ugliness.'

How many copies of his novel, *Mr Roberts*, has he sold? I wonder. '20,000,' he says. 'I'm a better writer than people think. My short story collection *Barcelona Plates* that came out ten years ago has sold over 75,000 copies – that's the biggest selling short story collection in the world. And still the *Guardian* don't ask me to write any fiction for them.' Has anyone questioned them about this, I wonder. Remember, the *Guardian* is edited by thirty-somethings, they probably don't know who you are. 'No, probably no one has. But I'm not sure I can be arsed. My previous career helps with my profile but I think it does prevent me being taken seriously. I haven't even been long-listed for any of the literary awards.'

Fortunately, we're walking slowly. I was a little afraid – I'd been playing too much tennis and am aching – that Alexei was going to be a hearty walker, but he's limping slightly

and more of a meanderer today; he's spotted across the road the incredibly kitsch Cornices Centre, which boasts some seriously garish objects, like a huge cartoon rabbit licking a multi-coloured ice-cream. It could be Jeff Koons but it's not quite shiny enough. We've reached the canal bridge, and Golbourne Road's landmark Trellick Tower – built as social housing in the 1960s – looks mystifyingly close. 'I had a camp mate at Chelsea School of Art,' says Alexei, revealing his arty past, 'who named it Clockwork Orange Towers, which seemed just right at the time.' Trellick Tower is an architectural wonder to some. Not to Alexei or me. It was designed by legendary architect, Ernö Goldfinger. On another occasion, I visited my friend Amanda's mother there, and the view from the twentieth floor is spectacular.

Is the satirically inclined *Stalin Ate My Homework* about growing up – he's Lithuanian Jewish and both his parents were members of the Communist Party – in Liverpool during the fifties and sixties? 'It covers from 1947 when my parents met,' he says as we find the towpath going east, 'to the end of the sixties when I was seventeen. It's a heterosexual, Communist *Oranges Are Not The Only Fruit*.' Mmm, just what I would expect from him.

As he utters the word 'Communist', a cyclist in a high-visibility jacket suddenly looms towards us, his eyes twinkling crazily. He stares at us both meaningfully and announces cheerily; 'God loves you'. He couldn't have chosen better timing. We burst out laughing at the synchronicity of it all. Well, that's what I'm laughing at.

Oh, it's peaceful down here. The willows are in bud. A couple of locksy young men with a dog and a canal boat are relaxing and enjoying the first signs of spring. The warmth, the relief at being able to 'be' outside.

I'm off again. This is turning into a walk interview. Are you a single child? It suddenly occurs to me in an intuitive manner that he must be. Working-class and doted on – a recipe for success. 'Yeah,' he says, 'my mum was thirty-seven and dad forty-three when they had me.' His mother is still alive and mentally alert in Liverpool. 'She's ninety-four,'[1] he guffaws, 'and lives in a house bought by her son. Does she ever say "thank you"? I did a reading from the memoir in Crosby not long ago – she came along in her wheelchair and heckled. "Lies, lies," she shouted.'

We've jumped onto a stone bench and are looking over a wall at the railway lines beyond. 'My dad was a railway worker,' he says. 'Which line is this?' The one that goes to Paddington. 'Oh, I think the Eurostar maintenance yard is over there, near North Pole Road where I filmed a TV film called *Sorry About Last Night.*' I check later and he's right, but it's not used by Eurostar any longer.

I've just heard that the controversial HS2 is coming near here in 2020, I say. He obviously doesn't believe me. No, I have, I say, Harlesden is going to be the new Kings Cross.

There's a silver birch grove to our left. Silver birches, I love their grace. They're my favourite trees. 'I find them sinister,' says Alexei, shocking me, 'there's a hunting plain where they grow near my house in a village in the foothills of the Sierra Nevada, near Granada. They're spooky.'

I can't agree with that. For me, they're more like delicate filigree lace than furtive strangers. Tangentially and somewhat provocatively, I mention his marriage as being one of the longest in 'showbiz'. He's been married to Linda since 1974 – that's thirty-six years. I'm agog in admiration! But Alexei immediately looks very uncomfortable at the mention of his personal life. So we divert again to the break-up

of Kate Winslet and Sam Mendes. 'I know I was shocked,' he says as if he knows them, in that cosy-with-famous-people way that our culture promotes. I was the same.

Is there anywhere decent to get a cup of coffee in Harlesden? he wants to know. Like Starbucks? No, there's no Starbucks. Long-term Marxist and strident non-conformist that he is, he comes out in defence of Starbucks. 'I think people like (left-wing comedian) Mark Thomas whinge too much. At least they make an okay cup of coffee available to more people. I don't like it when people can't admit what's good about capitalism as well as what's bad.'

We stumble across some drinkers' detritus. Alexei wanders over and examines the Lech lager can. 'I hate it when street drinkers are so untidy,' he protests, 'they should have to put a deposit down on the cans.' As we leave the canal, there's an office building on Oak Lane that is derelict; almost every window is broken and it stands in an ocean of litter. 'Good, good,' he mumbles, meaning the faster this terrible architecture falls down, the better.

We're at the railway cottages and Alexei remembers filming in some similar ones. 'They replicated houses up north in the seventies,' he says, 'because they didn't have double glazing or central heating.' I tell him about my recent discovery that the sixties sitcom *The Likely Lads* was filmed at Willesden Junction. 'Exactly, that's what I mean,' he says.

'Look at that guerrilla gardening,' he adds, pointing down a communal alleyway full of yuccas. 'The community have got together there. It's like that Heaven 17 song. "We don't need no fascist government"... '

I have to admit there is a subtext to our conversation, which revolves around the eighties. I was a pop 'n'rock journalist for music paper, *Sounds* – better known for its

Iron Maiden interviews than its Flock of Seagulls ones, and guess who did the latter? – as well as seminal style magazine, *The Face*. Alexei wants to know if I enjoyed being able to make or break bands? I assure him that I personally did not have that kind of power. But there were those critical reviews and confrontational interviews. Not only did Frankie Goes To Hollywood pelt me with bread rolls for giving them a bad review, I got into a heated spat with The Stranglers, who were provocative lads. Those were the days when journalists were expected to be opinionated and go for the jugular. Oh, those were the days, I say. Before the ubiquitous PR protection started.

I make a remark about his limp that I've been noticing for some time. 'I've done my back in,' he admits. 'I attacked the gym workouts and I've overdone it. I'm trying to lose a couple of stone.'

And then he pursues the coffee question, obviously not aware of how absurd he's sounding. Isn't there an organic deli where we can get a cup of coffee, he asks? I smile not only at the ludicrous nature of the question, but also because I was intending to take him to one of the Irish pubs up the road.

Alexei, it has to be said, has an interest in history and architecture, which manifests itself in a surprisingly erudite way. As we stand at the corner of Acton Lane, he looks at All Souls Church and declares, 'This Church of England one is gothic revival, but look at the Catholic one up to the left; it reminds me of the Tate Modern, of the power station. It's industrial bleak and I think the Catholics could have borrowed that aesthetic.' I hadn't thought of that, but he is right.

Somehow I feel a compelling urge to change the tone, and show him Wrights. We stand in front of the racy underwear

window and I hear myself saying brazenly, 'Do you think Linda would fancy anything from here?' Alexei is unusually quiet. I've done it again. I've stepped into overly personal territory. Deliberately. In fact, I'd go as far as saying that he's embarrassed. And then, I can't stop – don't want to. I find myself babbling about the sexy nurse outfits. Patently, Alexei does not do sex in public.

Or public houses in private. The Shawl[2] is festooned in orange and green balloons; it's St Patrick's Day. We go in. Faces are fixed on the TV racing. There's the pervasive stench of Guinness. I run out of the door. He stares at me – not that he wanted to stay. 'Oh, the breath of death,' I find myself announcing. Next I try the Misty Moon. 'Do I have to come?' asks Alexei, firmly weighing in against the pervasive mid-afternoon state of alcoholic stupor. I have to give up. The strains of 'She died giving birth' waft out of the drinking hall, and I smile wryly.

Finally, we find a welcome space in the empty Os Amigos.[3] This was KT Tunstall's favourite local restaurant. I comment that no one seems to have recognised Alexei today. Is he surprised? 'Sometimes people say "hello", but Liverpool is really the place where I'm still up there,' he says, smiling. At this point, he launches into a complex story about his fascination with flying business class, having a column in the *Daily Mirror* during the nineties which was read by 8 million people, and the dedicated band of airline seat aficionados who not only take photos of these seats but chat about them online. His point being that more of them chat about seats, than post comments on his website. From 8 to 20 million. 'But does it matter?' he intones in half-funny tones.

One of Alexei's core theories is that we're all a mass of contradictions and we should be allowed to inhabit all of

them fully. This is one of them. He's a Marxist and he also loves flying business class and looking at photos of first class airline seats on the net. Tony Blair, he reckons, needs psychotherapeutic treatment for his inability to own up to his internal contradictions. 'And that is really is corrupt,' he says, emphatic as ever.

Alexei down
Park Parade.

The Man Who Makes Art and Cuts Hair

You will have noticed already that I'm an admirer of the combination. Faisal Abdu'Allah is an artist and a barber. Faisal, the barber's, is always full and its owner is reaping rewards internationally as an artist. His work (photographs, screen prints, film installations) filled four floors of a super dooper new museum, Centro Atlantico de Arte Moderno in Gran Canaria, two years ago; he's also a visiting professor at Stanford University[1] as well as a lecturer at East London University. All another fabulously crazy mash-up collision.

This man is a dude, if one can still say that. Today, he cuts a dapper figure with his spotted cravat and low-key swagger. And he's full of art tales, Harlesden tales and Louis Farrakhan tales. The barber's shop – white modernity prevails – is on the High Street near Willesden Junction and he has a work/gallery space downstairs. A local boy, he was born down Tubbs Road – his Jamaican parents came over in the sixties; his father worked at the Heinz factory in Park Royal – and he went to what was Willesden High School. One of the first things he says to me is, 'I think the Capital City Academy is one of the most beautiful buildings in London,' which makes me want to look at it again.

Faisal chez Faisal, the barbers

He starts showing me the brochure from his 'mid-career' show in Gran Canaria, which is large black-and-white photographs of people that form a kind of wall of trust; they were taken when he was based at Stanford University for a year. 'It's called "10% of Separation",' he says. 'I got a student to choose someone they totally trusted, then took their photograph, and then continued from there. One twenty-three-year-old chose his fifty-something professor, which was moving. Then other people had dilemmas about whom they would choose. That was all part of it.'

Faisal has been in a few documentaries. Someone is following him at present as part of a documentary about four barbers from around the world. There was one in 1991 called *The Day that Changed My Life*. That day was when he was a twenty-year-old art old student in Boston. 'My

parents were Pentecostal Christians and when I was a child, I went to a church (the Rebirth Tabernacle) every Sunday down Leghorn Road. I had some surreal experiences there. But when I got to the US, I realised that there were gaps in my consciousness spiritually, politically and culturally. I didn't know anything about the Harlem Renaissance or Black Power. Someone mentioned Malcolm X and I started reading. Someone mentioned Billie Holliday and I started listening. It was all about discovering my own sense of purpose and also who I was as an artist. I started listening to the radio and I thought I was hearing Martin Luther King, but it was Louis Farrakhan. A couple of weeks later, someone invited me to a Nation of Islam mosque. That was the day that changed my life. The women were all in elegant white, the men all in suits and bow ties and the words were all about empowerment for young African Americans. Somehow it fitted with where I was going. I went every week after that. In fact, they sent a limo and two minders to pick me up. That was because I was English and therefore somehow special. Often people talk about the Nation of Islam as though it's all about hate, but for me that place was nothing but love. But I didn't follow Farrakhan or any of his racist beliefs.' When he got back, Faisal became a Muslim and changed his name from Paul Duffus to Faisal Abdu'Allah.

As we set off on our walk, I discover Faisal has a wife and three kids and lives these days in North Harrow. 'Well, I sleep there but my community is in Harlesden, and I go out between here and the West End,' he says. He still cuts hair on Saturdays and says it keeps him real. As we walk down Tubbs Road to Number 52, where his family used to live, he says he remembers it as a friendly neighbourhood with mainly Jamaican and Irish families. He was the 'wash belly baby', the last of eight.

After being inspired to start cutting hair by lack of good barbers in Boston, it was shaving palm trees into the head of his nephew that got him the job at City Barbers, which was once on the corner of Tubbs Road. 'They saw him on the street and asked him where he'd had his hair cut, then they employed me for six years. That took me right through Central St Martins and the Royal School of Art – it paid for my materials. It was great, it was also bringing two worlds together that don't usually meet. And cutting hair informs my work. The stories of the people I cut often become my work. At Stanford, there was an exhibition of my photographs that showed the complexity of the Black British identity and I was invited to do a barber shop performance where I cut hair and they totally got it.' He even met his wife at City Barbers!

We start talking about invisible Harlesden – in that Faisal wants to find archive photos of his shop from the past. 'I know it used to be a record shop at one time,' he says, 'but I want to find out more.'

As we're walking past the shops that admittedly still look shabby generally, i.e. facades, general cleanliness and arrangement of contents, I discover that Faisal has distinct potential as Harlesden's own male Mary Portas. He has opinions about the place and how it could be. He suggests dressing spaces, in fact – a Harlesden shop makeover event, which is a great idea. And that the shops could do with having a visit from 'the style police'! 'Brent council need to do a clean up here. Look at the pavements, they are filthy,' he exclaims. 'After all, Harlesden is the gateway to Wembley. Look at these facades – standards need to be set and an aesthetic created. Windows are dirty, interiors are crammed with items and there's not enough light. I know when I did the interior of Faisal, I had the first plasma TV and all the other barbers stepped up their

game. Look at that shop over there. It could be a sculpture by Sue Noble and Tim Webster.'

We pass the Jam Down Bakery and Faisal has nothing but praise for their meat loaf, patties and coco bread. I mention that I'm soon off to Trinidad where the family of my friend, novelist Monique Roffey, live. 'I know Chris Offili really well,' he says of the infamous-for-using-elephant-dung artist who now lives in Trinidad. 'We were at the Royal College of Art together.'

For Faisal walking the High Street is like going back in time. 'I remember this shop being a toy shop,' he says near JJ's wine bar. 'My family could never afford for me to have my favourite toys, so I did a lot of looking. I make a point of taking my own children to toy shops and letting them have what they want. I talked about my lack of toys when I opened my show recently in Gran Canaria and how it affected me. But the most important thing is sanity, and for that we have to keep our values. That means not getting distracted by the "success" of peers.'

On the corner of St Mary's Road and Craven Park Road is a new block of flats. Underneath, I've been told there's a squat. We arrive, and there are strange curtains up at the windows but also a sign pronouncing 'The Citadel', so we assume that the owners have agreed for this church to rent it. In my mind, I'd been imagining an Occupy Harlesden, but sadly that is not the case.

Walking back, Faisal talks about the influence the Pentecostal church had on him as a child. 'For years, their prophecies that the end of the world was nigh plagued me. I was really affected by that and scared,' he says. 'It also influenced my work. It's a very one-dimensional way of interpreting the world and trying to scare you into being "good".'

Sparkly Bras, Cockroaches and Little Brazil

Thank goodness for twenty-one-year-old Julia Divine! Yes, Divine. Name of names. A Brazilian – her sumptuous, kind-looking mother, Victory Divine, recently opened an eponymous vintage and seamstress atelier in Park Parade – at last, who is willing to walk with me. A rare breed, it seems. I've been trying for a few weeks. Emails, trips to local shops, to no avail.

This was until I found the lively, deliciously opinionated Julia. I'd found her amid the pink feather boas and glittery jumpers in her mum's shop. And now we are walking. 'We came over from Brasilia in 2006,' she explains. 'My mum is actually a pastor and she came with the church. My dad is a prosthetic dentist but they split up a long time ago. I was sixteen when I came here and went to the Capital City Academy. It was a complete waste of time. The teaching was really bad and they made me feel different.'

Although Julia used to live here, she's moved in with her fiancé – who has a wonderfully strange name that I sadly can't mention because, post-walk, they both have an attack of the privacy virus, but he explains later that his parents were hippies and it's Anglo-Saxon as an explanation – in

Acton. She met him through a friend who went to Cardinal Hinsley, the Catholic boys' secondary school near me that has now been renamed Newman Catholic College. 'We're getting married in June,' she says with sudden animation, 'at St Lukes in Queens Park where my mum is a pastor. It's an evangelical Christian church.'

By this time, we've walked down Station Road as far as the Amber Grill. Formerly the Willesden Junction Hotel – built in Victorian times for travellers who arrived by train, it was probably rather grand; the original painted letters are still at the top of the building at this point[1] – it became a very tatty pub but is now a Brazilian restaurant. To be honest, I've never seen anyone much in there and had relegated it to my 'no interest' mindfile. But Julia is an unexpected fan. 'They do traditional rodizio,' she says, 'where waiters bring you slices of slow-cooked grilled meat to taste at your table. I really like it here.'

The strangest discovery is that a pastor – they are popping up everywhere – co-runs it and that it is linked financially to the International House of Prayer next door. Another evangelical Christian church – I'm having a run of them too. The waitress is Brazilian and a member of this church. 'I'm studying English,' she says, 'and I live upstairs with my husband.'

The conversation turns to the defining qualities of a Brazilian, physically. 'I'm half-Italian,' she continues, 'like many Brazilians, but there are so many different types of us. You can't generalise.'

'There's a waiter here who is half Chinese and half Brazilian,' says Julia, confirming the Brazilian melting-pot identity, 'and we also have more Japanese outside Japan than any other country.'

Next we pop into the Associacäo Portuguesa, which helps Portuguese speakers with benefits, jobs and legal advice. 'There are 30,000 Brazilians in Brent,' says Edmar, a PhD student who is volunteering here. 'A lot came to learn English in the nineties, but US is the first port of call. It was difficult to get in after 11 September so they applied to the UK again.'

Julia seems to have sneaked off, but re-appears again with a young man in a high visibility jacket. It's her darling *****, twenty-five, who used to be a DJ and a radio pre-senter but lately has gone sensible and got a job over the road as a bus mechanic with First Direct.[2] 'I usually work from 4 a.m. until 12.30 p.m.,' he says, 'but because Julia is with you, I'm doing overtime.' Saving up for the wedding? 'I am,' he grins contentedly, a young man who knows he's lucky, lucky, lucky in love. They've already bought the dress on eBay. It's a size 6. If it doesn't fit, Julia's mother is a seamstress.

Julia hasn't got a job at the moment, but she does have a voracious interest in criminal law. She is also ambitious. The Capital City Academy has, fortunately, failed to drain her of that. 'I've just applied for a job translating Portuguese legal documents,' she says.

She is sparky, too. Sabor Mineiro is a little Brazilian café on the corner of Tubbs Road. I have friends who love going there. But Julia disapproves. 'Their food is not sea-soned properly – it's not good,' she says authoritatively. That doesn't stop her giving me a quick tour of the (mostly deep-fried) specialities, from coxinha, which are shredded chicken and cheese in dough, to pastels, which have minced beef inside a pastry envelope, to kibes, which are a bit like falafel.

We cross over to Planete Brazil – the bikini and hand-bag shop which has also turned into a hairdressers. The receptionist at the hairdressers is diffident, even with Julia in tow. She says she doesn't have time to speak. They have one customer. Have I mentioned the flat screen TVs? They are everywhere. They scream shininess, as in big new shine. How important 'new' is to the newcomer, and their soap habit. 'They've all got Sky,' says Julia pragmatically. 'They get all the soaps on the Brazilian channel, Record.'

The butcher and mini-supermarket owner next door is much more friendly. He's been here for nine years and has five businesses. 'I'm from a central state called Minus Gerais,' he says, 'and I always hang my Easter Eggs from the ceiling like that, it's tradition – just like they do in Brazil.'

And then we have an unexpected bit of information from Julia. 'Look, pest control,' she points out as we pass First Direct and her now invisible beloved. 'Did you know number 18 buses are full of cockroaches?'

To be honest, I had no idea. 'They like the back seat near the engine,' she says with the benefit of insider's knowledge, 'they always find loads there.'

After that brief but significant cockroach moment, we go into William Wallace. Another hairdressers, this time dominated by black and red, and again warmth. Down a corridor at the back, we discover Brazilian Lingerie. It is truly secreted away. Patrizia, the mistress of the lingerie, gives me a tour of her sparkling bra-bedecked hangers. 'The difference is that Brazilians wear bras like this,' she pulls out a verdant glossy one with diamante straps, 'every day. It's not special to us, it's what we wear. Whereas in the UK, you'd probably wear it to a club. Also Europeans hide everything, we like a nice cleavage.'

Patrizia has been here ten years. She came to learn English and ended up meeting her husband and having a child. 'My great grandfather was Portuguese, but I'm not Portuguese. I'm totally Brazilian,' she says, her six inch wedges confirming it.

Our final destination is Kero Coffee,[3] a cafe on the left past the Post Office. Here we find Limarie – a Brazilian with one set of French grandparents – who is full of beans. She points out one of her customers, who 'is Moroccan but tells everyone he's Brazilian because he wants to be Brazilian so much'.

Limarie tells us a little bit of her story. 'My indigenous Indian grandma was really pretty and my Spanish grandfather chose her, then raped her. She never forgave the Spanish, she wouldn't let us get Spanish passports. But in Brazil, we're not racist, it doesn't matter what colour your skin is. And we don't use skin whitener, we'd rather be dark.'

She has one of those big, generous hearts. She has a seven-year-old son, a nine-year-old daughter and an Italian husband. 'My daughter gets bullied at school because her hair is curly and different. Those curls are so gorgeous and it makes me very sad that she is treated like that here.'

However, the next instant she looks over at Julia – divine as ever – and pronounces that she reminds her of a celebrated Brazilian actress but she can't recall the name. 'Well, people do say I'm like a Brazilian Angelina Jolie,' pipes up Ms Divine. Stellar as well, it seems.

The Heady Delights of Willesden Junction Station

Delight and Willesden Junction station[1] do not sit easily in the same sentence. 'Terrifying and bleak' might spring more naturally from the tongue. Especially after midnight when I have to embark on the long, long, lonely walkway – used to be rat-infested, has improved – towards Harrow Road. It is frightening. I have been known to run the entire distance. In the daytime, it's more urban desolate. Ugly graffiti, derelict buildings, imposing wire fences, detritus.

However, since I've been visiting more often as part of this project, something unexpected has happened. I've started to see beauty and intrigue where once I only saw an industrially scarred means to a transport (hopefully) end. Taking the time to look more closely has widened my vision, both literally and aesthetically.

And Willesden Junction is extremely significant in the development of Harlesden, demographically and historically. In the 1840s, a Willesden station opened on Acton Lane. It allowed City workers to build their rather grand villas in the countryside (yes, Harlesden) and commute into town. In 1866, a new station, Willesden Junction, was built about 1,000 yards further east, at the point where

trains going to Birmingham on the London & Birmingham Railway diverged from trains going to Bristol on the Great Western Railway, which was built by none other than Isambard Kingdom Brunel. Gradually trains transported more and more immigrant workers (especially Irish) to the area, which slowly became more industrialised.

Willesden Junction station is huge. And I don't – this is an understatement – understand railways, so I have found Ian Bull to guide me. He has kindly informed me via email that he has a nose stud, long hair and has a bit of a Goth thing going on, so when I see an boy/man (he's actually middle-aged, but that adjective seems completely wrong) quaffing water on the Harrow Road railway bridge, I assume it is Ian. It is.

He is immediately eager to point out the distinguishing characteristics between the train-spotter and the railway enthusiast. Train-spotters collect train numbers whereas railway enthusiasts are keen on research, taking photographs and history. Naturally, Ian is the latter, although neither is he a stereotypical railway enthusiast, because apparently they wear grey raincoats and horn-rimmed glasses. And Ian is definitely sporting neither.

'I think I was born with it,' he says mysteriously, 'I remember being in the garden when I was about three and seeing a steam engine in blue and yellow going by. It was a prototype Deltic and it was very powerful. That was 1962 and it was doing 100 mph. I've never forgotten.' I had never before contemplated the idea that people could be born as railway enthusiasts, but no doubt the *Daily Mail* has already recorded scientists working on identifying the railway enthusiast gene.

Interestingly, he also mentions that many railway enthusiasts have a touch of Asperger's Syndrome about them,

although he omits himself from that category. Rather too quickly, methinks.

'Willesden Junction used to be a far grander station,' declares Ian ardently as we descend the steps at the entrance. 'It used to have an overall roof, but there's not a lot of old stuff left. It's been re-built so much over the years.'

Ah, first of all, there's the strange and compelling metal building on stilt legs that a train-spotter (I say this with new authority) informed me was a water tower where water was stored for the steam trains, possibly going back to the 1860s. But Ian disagrees. He looks across at the odd little edifice and, as he ponders its enigma, I can hear the mounting excitement in his voice. It starts off slowly and then gains momentum. It's the thrill of potential triumph that I'm witnessing audibly. 'It's too small to house the water for a steam locomotive and the building is quite modern. I think it's 1930s because it has rolled steel joints,' he says, his voice speeding up, not unlike a head of steam. 'I suspect that it's a carriage washing plant.'

Ian, I will discover, is a bit of a one for inspired guesses.

And then, there's the disused stone building at the back of it with its broken windows and rows of pigeons. Ian stares up at the windows. 'Pure 1904,'[2] he says with what I can only describe as unadorned victory in his voice. 'That's a transformer station. When the lines were electrified in 1914/15, transformers were needed to change the wattage of the electricity coming in from the power station according to the needs of the railway line. They had to have windows because they were manually operated and the operators needed to be able to see what they were doing with the large levers that they had to use.'

I so enjoy finding out these tasty morsels of information, which otherwise I'd never, never have known. In fact, never have known that I wanted to know.

That mysterious Willesden Junction stilted metal building.

The graffiti-covered (it's not very high quality) brick building in front of the old transformer station is a modern transformer station. No lovely windows, only vents. No people needed to operate them. Much less appealing to the eye. How the technology changes can affect the aesthetics adversely.

Blackberry brambles, pink willow herb, deep purple blossoming buddleia trees all scramble together besides the tracks, nature amid industry. Railway sidings are often prolific in terms of wildlife. 'Buddleia originally grew in the Himalayas,' says Ian, easily stepping out of trainland into plantland. 'Naturalists think the seeds arrived in the docks with goods from the Far East and got there on axle grease on trains.'

There's lots of maintenance going on here today, a Sunday. Orange-bedecked labourers 'are adding ballast to the tracks

to support the rails'. Obviously something I would never have noticed if Ian hadn't been here. I'm not sure I even knew that ballast was broken up stone. I certainly didn't realise that railway lines need ballast shoulders. 'This is a very good shoulder of 6 inches,' says Ian approvingly, implying that this part at least is well looked after. 'These rails carry a lot of heavy freight and high speed trains.'

The underground system is not working today because of building work. The platforms are being extended, a new footpath is going in and there are new steps being built. The booking office is housed in an almost rural-looking cottage brick building. We walk up a pathway – one I've never been up before – behind it. 'It was built at the end of the nineteenth century, look at the lead in those windows,' says Ian, in one of his favourite refrains. 'It's pure Arts and Crafts movement. Look how they've used lots of different terracotta mouldings and brick in different patterns to make it look complex.'

On our right are the tracks for the North London Line to Stratford and the South Western Railway to Richmond. Unfortunately, the buildings are from the sixties. Ian is more interested in a buried entrance to our right. 'This footpath has only been here about ten years,' he says. 'That's when they buried the entrance to this covered walkway.' Now we've emerged near the Station Road exit to Willesden Junction but there seems to be an opening to our left where it is possible to walk. Men in orange jackets are leaving via this route.

Ian is distinctly hesitant at this juncture. 'The public never used to be allowed down there,' he says.

'Come on,' I say encouragingly, 'let's go.' This is what I like – a bit of forbidden adventuring. We wander down

and find ourselves in deep Willesden Junction railway wilderness. In fact, later I read that it used to be nicknamed 'Bewildering Junction'. A high-speed train bolts past. 'That was the Birmingham express,' says Ian.

We gaze across the lines – a Virgin express to Glasgow whizzes by – and there over on the other side is something that could be an Anish Kapoor tubular sculpture amid gigantic mounds of earth. It transpires that it is the European Metal Recycling centre.

There are steps to climb and I look back on a bevy of yellow and blue trains, which look like exotic beetles just about to rampage across this urban wasteland. 'They are Class 378 engines, which have just been built in Derby,' announces Ian. 'They travel between Euston and Watford.'

Now we're crossing a footbridge – steel, 1960s – which Ian has never been over before. Let alone me. I'm feeling the excitement of previously uncharted (to us anyway) landscape. We're getting nearer to the huge mounds, which Ian has guessed might be crushed cars. After passing a couple of noble spruce trees, we see dozens of white bags full of some sort of mechanical parts. 'Oh, they are fridge compressors,' says Ian his voice ascending towards the highlands of an inspired guess, ' so those mounds of rusty metal must be old fridges.'

Fridges. Whoever would have thought it? But it's true, the mounds are not earth but rusty metal. Wow, I'm sort of impressed. 'Can you smell that oil in the air?' says Ian.

I couldn't but now I can. On this hot sunny day, it's like a weird garage extra. The wire fences are covered with over-active morning glory or, more prosaically, bindweed, and bushy horsetails burst out of the poor soil beside them. Suddenly – we've been totally alone so far – a denimed

man is approaching us. 'Where have you been?' I ask him cheekily. 'Car Giant,' he says, somewhat disappointingly. I was imagining something more industrially romantic like a tryst in the railway undergrowth.

The path ends and we find ourselves near Scrubs Lane, but we turn right into more of the industrial heartlands. There's a Portuguese Bi-café with fake pink flowers outside and gingham, there's a Lebanese foodstuff warehouse, the Icehouse, an ice cream centre and another footpath that leads to the Grand Union Canal.

'I wonder if there'll be a footbridge,' says Ian. And there is. It looks straight onto the disused Old Oak Common locomotive shed. 'Crossrail should emerge here in the future,' says Ian, talking about the plans for a Crossrail HS2 hub, 'which I think is a good idea. There's even a railway turntable over there on the right which is still used.'

Fascinatingly, he then reveals a little of the inner sanctum railway bitchery that goes on. 'This is the Great Western Railway and it's a very self-important railway. Magnificent steam trains ran along it from 1900 to 1922 and somehow the people connected to the GWR think they are superior. I don't get on with it.' Somehow the railway has become imbued with the attitude of its employees. This must be a railway enthusiast thing.

We're walking beside the canal now but, before we know it, there are two railway bridges. The first is the London and North West Railway to Acton, and then there's the South Western Railway to Richmond. Normally, I wouldn't even have registered that they are railway bridges. We exit at Oak Lane because there are railway cottages up the road; however, I know Ian is going to be interested in the derelict tower block over the road that I first saw with Alexei.

Broken glass, gas cylinders, plastic bags, every imaginable bit of rubbish has gathered like a polluted sea around it. 'Blot on the landscape' totally underestimates the extent of this eyesore. An office block, it has been attacked by urban marauders. Burnt, broken, covered in graffiti – it is nevertheless somehow amazing.

When something or someone is broken open, there is always the opportunity for beauty. It's hideous, dystopian and falling apart but there's something gloriously wonderful about it. Like Detroit now. Like the Road. Like me when I was breaking up with the father of my son. The decay almost radiates in its slow dying.

On the other side of the road, there's a seventies concrete building that Ian thinks – wrongly this time – used to be a pub. In fact, it's Willesden Junction Maintenance Depot. Ah ha, more railway stuff. We peek around the corners, find an overgrown garden – the out of control limbs of honeysuckle, sedum and traveller's joy tangle together – beside the Richmond line. The lights are on, but I can't get them to answer the door. I was going to ask them about the derelict building over the road.

Even Ian doesn't have an answer, and even more surprisingly, no inspired guesses. Huge concrete blocks have been dropped at the entrance. 'To stop gypsies moving their vehicles in,' says Ian. We spot a canal-viewing ledge where evidently itinerant drinkers – there's quite a few of them who frequent the canal – repose on a regular basis, although not today. There's a brown velveteen sofa and a wooden crate, presumably where they put the TV.

Oak Lane railway cottages have become quite gentrified, with window boxes and sometimes BMWs. However, Ian is more interested in the bricks. 'They would have housed

workers in the nineteenth century or been lodgings for travelling engine men,' he announces, the pace of his words quickening again, 'but what's fascinating are all the different sorts of brick that they are made out of. London brick over there is yellow and stains really easily, but these ones are from Staffordshire and much smoother and redder. These cottages are made from so many different types of brick, I think the railway could have been using them as part of an exhibition which would demonstrate how many places their trains visited.'

I have a feeling Ian is off again into inspired guess territory. He has been a very entertaining, not to mention informative, railway host. And I have to admit my feelings about Willesden Junction station have changed. I'm actually feeling inspired by everything that I didn't know.

The Philosopher

I can't write about this walk without mentioning my mother. I arrive to meet philosopher Robert Rowland Smith – whose book *Breakfast With Socrates* came out recently and emphasises that philosophy should be wise and about life, as opposed to clever and purely abstract – in a state of upset. My eighty-three-year-old mother, Nancy[1] – a small, feisty Yorkshire woman who lost my dad over twenty-five years ago and has been a whirlwind of independence, cruising, dancing, golfing and gardening ever since – has just spent the night in hospital. She's not ill in a big way. She had cancer of the colon when she was fifty-four and survived that with typical brio. But she's ill in an alone-in-the-world way. Suddenly, everything has got too much for her. I've just spoken to her and she sounds fragile, vulnerable and lonely.

It feels terrible even going on this walk. I feel how she feels. And the strange thing is, I had a terrible relationship with mum for years, for all sorts of reasons. I couldn't stand her. Or my father. But over the last fifteen years, a gradual healing – she helped me out with money after I split up with my long term partner, we've been on lots of little English adventures together to Northumberland, to

the Lake District, to Dorset and more – has taken place. She trusts me and says so. I still find it hard to believe. I was always 'the teenager who used the house like a hotel', even twenty years later. However, whereas once I would have had huge difficulty imagining the possibility, now I can say clearly that I love her. In many ways, we occupy such different lands – I'm an extrovert, she's an introvert, I'm in the inner city, she's in the countryside, I read voraciously, she reads to get to sleep, I'm ever-curious, she's happy not to know – but the love of landscape we now share.

And so I arrive in a state of stirred anxiety, like a puffin that is just about to fly across the North Sea and discovers one of her wings has been damaged. Initially, I don't realise that Robert – who has a boyish way about him, despite being a father to a twenty-two-year-old daughter, as well as a nineteen-year-old and a four-year-old – hasn't arrived on the train. We meet at the top of the steps at Willesden Junction but, later, it transpires he got a taxi because he is afraid he will have a panic attack if he goes on the Tube. That's too claustrophobic for him.

Despite his forever-young air, Robert is an expert self-confessed pontificator. Will he be wise or just clever, I wonder? He looks down the long, long walkway with the chilling wire fences. 'Look, it's like the narrow channel between life and death,' he says, 'it must be like walking through the Valley of the Shadow of Death at night. In fact, like taking your life in your hands. It must be at least 200 yards, which means you have a long time to be scared.'

Ah, thanks Robert, great start. And he's scathing about the view. 'I actually like the view over Willesden Junction,' I counter, 'it's bleak but somehow magnificent. There's something about wide industrial landscapes, the odd ugly beauty.'

'Well, I know what you mean,' he replies. 'Plato said the ideal was from afar, and I love the cooling towers[2] at Didcot Power Station from afar, whereas up close, they are horrible. There is a type of poetry to that difference.'

One of my ideas for this walk is to look at buildings afresh and see how their usage has changed over the years or even months. It sounds drier than I hope it is. For instance, I've noticed that the former club, The Lodge – a funky, unusually white-boy-cum-middle-age, post-Ibiza nightclub where house music was the thing, as well as groovy, local bands like The Trojans who play energised punk ska and are led by the alternatively royal, befeathered boho, Gaz Mayall – which has been boarded up for a couple of years, has re-opened its doors. I've been observing what I assume are Somali men leaving its premises and have started to wonder if it's become a mosque. Which sounds ridiculous, but you never know. Remember that period in the early nineties when public toilets turned into snooker clubs (Shepherds Bush) and architects' offices (Fulham). This could be the early twenty-first-century equivalent – house clubs become mosques.

Robert and I hang about until Mohammed, a charming young Somali who is running a newly opened[3] lettings agency next door called – wait for it – Cosy Way, helps me out. 'It is a leisure and social club now for men and teenage boys,' he says with a winning grin. 'It's not just for Somalis, but a lot of them do go there. There are snooker tables down there and a big screen.'

We look across the road, and there is a huge restaurant asserting itself in a way that you can't miss. It's Iranian and always empty. Although that doesn't seem to prevent the owners putting showy, garishly beflowered window

boxes outside. It reminds me of the infamous Cleopatra's in Notting Hill. A huge Greek restaurant, it was always empty. Mysteriously so. There were rumours about money laundering, and eventually it became the uber-trendy but short-lived Pharmacy, a restaurant that housed Damian Hirst's medical pieces but was ultimately so empty-hearted it drove people away.

Robert casually drops into the conversation that his twenty-two-year-old daughter is just applying for a diplomatic job in Tehran. I erupt in surprise. Apparently, she's already in charge of nuclear non-proliferation at the Foreign Office. At twenty-two! 'Well, you or I would be frightened of the job,' he laughs, 'but a twenty-two-year-old just takes it in her stride.'

We're just passing the Open Door Ministries of Prophecy church at the top of Tubbs Road and I'm telling Robert about my walk with the ex-gas meter reader and poet Sue Saunders. 'Did you know that the word gas comes from the same German root as *gast*, which means "host",' says my walking/talking philosopher, 'and that gist and ghost are both related? So zeitgeist is the gist of the age and it's no wonder that philosophers spout a lot of hot air or gas.'

I'm not sure how we launched into the next tangential topic, but it seemed apposite at the time. I think I was explaining that the Job Centre Plus site used to house the Edwardian Willesden Hippodrome when Robert made an analogy with Sydenham and suburbs on hills and good health back in the early 1900s, before telling me a story about friends of his being held up at knifepoint in LA. 'They both had completely different recollections about who their muggers were. One thought they were white, the other Mexican,' he says. 'I'm writing a book at the moment about

how we frame things differently as individuals and what governs our way of seeing, and ultimately what is truth.'

Ken Livingstone is mentioned. Not in the truth discussion, but casually as we walk up the road. Robert is a management consultant specialising in change as well as a philosopher, and worked from time to time advising the New Labour government. We both admit to being former Ken fans, but agree that he was suffering badly from blind complacency at the end of his term as mayor and we can't see him winning again in 2012. 'There was a fatigue about him,' says Robert, 'and I think he's had his time.'

The next moment, we're outside that Christian bookshop, The Rock, staring incredulously at weirdly inappropriate unChristian tomes like *Getting Rich Your Own Way* and *Prayer Passport To Crush Oppression*. Does he have any spiritual beliefs, I wonder? 'In my twenties, Buddhism had a certain appeal,' he says, 'because it wasn't a religion. I suffer from panic attacks and I was searching for something. I started meditating and began to change and become calmer. The trouble was I felt myself losing desire and longing and I questioned what was happening. It seemed to me that Buddhism was trying to eradicate the screwed-up bits of being human and I decided I didn't want to exclude those parts of myself. I've been in psychoanalysis and discovered the roots of my panic attacks, and now I also teach Family Constellations work which is a sort of dynamic therapy.'

I am definitely all for befriending and integrating the shadow side of our characters, rather than relegating them to a sinful position as most religions do. In fact, I confess that I am just about to help organise a ten-day camp called The Field of Love on an organic farm in Suffolk, where there is an ethos that embraces exactly this idea, as well as freeing the body into

dance and bliss. Oh, how can I even say that on a walk in Harlesden. Okay, okay – I am the hippie of Harlesden.

We wander into a shop crammed full of scents, oils, materials and long black dresses. And washing powder and matches. I've never been in here before. A woman in a black veil and dress stares at me fiercely, as if to say 'How dare you come in here. I know you're not going to buy anything'. I ask her hoping that I sound friendly where she's from originally and she says 'East Africa'. Somalia, I think. There does seem to be a significant Somali presence in this run of shops right here next to the Jam Down Bakery on the High Street.

'Where are you from?' she counters.

'Yorkshire originally,' I say. One of the twenty-something girls with her pipes up that she used to live in Hull. Which is fittingly surprising. There's a Yorkshire connection. I'm amazed in general by my Yorkshire connections in London. Doe, one of my close friends, who lives round the corner, happens to have a sister who lives in the same village as my mother, which is where I grew up. Jake (AKA Jacqueline), who I met at a Tantra Festival in Catalonia, has parents who live 3 miles from my mother. And there are more. It's as though I'm reassembling my Yorkshire roots around me in London.

On the spur of the moment, I decide to see if Our Lady Of Willesden, the Catholic church with the other Black Madonna is open. It is. A 1930s building, inside, it's an excitingly jarring mixture of a favourite elderly auntie's flat and a Las Vegas casino.

'I rather like it, because I've got soft spot for the 1930s and the optimism of that era of industrial expansion,' says Robert, 'I like the flatness of the surfaces.'

I look up at the Art Deco organ and, frankly, it looks like a beige box. 'I like the simplicity of the lines,' he waxes,

'there's a formal elegance to it.'

And the altar, which is much newer, has huge pillars and the nouveau grandeur of a casino that needs to succeed. It's gaudy in a way that could be kitsch. In a good way. But it isn't; it's too downright ordinary. Robert disagrees. He's still going on about simplicity. I'm not convinced.

However, the piece de resistance is the annex where the nineteenthcentury Black Madonna is housed. In high camp extravaganza style, it is surrounded by fluffy clouds and cherubs painted on to the wall in blues, whites and pinks. Whereas the main church is Las Vegas, this fresco here is more Harlesden pound shop. It is a little strange, as if David La Chapelle is about to do a photo shoot. But the actual Madonna herself is beautiful, finely carved and full of grace with a sparkling tiara. Strangely enough, this black Madonna would go much more fittingly with the interior of St Mary's, and was in fact originally carved from an old oak tree in St Mary's graveyard.

There is another artistic triumph in this annex. The stained glass window at the other end showing a contemporary version of the Sermon on the Mount. 'I love the man waiting with his toolbox,' says Robert. 'He looks Portuguese – it's perfect. Like a Phillip Pullman book.'

Back on the High Street, I point out the famous Irish Meat Market[4] where my carnivorous friends fulfil their desires. 'It could do with a new name,' asserts Robert, in jokey marketing mode. 'You know, I could become the Gok Wan of Harlesden.'

What, do you mean as in Harlesden looks good naked? Well, it's already pretty naked.

Clever, yes, he's definitely clever but wise is in there somewhere too.

Reggae, Reggae, Reggae

Mr Locksley Gichie is a man with an extremely firm handshake, an air of modesty and a hat full of locks. In Harlesden – as Gerry from Hawkeye Records says – 'everyone knows Locksley.' Everyone, that is, of a certain age who knows about reggae.

That's because Locksley was the guitarist in the Cimarons – they got together in 1967 because they all went to the youth club at the Methodist Church in Tavistock Road – who became Britain's first home-grown reggae band. As well as backing musicians for everyone from Bob Marley to John Nash and Ken Booth to Toots and the Maytals.

'I came over from Jamaica in 1962 when I was twelve,' he says. 'My mum came over three years earlier and got work in a factory. My dad, who was a printer, came over for six months then went back. Two of us were with mum, the other two kids stayed in Montego Bay. This was when the UK was doing big promotions over there to get workers. At that time, it was easy to get a job in Harlesden. You could leave one factory if they weren't treating you right, then get work in another one the next day.'

In the seventies, NW10 was heaving with bits of the reggae business. Trojan Records – the biggest indie label

that Chris Blackwell co-ran, until he went off to form Island Records – was in Neasden where Willesden County Court is; Palmer Records was in Craven Park Road and was a record shop and a label, Jet Star records, and there were lots more. Hawkeye, of course, is still there and has the wonderfully opinionated Gerry behind the counter.

I wonder what they sell these days? Is it newer stuff by younger artists? 'We sell reggae from Jamaica and the UK,' says Gerry, 'but also R 'n' B, Soca, Mento and some surprising CDs. Like Jim Reeves' *Christmas Songbook* because old folks used to hear his songs at Christmas and they want to hear them. And Fats Waller's 'Write Myself A Letter', but we've got CDs from newer rappers like Gappy Ranks too. He used to come into the shop when he was a young boy; he tormented us, and now look at him. But we also have had a staple diet of artists like Dennis Brown and Prince Buster.'

And then he has a little rant. Something that is not unusual, by all accounts. About computerised music and modern musicians who take old tracks, feed them through computers and pretend they're making new music. 'There's a track by Damian Marley called "Welcome To Jamaica" and it's a version of a Sly and Robbie-produced track called "Reggae World" by Ini Kamosa. You lose all the feeling when you lose the instruments,' he says, with his own vocals at full volume.

At this point, a gentleman wearing a fetching red, gold and green shirt with pictures of the Emperor Haile Selassie on it wanders in, to much acclaim. Turns out it's Vivian Jones, the lovers' rock singer. 'Sugar Loaf, Sugar Loaf,' says Locksley trying to remind me of Mr Jones' most well known number.

But Gerry is already on to Bridge Park Leisure Centre – his voice rising again – where Hawkeye promote monthly music evenings. 'We get seventy-year-olds coming out for a bit of

music; they haven't got anywhere else that provides this,' he says, 'and it was supposed to be for the community, but now they're charging higher and higher prices. Trying to push us out. It's somewhere where the older members of the community can enjoy themselves away from the younger ones.'

And the monthly Apollo night – in Willesden, on the first Sunday of the month – which has been going for thirty years. 'It's run by Geoffrey Palmer, one of the three Palmer brothers who used to run Jet Star records in the seventies,' says Gerry, before putting on an old Mento & R 'n' B CD, which is on Trojan records. 'Mento precedes calypso, then there was ska and reggae, but lots of those singers looked to the old R 'n' B singers like Otis Redding.'

Somehow Bob Marley comes into the conversation. Gerry erupts. 'Reggae had so many people before him. He's not the only reggae artist. Look, look, I'll show you a picture where he had no locks and no spliff and play you some of the tracks before they became commercialised, when they were still roots.' And out comes the original 'Trench Town' with all the huge bass intact.

Gerry is on a roll. Out come more records he rates. 'Black Heart Music' by Bunny Wailer is one. Meanwhile Locksley is telling me about his time backing Bob. 'It was 1974 before he'd got a deal with Island,' he says, 'Bob was a joyful person but he made us understand that we couldn't mess around. When he got his deal he wanted our rhythm section to tour the US with him. But we loved the Cimarons and wanted to stay in the band. We were the foundation in the UK for reggae; other bands like Aswad were inspired by us.' Oh, and turns out Locksley used to rehearse with Bob in his house up the road in Neasden.

And then there is a local revelation for me. The guy

– white long locks, kindly face, runs JJ's Wine Bar and the Jerk Chicken shop over the road – I met a couple of years ago with Dawn Butler, when she was our MP, turns out to be a reggae star who was called King Sounds and used to play with Ken Booth. Well, well, well.

As we're walking down Craven Park Road and Locksley is telling me the story of the Cimarons. 'In the seventies, we played the 31 Club, which was in a basement on the hill at Stonebridge. Later it became the Apollo. There was also Burtons on Cricklewood Broadway, where all the best sound systems used to meet up and all the latest music from Jamaica was played, so that's where we were inspired,' he explains. I ask him about the shebeens in those days. 'On a Saturday night we'd all get dressed up and wander around until we found a party in someone's house. I remember the first carnival in the early seventies when it all started building up on a Thursday night.'

Locksley is a self-taught guitarist. Delroy Wilson, Arton Ellis, Ken Booth, the Heptones – they were all were formative for him.

I wonder if he's ever looked at his genealogy? 'My grandmother was a maroon which means she came from free slaves, those that broke away from the boats and lived freely, while my grandfather was from Puerto Rico and had freckles just like you. He was a boat-maker, he made yachts. Jamaica gets its strong energy from all those free slaves whose spirits remained unbroken.'

Locksley points out a shop where they used to buy their suits. 'It was called Marcus' and we used to get red, brown and yellow mohair suits for wearing on stage. They were great.' They used to get their equipment just down the road too, as well as swordfish and ackee from the famous Mister

Patty.

'On Mondays, all the musicians used to meet up at the Palmer's shop (now a shop called Hair Control) because they were also booking agents and we all got paid. In those days, I was getting £9 an hour, which was a lot. I was doing sessions for other people. I was young so I squandered it on clothes and clubs.'

The Cimarons had some momentous times. In 1969, they were the first reggae band to go to Africa. 'We went to Nigeria and Ghana,' he says. 'They went crazy for us. I couldn't believe it. I didn't think it would explode in that way. We were so successful, all the artists like Jimmy Cliff who came over from Jamaica wanted us as their backing band. Jimmy Cliff taught us how to be disciplined. He used to say, "We can be friends again after 5" – in other words, when the work is done. From Toots and the Maytals, we learnt spirituality; they were on a spiritual high when they sang.'

As we pass Odeon Court, Locksley tells me that the band used to go and see Westerns there when it was a cinema. 'Robert Mitchum was a favourite, and Lee Van Cleef,' he says.

The mention of 'high' makes me think of 'ganga', so I ask that question. 'We didn't start smoking until about 1974 when we were recording all day and night. It kept us awake and really helped the music flow so sweet and got us so creative. But it was proper weed, not rubbish. Sometimes I'd do a guitar solo and wonder how I'd done it. At that time, we'd smoke in the street and the police wouldn't understand what we were doing. It wasn't banned at that time.'

They were on *Top Of The Pops* supporting Ken Booth, they played Belfast when no one else would, they were the first reggae band to play Japan, a private plane was hired to fly them to do a gig in Cork one day when they had a night

gig in Manchester and they managed both. Paris loved them. They were number one in Jamaica with a cover version of 'Talking Blues by Bob'. But it was all over by 1977.

'Reggae was so big and then the music industry pulled the plugs on us. We couldn't get radio play. Thatcher came in and closed down the venues like Top Rank where we played. Trojan Records went bust. I carried on being a session musician and we re-formed the band a few times,' he explains.

But there is news. The Cimarons are coming back in their original format – most of them live still around Harlesden. 'Through the internet, we've discovered that we're actually still popular in Europe, so we're setting up a tour,' he says, with such an optimistic tone.

Locksley and I.

Mother's Day with the Salvation Army

Everything I knew about the Salvation Army could be summed up as fire and brimstone speeches involving multiple mentions of damnation, novelist Jeanette Winterson's strange upbringing, lots of brass instruments and my friend Caralinda Booth, now an A&R woman in Bejing but also the great great granddaughter of William Booth, its founder (in 1865, I read later). They are also evangelical Christians. There is a large building in Manor Road that proclaims 'Salvation Army' from the outside in big, bold letters, with a brown and white cross to back it up. I'd been meaning to get in touch with them. Somehow, I'd imagined a shabby interior with heaps of second hand clothes ready for the homeless.

So I was happy to discover a huge, fairly freshly painted hall/place of worship – in fact, it's been there since 1903, when there were well over 100 Harlesden residents at services with a full band on the stage – a very modern screen showing a baby for Mother's Day and a mixed congregation of about twenty people. Mind you, the original crest declaring, more lustily, 'Blood and Fire' is still there. And copies of their old-time newspaper, *War Cry*, are also available.

'Where are the officers?' pipes up one evidently regular member. A ripple of laughter wings its way around the attendees. And territorial envoys – yes, a fascinating title, which makes them sound like they have arrived temporarily from an alien planet, and maybe they have – Mark and Julia Cozens appear. To cheers. Another shock is their lack of uniform, or I should say the casualness of their apparent uniform. They are attired in dress down black trousers, navy blue sports shirts with an up-to-date-ish red shield Salvation Army logo and black shoes; their navy fleeces are on the backs of their chairs. They look as though they are about to facilitate a social workers' meeting. Which turns out to be an apt impression.

There are more formal uniforms – navy, lots of badges, with mini bowler hats – but they are in the congregation. 'Soldiers' – who, I find out later, are members who commit to the SA core belief system, including no alcohol, no smoking and no gambling – are allowed to buy themselves uniforms. The flags, the colours, the uniforms, the ethos – they all remind me of the girl guides. Yes, there's definitely the same do-gooder spirit.

Julia takes to the lo-fi pulpit (there are several kerfuffles around sharing a mini-mic), which really is in the midst of the people. There is the Mother's Day introduction, and then Mark on the piano. Absolutely no pomp and ceremony, not to mention sacraments. This is very much employing the love of God as a community reassurance and inspiration. I'm an atheist but I can appreciate these sentiments.

Psalm 139 – thanks to the mothers, and those who act as mothers, for instance, foster mothers – then Mark encourages everyone to dance as they sing. There's clapping and swaying and giggles. And lovely inclusivity. Jasmin is invited to read a poem she found on the internet about mothers, there's a history of Mother's Day (apparently it goes back to

the days of Isis worship, but Christians appropriated it for the fourth Sunday of Lenten and by the 1600s it was a day when servants and tradespeople could visit their families) and a lot of little jokes.

Natasha, a British Asian woman, has her husband and her baby son Adam with her. It's his first birthday today. We sing 'Happy Birthday'. Where else do you have birthday singing in the middle of a service? Natasha tells us how she was a successful career woman who never even considered having a child. And now, she prefers to stay at home with him rather than go out to work. There are wild whoops.

However, my astonishment rises to its zenith at the next section. Mark actually introduces a Mother and Daughter Quiz using the screen on the wall. I'm thrown into a publand state of altered reality. Princess Grace of Monaco and Stephanie, Judy Garland and Lizzie Minelli and many more are all part of this challenge. All I can say is, thank goodness I am here. Because no one else recognises Pixie Geldof. Frankly, we could be in the Misty Moon next door and I think that's the point.

We're even invited to talk about our own mothers. As you can tell, I'm being swept along on this amiable wave of participation. And I find myself describing a fish 'n' chip meal my mother and I shared recently up in the market town of Otley (we were both born there). The haddock was so fresh, the batter so light – it's a Yorkshire thing. We were both so content.

A young woman – she must be in her twenties – called Fui stands up to talk about her mother. She's from New Zealand (like many here, her family are all Salvation Army members) and her roots are Samoan. 'I have an extraordinary mum,' she says, softly but proudly. 'She's very giving, and she also worked her way up from being a cleaner to being the vice

president of the most successful cleaning company in New Zealand. I find her inspiring.'

A daffodil moment follows. 'If you are here with your mum,' says Julia, 'take a bunch of daffodils and give them to her, and give her a kiss too.' These territorial envoys have been out shopping for mother's delight.

'There's one son being very quiet,' mentions Mark, and he's talking about their seventeen-year-old son Luke, who is himself a 'soldier' based at the Regent Street Salvation Army. He's sneaked out, but comes back and makes his way forward to hug his mum.

Informality with a capital 'I'. That's what impresses me most about this service. I'd imagined something musty with a large helping of 'you will die in hell if you step on a crack in the pavement', and what I found is so much more compassionate and friendly.

There is a moment of prayer led by Mark. He asks us to think about our mothers, those who have cared for us, and extends his invitation to all of those who love and care for children, including doctors and nurses, and gives us the opportunity to say 'thank you'. I find it useful to have a little time to reflect in this way.

He reads from the Old Testament, and there's a 'is that a new bible, you've got?' comment from the floor. It's Carol, she is a regular who is a bit of a joker. I love these interruptions and the way they are so naturally threaded into the more reverent. This bit of the bible talks about treating others as though they are your family. Mark quotes a sticker – this is making-the-Old-Testament-relevant time – he saw on a bus. 'Treat cyclists as if they are your granny.' Exactly; that's Mark's view too. He wants us to know that there would be no trouble in the world if that simple message

were adhered to. He's not afraid to mention the difficulties involved either. 'It's not always easy to love our family,' he says, 'but ask God and he will give us the compassion we need. When you meet someone, whether a shop keeper or a bank assistant, treat them as a family member and see what a difference it makes.' We end on a song – 'Let there be love shared around us'.

I find myself smiling despite the potential dreaded sentimentality, and asking eighty-year-old Joyce (okay, I have to admit the majority of the congregation are over fifty) what had made her decide to attend the Salvation Army services. 'My family is Methodist,' she says, 'and this was the nearest thing I could find. I would describe it as very comfortable as a place of worship. I come to their luncheon club as well.'

The Salvation Army is the polar opposite to high church. It started up to help the alcoholics and homeless in Bethnal Green and their key words were soup, soap and salvation. They don't do the sacraments like baptism and holy communion; they focus on the message rather than the rituals of Christianity.

Tea and cakes follow. Someone even saves me a piece of Adam's first birthday cake. People chat. I ask sixty-something Jean, who is a soldier, how she got involved. 'I was brought up in Paddington,' she says, 'and the Salvation Army ran the nearest Sunday school. It was the Good Will section and there were a lot of slums in that area at that time. I started helping out and have carried on. I also play the cornet.'

Ah yes, the cornets. Back to them in a moment. Jean starts talking to me about the symbols in the SA flag. 'The blue is for the purity of God, the yellow is for the Holy Spirit and the red is the blood of Christ,' says Jean quietly. 'That's almost the same as the Jamaican flag,' counters Leroy – yes, that Leroy, who also works on projects with the SA. 'Black

is for our skin, gold is for the riches to be found there, and red is for the blood spilled by our people and green is for the lushness of the landscape.'

Mark very kindly gives me a sepia photo of the Harlesden Salvation Band in 1937 – fifty-five of them with the mayor and their trumpets, trombones, cornets etc. – and leads me to a back room, where there is a lot of brass 'umpahing' going on. Not to mention squeaks and groans. It's cornet practice, taken by David, whose family has also been in the Salvation Army for years. 'At the turn of the century, it would have been all the local business people who were members here,' he says.

'Julia and I like to make everyone in the service feel at home. For us, the content is all about what we call the Kingdom lifestyle,' says Mark. 'We want to talk about God's kingdom as if it is in our daily life. It's all about our relationships with each other. That's why I mentioned treating everyone as if they were a member of our family, and related it to the cyclist and granny poster.'

What does evangelical Christianity really mean, I wonder? Evangelical comes from Greek which translates as bringing good news. I'd always thought it meant that they are ardent proselytisers, in other words, their propensity to stand on street corners proclaiming that we would all go to hell if we did not repent and join them. But my impression is out-of-date, if this service is anything to go by. 'Living out the core beliefs and sharing them by example,' says Mark as his explanation of the modern ethos. He also mentions that this approach is post-modern in that the realists in the Salvation Army have to take on board the dwindling congregations and develop new ways of telling their story.

Ah ha. It seems these particular territorial envoys are not from alien planet after all.

The Sex Tour (a Walk with a Tantric Goddess)

Not enough sex on these walks, I decided. I'll have to invite the leonine and totally outrageous Kavida Rei along. Kavida – who organises monthly sensual soirees in Convent Garden and has written books on tantric massage and sex – describes herself on her website as a Tantric Goddess. Are you getting the picture? She's a force of nature. Her latest blog features her own long-sought-after, and recently achieved, ejaculation.

The day before we met, I sent her an email asking her to dress discreetly because we were going to visit a religious establishment. I didn't want to reveal where we were going. 'Be direct, darling,' she replied, 'do you mean I have to wear underwear?'

'I don't care about your underwear,' I shot back, 'but no shorts, probably a below-the-knee skirt and bring a wrap-around.'

'I'm getting my Amish look together,' she countered.

And so I'm waiting for her one sunny Wednesday afternoon at the top of the steps at the Harrow Road end of Willesden Junction, one of my regular locations. Before I get to hum 'You're so sexy', there she is – sunglasses, muted

colours, mad hair, big smile. But hold on. Whoops, up goes the skirt, and the naughty Ms Rei is posing at the bottom of the steps demonstrating her lack of knicker-wearing! Willesden Junction may not recover. Sadly, there are neither train-spotters nor railway enthusiasts around to share this unusual moment.

Our Tantric – it really (as opposed to the reductive media Sting version) is a Hindu philosophy, which says you can find sensual and spiritual bliss in everything from breathing to dancing to putting out the rubbish – Goddess is from rural Hertfordshire and Harlesden is a bit of a shock to her system. 'I don't recognise this produce,' she says as we pass bowls of okra outside one of the many High Street butchers and grocers combined.

Her own neighbours, she insists, are completely au fait and comfortable with her activities. In other words, one week she is collecting one of her sons from school (he is sixteen; the other is twenty and studying History of Art) in appropriately low-key school-run clothes and the next week, when her son is with his father, she might be going out with her new partner sporting full-on PVC fetish wear.

'Oh, the hair shops are fantastic,' she shrieks as we peer into one of the amazing emporiums of hair. 'I needed one of those when I dressed up as Cher recently.'

I know Kavida will love my favourite shop – as you know by now – Wrights. 'That's so cheap,' exclaims Kavida, pointing at a black basque with red ribbons. 'In Coco de Mer, it would have cost a fortune.' I point out the Nueva Donna nurse's outfit, but she says her partner Roland would go for the policewoman's costume. Especially the handcuffs. They're both into the dark side of tantra as well as the light. 'We love BDSM (Bondage, Discipline, Sado-Masochism,

made well-known by the popularity of *Fifty Shades of Grey*),' she smiles proudly. 'We often sort out our differences by doing some sub and dom role play. It's about surrender. The more you can receive, the more you can let go. There's no space for the mind to sabotage you and so you really can reach an altered state. I'm very passionate about it because it is very healing for both men and women. But we also like the theatricality of dressing up. We had fun shopping at Sh!, the sex shop for women; they've got a great dressing room which is quite private downstairs and Roland would test out the outfits with me. I bought a great waitress' uniform with apron and cap. Ro has got a doctor's coat and stethoscope. They all add to the fun.'

One of Kavida's many activities is offering sex therapy and tantric healing. As I stand outside Wright's startling display, I wonder how she feels about tantric massages being offered in such a prolific way everywhere? If you look in the back of *Time Out*, every masseuse is selling supposedly tantric massage experiences. Does she get pissed off? 'Oh yes,' she snorts more like a horse than a lioness at this point, 'they all think wafting a few rose petals around and a feather is giving a tantric massage. It's ridiculous. That couldn't be further from the truth. A healing tantric massage is really about creating an intimate space and allowing vulnerability. The tears are the healing, as well as the orgasm.'

At this very moment, Lloyd (not his real name because he's married), the muscle-bound and very sexy forty-something that goes to my local gym who's wont to turn up on my doorstep occasionally expecting a sexual greeting – saunters by. He hasn't had one so far. But what synchronicity that he should appear in the middle of Harlesden High Street just as the conversation is turning to sexual healing. All in red,

he looks great. I wave. He won't have a clue what we're discussing, which is probably quite fortunate.

Inside the shop, Kavida makes a beeline for the tights. I find myself talking to Sonia Uttam, who came over from Kenya – her family is originally from eastern India – thirty-five years ago. She's a gorgeous sixty-something. 'The Irish used to buy so much from us,' she says, confirming my previous theory about this being a quintessentially Irish shop. 'But the Somalis and Afghans don't buy so much. The Polish do though. And the Portuguese and Jamaicans.'

Meanwhile Kavida is striding over to Ben Uttam – who came originally from Mumbai – and asking him if he tells his wife she is beautiful. 'I tell her that marrying her was the best decision I ever made,' he says. There's a communal 'ah' from us two at the longevity of their love. At which Sonia strolls over and insists that they have a photo taken together. Kavida is still not quite satisfied. 'I hope you're still enjoying yourselves sexually,' she interjects cheekily. Ben is still unfazed.

'I still get excited when I see her bare thighs,' he says ever so sweetly. Tantric Goddess and I have tears in our eyes at this moment. We have found that rare jewel of lasting, sexy love in the lingerie shop.

Tantric Goddess is unstoppable in her shopping. 'Because normally I don't wear underwear, I have to buy a thong,' she explains. 'Roland gets excited when I do.' As we leave, Ben rushes up to Kavida with a present for being such a good customer. It's a pair of pink furry handcuffs. He doesn't realise what a perfect present this is.

Spotting The Shawl across the road, Kavida suggests we share a Guinness. To a pub at 3 p.m. Both of us profess we hardly ever go to pubs these days. This one is half-

The lovely Uttams from Wrights.

full of Irish gentlemen nursing pints. She's just telling me proudly about her twenty-year-old-son being in New York at the moment as a DJ, when the Guinness brings on a sex memory, in typical Kavida style.

'I had sex with this bloke in a synagogue in New Orleans,' she says, 'in front of the Torah ark, which is considered the most holy place. I consider sex to be the holiest of holy activities, so for me, it was entirely appropriate.' Kavida is Jewish and obviously has a history of fruity rebellion. 'There was a time when I loved having sex in churches,' she

giggles. 'I loved pulpits. In fact, if boyfriends wouldn't shag in a church, they were out.'

I've got another surprise in store for her. I can tell she's thinking, where on earth are we going? But she's being bubbly to cover any such preoccupations. The route – Craven Park Road, then right before Hillside down Brentfield Road – is urban bleak. So I ask her how she's changed since she's been – eighteen months – with Roland, to distract her from the concrete. 'I'm much more feminine,' she says, 'because he is so masculine in his energy. He is very sensitive but he still takes charge in that male way. That has meant I can be softer.'

Eventually, I'm able to stop her talking for a second and direct her attention to the left. There it is – the magnificent Neasden Hindu Temple. It really is an overwhelming sight. So unexpectedly decorative in this relentlessly industrial landscape. Kavida is ecstatic. She hadn't guessed that this was the religious establishment that we were visiting. 'It's the perfect heart-centred place to take a Tantric Goddess to,' she exclaims.

We're lucky, we've arrived at one of the prayer times when the sacred shrines are open. Ironically, it's me who is handed pieces of material to cover my legs and arms. We're directed inside once we've removed our shoes. The craftsmanship – 2,820 tons of Bulgarian limestone and 2,000 tons of Italian Carrara marble were sent to India and carved into these ornate pinnacles by over 1,500 artisans and finished in 1995 – is spectacular. We're drawn to the voluptuous statues of dancing goddesses on the outside of the temple. They are flexing their barely clad bodies in all sorts of joyous, celebratory ways. They are incredibly sensual. 'So these goddesses are allowed to be this sexy and

undressed,' says Kavida, 'and we have to cover up. What's that all about? Look, they've even carved their nipples in. No doubt it's men who are scared of women's sexuality and ultimately their power, and so want them to hide their bodies away. It's not right. That's so non-tantra.'

We enter temple and a few Indian families are in prayer. One of the men lays prostrate on the floor. They touch the shrine and kiss the hand that touches it in a time-honoured fashion. We stare at Rama and Parvati – the heroic prince and princess from the Ramayana – who are fetchingly bedecked in pink and blue. There's an atmosphere of spiritual reverence but also a crazy sound of beating in the background.

'There isn't an S&M party going on behind the scenes,' says Kavida.

I burst out laughing but smother it with my hand. 'I think they are feather-dusting the deities,' I say.

As we walk away we tip our heads back and allow ourselves to be transported by the marble lotus flower ceilings. Then, Kavida tells me about a twenty-five-year-old British Asian man she knows. 'Often Indian families are so repressed when it comes to sexuality,' she says. 'He is a virgin and very shame-filled. But I got him to come to one of our sensual soirees and he ended up kissing someone. He felt ashamed at first, but came back and now has started getting rid of those layers of repression. I'm really happy for him.'

I decide to ask one of the information assistants why we have to cover up when the goddesses on the temple depict such an overt pleasure in their bodies. 'Because we are ordinary people,' he says, 'and they are not. They are on another planet so they can do what they want. They have attained that right, we have not.'

Ah yes, they are 'in heaven' so they can take their clothes off and act erotically. We mere mortals must wait until we die before we are allowed such unabashed pleasure. 'An enticement to death?' wonders Kavida.

In the temple shop – truly fabulous tat, from sparkly garlands to ayurvedic remedies – we hear a family discussing the stock. 'Why have they got an Eiffel Tower key ring here?' asks the young father. His wife cannot explain. Neither can we, but we can't help loving the idea of it anyway.

Kavida and I after visiting Neasden's Hindu Temple – Shri Swaninarayan Mandir.

WALK 20

A Militant Modernist
Visits Stonebridge

There has been architectural outrage in the broadsheets about Owen Hatherley. 'Excavate utopia from the ruins of modernism', 'provocateur nostalgic', 'fierce commentator', 'angry young man' have all been mentioned to describe this thirty-something political, cultural and primarily architectural critic whose books range from *The Militant Modernist* (2009) to *The New Bleak: a Journey Through Britain* (2013).

And so I thought he'd be a perfect invitee to look at the new state of Stonebridge. I actually wanted to take him to Church End as well, but other events overtook us.

As I wait at Harlesden tube station – an unusual event for me, Willesden Junction temporarily abandoned – I'm expecting a firebrand dandy to arrive. What strikes me initially about the floppy-haired Owen is how soft-spoken he is. And delicate. He has the air of a turn-of-the-nineteenth-century aesthete. Hearing him reminds me of the shock I felt when I first heard Julie Burchill on the radio. She – punk warrior of NME in the seventies – has a squeaky voice. Owen is a quiet man in person, and a loud man on the page.

But he's come from Woolwich, which I can't help but admire. 'It's quicker to get to Manchester than to Harlesden,'

he smiles, with a hint of that vim and wit. It turns out that Owen does have a connection with this part of the world; his father was born in Perivale and his grandfather worked at a car factory in Park Royal.

It's Owen's first time in Harlesden and, in a small way, he's thrilled to be here. I know that Owen tends – his parents were activists and socialists – to take the line that contemporary public housing is like rabbit hutches and that in the critical siege on sixties and seventies tower blocks, the virtue – the space, the light, the fortitude – of that architecture has been dismissed. And he often writes about the need to re-find those values. So I'm anticipating his condemnation of what's been created here.

First of all, I inadvertently test him. I see a block of flats I take to have been built in the eighties. 'No, they were built in the seventies,' he says. 'You can tell by the weatherboarding at the front.'

We turn left into some of the low-rise new housing and I'm waxing about how it would seem to me that this kind of housing creates more of a community feeling than high-rises when we see the white block of flats that has red and black checks at the edges. 'This must be part of the mixed-income approach to public housing,' he says. 'Look at the size of some of those cars.'

Actually, Washbone House looks like something you might find in Marbella. It's got wavy balconies and the air of holiday flats. 'I think they could be CZWG,' says Owen knowingly. There's a big black Mercedes and a full on yellow sports car with 'knightracer.com' on the one of the windows and 'fast and furious' on the number plate. And it can't be drugs dealers because they apparently – sensibly – use rental cars these days.

So far, Owen thinks Stonebridge is like North West London's Lewisham but is startled by how huge this all is. We turn into an area with a version of the village green and playground. However, the green is pitifully unimaginative. It's flat and wide open with a children's park that looks space-age but hostile at the same time. 'The housing here is quite good,' he says. 'It almost mimicks sixties weatherboard, but the green is an example of design determinism. There's nowhere to shelter. Everyone can be seen. There's a square in Woolwich where they've got rid of all the mature trees for similar reasons.'

I'm immediately reminded of how much time, in my former village life, I spent playing in a field outside where no adults could see what we were doing. Building dens, lighting fires – they were all out of sight.

The idea that untetherable groups of young people are dominating the landscape seems to have dominated this design, to the detriment of the social environment.

At this point, I really want to speak to some of the locals who were here before the tower blocks came down, and are still here. I see an amiable-looking bloke on the corner so I ask him what he thinks of the changes here.

'The changes are nice,' he says; it turns out that he's an artist called, bizarrely, David Bailey. 'But the tower block flats were solid and bigger. These flats and houses are prettier but they're hollow. People had to throw out all their furniture when they moved, it wouldn't fit into the new places.'

His friend Steven adds: 'This housing were part of trying to get Gordon Brown in, but they are like those houses made out of wood in the Three Little Pigs.'

Then I ask them if this new housing has made a difference to the levels of violence. I feel a bit nervous about asking but they seem open.

'It's not that Stonebridge was ever Syria, it wasn't Iraq or Afghanistan,' exclaims Steven, making out that the shootings at the end of the nineties and beginning of the 2000s were over-hyped by the media. Which may be true, but shootings did happen at a high rate during those years and it did sound as though 'gangs' were able to rule the roost, in terms of policing and neighbours.

'What is a gang, anyway?' asks David, questioning my right to reduce groups of young men to this terminology. 'Five black guys hanging around on a corner is not a gang, they are guys who know each other, hanging out together. The point is there's still no employment, and still no hope for the young people here. But a lot of talent has come out of Stonebridge. Don't forget that. And don't reduce all black people to sports people and musicians, we want to have more opportunities than that.'

We're actually on Lawrence Street and this animated duo – David B gives me his phone number in case I need more information – are eager to point out the plaque to Stephen Lawrence, who happened to live on the sixties Progress Estate in Eltham that Owen rates design-wise. He's far from a totally sixties architectural man, but that one does apparently fulfill his politopia ideals.

And so far, David and Steven have backed up Owen's ideas about these contemporary housing projects. They might look better, but they are insubstantial and often badly built. And there's a Harrison Street nearby in praise of Audley.

What about K-Koke? 'He's a good man,' says David. 'He sings about his life here on Stonebridge. He knows life is about what you make it. The police just wanted him off the streets for a while. And he'd just signed to Roc Nation.'

Stonebridge has wastelands between the new builds. Presumably where tower blocks were. Now there's buddleia, thistles, dandelions. We're peering into one of these wastelands when a small fox appears in front of us. 'We probably woke him up,' says Owen, going a little gaga. 'I remember when it was quite a thing to see a fox in London but not now.'

'I've got a fox who lives in my garden,' I say. 'She sometimes comes right up to the house.'

We look to our left where there is some old-fashioned, landscaped public garden with mature plane trees. 'Look at how much more inviting that is,' he says, 'there are places to hide and to sit in the shade. It's not uniform.'

Now we're on Hillside and Owen wants to pop into the Hub to go to the loo. This is one of those residential, community and commercial enterprises. There are flats for sale on top, a medical centre below and apparently a mixture of Siberian larch-clad and modern concrete. As we enter, we're handed a leaflet announcing that it is part of the Open House London weekend. Apparently, 'it stands like a sculpted white headland as traffic swirls past but it welcomes rather than dominates'. Owen opines that it's 'okay' and disappears.

He's gone for such a long time that I think he must be reviewing a book on architecture for the *New Statesman*. Eventually, he emerges in a distracted state. We look across the road to the *de nos jours* blue curved building that reminds me of every city I go to, in terms of just built edifices. 'It's so Leeds,' I declare buoyantly. Owen agrees but is avidly texting.

I've been looking forward to showing him the next building, because he's made it clear in print that he doesn't approve of Will Alsop. Too child-like, pink and sparkling for an adult

world. And just down the road is Alsop's 2001 nursery in an enormous, red, yellow and green spangled inside-outside building. I visited it with my French 'urbaniste' friends, Francis and Isa, who pronounced it a triumph.

But the way, it's going – Owen has now disappeared with his mobile – I'm not sure we'll even get there. He re-appears in an agitated state. 'But I invited you,' he declares loudly, by far the loudest that I've heard him in the last hour. 'If you come to Stonebridge Park station, I can meet you.' More angst is transmitted. 'I've walked with you all over Western Europe,' he almost screams, and disappears again.

It turns out that this is his girlfriend. 'I'm really sorry,' he says, 'but I'm going to have to leave in about ten minutes.'

I'm disappointed. And tell him so. I feel like we've had half a walk. However, it was interesting while it lasted and I think he liked the new Stonebridge.

Not Donald the Duck

Before I met Don Letts – calls himself 'the Don', legendary punk film-maker, member of Mick Jones' post Clash, Big Audio Dynamite and DJ, he has a show called *Culture Clash* on the BBC's Radio 6 and is a noted big mouth – we had a few bantering email exchanges. I dared to call him Donald. I was winding him up. He sent me an email back titled 'Donald is a duck'. Apparently, he's a Donovan but 'the Don' will do.

So we find ourselves in the road where I live and he is insisting – goodness gracious, this man is more insistent than me and that's saying something – that Bramston Road is not Harlesden. 'Nah, nah, this isn't Harlesden,' he says, while admitting hilariously that he used his sat nav to get here. From Kensal Rise. Five minutes away. He is also emphatic that he's never been to Harlesden. Which isn't true. Of course. However, it's less untrue than I think.

According to Lloyd Bradley, renowned music journalist and old friend of 'the Don', in his book *Bass Culture: When Reggae Was King* – Don Letts 'used to operate his dad's system at The Roxy Theatre, a big Harlesden dancehall – where punk and reggae came together.'

But according to 'the Don', and I believe he believes it, there is a huge mix up between the Roxy, which was the Covent Garden punk venue in the mid-seventies, and the Roxy Theatre in Harlesden. However the Clash did play at the Roxy Theatre in 1978. But 'The Don' claims he only ever went to the one in Covent Garden.

And what about The Clash video 'Tommy Gun' which apparently Don filmed at the Harlesden Roxy in 1978? 'It's all lies,' he says with characteristic edge. 'I didn't even make that video.'

Ah, but I do think I have some concrete proof of his previous in Harlesden. What about 11 March 1977 at the Coliseum (now the Misty Moon and soon to be a newly named pub) when fabulously feisty female band, The Slits played their first gig in support of The Clash and 'the Don' filmed them on super 8, which eventually turned up as *The Punk Rock Movie*? He's a bit vague about it, but concedes that this is probably true. At last!

He starts telling me that he and his family – his second family, wife, Grace, and girls, Honour and Liberty, who are six and ten – are growing out of their flat in Kensal Rise and are thinking about moving over here. And that Louis Theroux was chatting to him in Queens Park about how good it is in Harlesden. Then, I spot All Eyes On Egypt – Park Parade's 'blackist' shop – and take him in there to have a look. One of the 'bredren', as 'the Don' likes to say, kind of recognises him. He knows he's something to do with music and then 'the Don' explains, whereupon there is much photographing and friending up, amid the murals of ancient Egyptian gods.

'The Don' is a man on the run. He doesn't like to hang around. Despite saying that the only exercise he does is at

the behest of the remote control and that he can't believe that I've got him out here on a two hour walk, he's got very speedy energy. Like a natty bee in his big trademark woolly hat and sunglasses.

Suddenly, he recognises the High Street. 'I've seen all of this in my rear mirror,' he asserts, 'the traffic is horrible. I can't move here with this traffic.'

I ask him about his Radio 6 show, *Culture Clash*. 'Yeah, the BBC let me do what I like,' he proclaims, 'I'm not just a two dimensional punk and reggae Don Letts. I can be all of myself and play what I like. I'm really happy with it.' Typically, a few seconds later, he declares, 'Not that I was ever treated as two dimensional.'

This is pure self-confessed Donism. He proclaims with one mouthful, and withdraws it with the next. Because the aim is to be provocative. His philosophy being, 'I'm a cunt, but interesting people are cunts.'

'When did nice people have good ideas?' he asks later.

I'd heard he was arrogant, but actually I like him. He's straightforward and full of himself, but aware of what he's doing. He likes playing the prankster, the mix-it-up person, the catalyst.

'I look more like London than a beefeater,' he says, 'but it wasn't like that in the seventies, then we Black British didn't know what to call ourselves.' He is very much an 'all tribes should be represented' kind of man.

The 2011 riots did hit this bit of the High Street – a jewellery shop was looted – but it was contained. I heard local elders came down and persuaded the young men to stop. 'Those riots were not good,' he declares, 'all I saw was young men seeing sneakers at the end of the street. I was in the Brixton riots in the eighties, and the Notting Hill

'The Don' at All Eyes On Egypt.

ones in the seventies – they had a point. I was disturbed by these ones.'

There was no political heart, you mean? 'There was a lack of humanity,' he says.

Has he ever bought his records up here? Like at Hawkeye? 'No, I used to get all my records at the Dub Vendor in Ladbroke Grove,' he says, and he used to live off the Grove for years.

He grew up around Brixton. 'My dad was a DJ, he was old school, he had a bible under his arm, not ganja.' So his neighbours were Afro-Caribbeans, like 'the Don's' family, who were from Jamaica (his everlasting anecdote is that he didn't actually visit until he went with John Lydon just after the Sex Pistols split up), Irish and Greeks. 'Why did the Greeks always have chip shops?' he laughs.

I take him to meet Harlesden's gorgeous George who has been running Avant Garde – a really traditional and very

funky men's clothes shop – for the past thirty years. There's a photograph I want to show 'the Don' of Jesse Jackson and George in 1995 at the shop. A friend of George's actually remembers 'the Don' as the video director of the Musical Youth track 'Pass The Dutchie' that topped the charts in 1982.

'I've got my own Jesse Jackson story in Namibia,' says the Don.

Meanwhile George is bemoaning the blandness of the High Street these days and how it's impacting on his business. 'It's all food and hair shops,' he says, 'and no one can park outside my shop.' He says he will be retiring soon and going back to Clarendon in Jamaica where he has a farm and he'll get involved with the community here. He's sure it'll be a much better life than the one he has here now.

'The Don's' Jesse Jackson tale is a funny one. Basically 'the Don' was there for Independence Day, 21 March 1990, and thought he'd get a sound bite from Jesse. Unfortunately, that was not to be the case. 'He went into a political rant and he wouldn't stop. I really learnt how to keep the camera still. After fifteen minutes, in my mind, I was like, "please shut the fuck up".'

Scandal is a famous Harlesden Jamaican takeaway, so 'the Don' pops in for some porridge. 'Made with cornmeal,' he explains. Here we meet Will, an MA photographic student who has contacted me and asked if he can take photos as part of this project. 'You didn't tell me I was going to have my photograph taken,' complains 'the Don', meaning he's not wearing his superdread togs, before taking charge of direction himself. Of course, he knows what he's doing. Will has failed to get the Scandal sign into the frame, and the Don insists on a re-shoot.

Was he a full-blown Rasta in the past? 'Yes, I used to go to St Agnes in Kennington for a long time and I defined myself as a Rastafarian but as I got older, I realised I didn't want to be told how to think. Now I'm open to everything.'

And you met Bob Marley? 'I went to his concert at the Lyceum in 1975 and it was a life-changing experience for me. I met up with him afterwards and we became friends. In fact, we had an argument one evening about punk rock, he really didn't get it, and I was in that scene. I was wearing bondage trousers. He took the piss and said I looked like a 'bloodclaat mountaineer'. I walked out in a huff. I was nineteen back then. But he got there in the end and wrote his song "Punky Reggae".'

As you can see, 'the Don' is not short of ripostes, so I'm surprised when I ask him where he gets his feistiness from, and he seems at a loss for an answer. A very rare event. It seems to be something he hasn't considered. In fact, self-reflection is not one of his big features. He's too busy getting to the next activity. He flounders for a few minutes as though this is a new question, and finally settles on, 'Well, being the only black boy in an otherwise white grammar school helped me get my shit together.'

Although he then adds, in a characteristic 'Don' manoeuvre, that in fact there wasn't an issue for race with him until Enoch Powell made his anti-immigrant 'Rivers of Blood' speech.

By this time, we've walked by Odeon Court – the flats where the cinema used to be and the Harlesden Roxy Theatre where 'the Don' did not perform – and up to Stonebridge. 'The Don' hasn't realised that the sixties tower blocks have actually gone from up here.

Earlier this morning, I was looking at a great photo of 'the young Don' and Jeanette Lee who went on to run Rough

Trade, in their zeitgeisty clothes shop Acme Attractions – 1975, Kings Road – and there is a scooter adorned with the Union Jack. It reminded me, I say, that the Union Jack has been used again and again to re-define Britain. 'Exactly,' he says. 'They used to say there was no black in the Union Jack but there is now.'

On the way back, we start talking about Malcolm McLaren, the maverick, the ideas man, the Sex Pistols' manager. 'I met him at Sex in those days. He influenced me. I might not be the man I am if it wasn't for him,' he says, 'he showed me how to join up the cultural dots. I'm sure he was ruthless and all the things people say, but he was also brilliant. It's like I said, nice people don't have great ideas.'

And so, of course, 'the Don' has to declare. 'People either love or hate me,' he says. 'That's how it is.'

Otherwise, it would appear he was a bad ideas person.

He's recently been on a six month world tour with Big Audio Dynamite – four men, including Mick Jones, in their fifties on the road. How was it? 'It was like revisiting our youth,' he says. 'I'm fifty-six and I want to shout it from the mountain tops, I'm having such a good time. I'm as old as rock 'n' roll. I've been through punk, rave, rock, reggae. I've done it all and I'm still doing it all. It hasn't stopped. I'm a product of youth culture before it all went pear-shaped with *X Factor*. Music here is in crisis but in other parts of the world, it's flourishing and is still about social change.'

Now we're sitting down in the O Tamariz Portuguese cafe. He's talking about being in New York and Tokyo. 'People say to me, "Wasn't it exhausting?" and I say how exhausting can it be, we're being flown around the world, staying in great hotels, I'm with people I still hang out with, it's not like we're strangers re-forming a band. Women throw

themselves at us. Get real, it's fantastic. And I still can't play. I still have stickers on the keyboard but I've co-written half the songs so I think I've got my credibility.'

He also goes out DJing – the history and legacy of Jamaican music, from dancehall to dub step – on his own. Here and abroad. No fanfare. 'I really enjoy it,' he says. 'They're fumbling around with the English and I love it. I like hanging around with funky, ordinary people and hearing their views.'

'The Don' hates a lot of different things, but equally he loves a lot too. On our way back, he's opening up and telling me he was a tubby teenager. Which I can't imagine, so I guffaw. 'Stop laughing,' he says, 'I'm trying to tell you something serious. I couldn't use my body to attract girls, so I had to start getting my mind together. I can't stand pubs, football or playing games. I've never been a man's man, I've always hung out with women.'

That is the truth ...

I forgot to mention the dreadlocked gentleman who approached 'the Don' down the road. He realizes who he is and wants to talk music. 'The Don' is impatient but gives him his email address. 'That's another reason I don't want to walk the streets,' he says in grandiose mode.

I say with understatement, 'Hey, it hasn't been that bad.' In other words, hardly anyone has recognised him.

'Yeah, there should be a fuck of a lot more people that know me in Harlesden,' he says with Don-ist brashness.

What Is It with
the Art in Harlesden?

'Do you know the blue sculpture of the Workers down Park Parade?' I ask Gabriel Parfitt, who runs the Harlesden Gallery, which is a group of forty artists rather than a physical location. 'I certainly do,' he replies via email. It turns out, as we stand beside this 1995 sculpture by Kevin Harrison – funnily enough, I sort of know him; his agent is Nicholas Treadwell, a man who is so fond of pink he has created a Pink Prison, which is in fact an art gallery in an Austrian town called Aigen where lots more of these cartoony Harrison sculptures reside – that neither of us are impressed.

'Looks very Eastern Bloc,' I say.

'Actually, it reminds me of something out of a Peter Gabriel video,' says this Gabriel, 'but I can see that it was made in the days of Harlesden City Challenge[1] and that it might have been saying that we are building a new beginning.'

It seems plonked, irrelevant and out of time. Harlesden needs some good art. What on earth do a bunch of huge painted steel and aluminium workers with a flag have to do with Harlesden? I think I will have to ask the sculptor[2] himself.

So what is the central philosophy of the Harlesden Gallery group of artists? 'Well, they all have to be willing to put energy into projects in Harlesden,' says Gabriel, 'like last year and I expect this June too, when we made the posters for the Love Harlesden day. There's a community ideal behind it, as well as our exhibitions. Recently, we had a group exhibition at the Tricycle, and we sold one piece and another artist was commissioned from it.'

Originally a sculptor using metal, Gabriel now paints. As we look at the Plaza car park, he points out that there used to be a public sculpture in the corner by Tesco. 'But it was made of bronze and someone stole it last year. Yeah, and they probably only got forty quid for it,' he adds. I'm shocked. I hadn't realised that it had gone.

A relatively new Harlesden resident – Gabriel and his wife Amanda have lived here for four years – he works as a technician at Latimer School, and had given up sculpting when they came to live in London. No space. But he took up painting in the studio at his workplace and then Lorenzo Belenguer, curator at the Willesden Gallery helped him exhibit. 'His gallery is so well organised and has a good reputation,' says Gabriel. 'Lorenzo is the opposite of me; he's a minimalist sculptor, so he might produce a white slab of plaster with a red rusty screw on it. He's always on a quest to find the perfect white cement.'

We hurry up Manor Park Road. I am eager to show Gabriel the sculpture[3] that sits on the corner of Hillside and Brentfield Road, just down from the Stonebridge Hub. I'd felt the same way about it as the Workers last time I was here. Another City Challenge waste of time, ignored by both passers-by and inhabitants of the area. Called Sun Disc, designed by Guy Paterson and Geraldine Konya, it is a

steel circle that has been cut out to reveal all sorts of joyous shapes, people, animals etc., all done in 1994 when there was money bobbing around. However, this time Gabriel points out the newspaper articles and images – all pertaining to Harlesden – that have been etched on to the pavement around the disc. They are brilliant, textured headlines like Our Challenge To Remake Harlesden and great photographs. 'Photoshop heaven,' declares Gabriel, as he takes photos to add to his website. We agree that this sculpture could have been improved if the artists had collaborated rather than worked separately (as it appears they did), and perhaps the newspaper cuttings could have been etched on to the disc itself perhaps?

At this point, I have to include that Gabriel is the Cultural Attaché (well, there is another name, but this is what I'm calling him) for Harlesden Town Team. He knows Leroy! 'He calls me Mr G,' he laughs, 'but for all his extrovert exterior, Leroy can be very sensitive. He's not one dimensional, although admittedly he is a character.'

Round the corner, on the corner of Acton Lane, is another sculpture[4], which is unnamed. The plaque has disappeared. It's a mosaic in two halves, apparently celebrating the dynamism of Harlesden with musicians and bright colours. 'It looks knackered,' says Gabriel. 'No one is doing anything about the upkeep of these sculptures.' Again, it looks old-fashioned now and uncared-for; there's a broken toilet nearby.

Finally, we visit the most recent piece of public art, called Girls and Boys in Harlesden, down Harley Road that I first saw with Sue Saunders in the third walk. I like it. Artist Mat Hand – now based in Berlin – wanted to make a mural that had social value. The words 'Bad' and 'Good' alternate next

to the images of all sorts of stereotypes – girls in hijabs, black boys staring – and the idea is that we, the viewers, challenge ourselves around our perceptions of young people and how they look. It's stark and startling, and at least it definitely does have something to do with Harlesden. 'It's a bit clichéd now,' says Gabriel.

Art in Harlesden? There was a plan afoot for a super tech, vandal-proof screen on the high street. Gabriel and Faisal plotted the concept so that there could be an ever changing art notice board in the centre of Harlesden showing all sorts of art including school paintings, films and much more. Brent council loved the idea. And then nothing happened. Come on Brent, yet again. Invest in art and attract the artists, then the visitors.

Prison, Paraplegia and Roundwood Park

La vérité, c'est plus étrange que la fiction. Six months ago, I bumped into an old friend of mine, Sandra Kane, artist and art director, at a dinner she was organising – only for her to tell me that she had just taken over the lease to the wonderful Roundwood Lodge Cafe.

I had no idea. As far as I knew, Marianne – a buxom blonde with a charismatic personality, who had heroically transformed this battered little space into a thriving enterprise for local families, having survived numerous vandal attacks along the way – otherwise known as 'Countess Romanov' and a respected local primary school governor, was still in charge.

'Haven't you heard about Marianne?' asked Sandra, incredulous that I hadn't. 'She's in prison.' Again, I was shocked. It was one of those ricocheting moments. The last time I saw Marianne was during the 'Save The Cafe' campaign two years ago (her story was that the council were about to evict her, although it transpires that this was not true), where I'd been videoed saying how brilliant I thought the café was. Monsieur Theroux had also joined in the campaign and been photographed with the Countess

herself in the local press. One of her fortes was rallying the troops.

Having seen Sandra, I scoured the internet for all the news I had missed. It turned out that not only was Marianne in prison for fraud, she had been pretending that she was a paraplegic confined to her bed and apparently claimed £197,000 since 1996 in benefits. 'Incredible' is too restrained a word for it. Phew.

I'm going to have to repeat myself. Marianne (only one of a whole raft of names) was a very public figure running a prominent local café, while at the same time maintaining this insane pretence. For twelve years. Brazen or just in la la land or both? Anyway, she managed it – obfuscation was one of her many talents – for a very long time. Finally in 2008, a Brent Social Services Officer recognised her while she was walking her dogs. Every time the Social Services visited her at home in Wembley, she apparently had the curtains closed and was wearing a head wrap plus sunglasses, as well as being obscured by bedclothes. She also apparently claimed forcefully – she has a fecund and almighty imagination – that she had a twin sister who was out there running the café.

After much more fantastical ado in court, she was sent to prison for four and a half years in March 2010. Hence the need for Sandra to step in; she had already been managing the café.

Originally termed a refreshment chalet – wait for it – with a verandah, which was built in 1900, the café was rebuilt – think scout hut – in 1958. Now there have been various additions like a kiosk and play areas outside. There is even a massage table in the summer.

In the early nineteenth century, this area was known as Hunger Hill Common Field. Its distinguishing feature was the

(still remaining) hillock where there used to be a rifle range. No more, of course. By the mid-1800s, Roundwood House had been built – apparently a magnificent, Elizabethan-style mansion – which later was owned by 'legendary' (i.e. rich and powerful) local figure George Furness. However, Willesden Council (pre-Brent) took out a compulsory purchase order on Roundwood House and it was demolished in 1937. The park was opened on 11 May 1895.

Of course, Sandra didn't arrive until the late 1990s, when Marianne was in charge. 'She was always very determined and full of energy,' says Sandra. 'In those days, she was in a wheelchair. The official story was that she'd fallen down an elevator shaft. I'm not sure what the reality was. But she did do a lot for the community, and in many ways was very generous. I have been to see her in prison but only in a formal way for the signing over of the lease. It is a new era for the cafe now. I've got new ideas, like the massages in summer and holding art exhibitions here, but it will always be a community cafe.'

Sandra, it has to be said, loves the people that come to Roundwood Park. The different ages and the differ-ent nationalities, the families, the teenagers. Everyone. 'I also really feel so lucky to work in this environment,' she declares. 'I see the dew on the burnished plane leaves on autumn mornings, and hear the first thrushes in spring. I see all the seasons in. And the variety of people, the older ones with their dogs, the toddlers, the teenagers letting off steam. Parks are so needed for schoolchildren to hang out and be independent. I'm a strong supporter of parks for teenagers.'

And then, there are the old men who frequent the Bowling Green and their own little wooden hut, like a vestige from

the 1920s – it was built by the unemployed – in their whites and their whiteness. Louis was keen for me to interview these players as an example, I assume, of particularly old-fashioned Harlesden dwellers. Perhaps I will.

Sandra and I take a walk down to the main entrance. I have to confess that I always feel amused by the flowerbeds here. Yes, in a snotty way, kind of perverse bohemian arrogance. To me, these flowerbeds are a little garish. Oh, the jolt and the jab of it. Red, oranges, purples, yellows – all tipped together like a seaside extravaganza. Think Bournemouth.

As Sandra and I gaze at these beds bursting with yellow and orange marigolds, red begonias and purple verbena, I feel mean to Sandra, who is so obviously a seaside flowerbed aficionado. I confess to my negative thoughts. She is politely aghast.

'Look at those beautiful orange cana lilies,' she says, defending her park, 'and we have a quite famous tulip tree. The flowerbeds here have always been an award-winning feature right from the beginning. Now we get couples coming to have their wedding photos taken here.'

Chastised, I follow her to the stunning wrought iron gates, which were created in 1895 at Vulcan Works in the Harrow Road. And then, there's the surprisingly grand faux-Elizabethan lodge where apparently Brent park workers now reside.

'It's a great house,' says Sandra. 'Look at those chimneys and the sun and the plough on the other side; they were Willesden Council's emblems at the time.'

There is the most hideous water fountain just nearby. Sorry, Sandra. Gothic, over-follied, ridiculously unattractive, unused (no water spurts sally forth). Created (I employ the term ill-advisedly) to mark the opening of the park, it

really should go immediately to that imaginary, but much-needed museum devoted to the most grotesque of Victorian inventions.

And then, there's the aviary. Here I go again. It is small, unadventurous and anachronistic; full of canaries and zebra finches, it lacks space and cleanliness. Maybe the children love seeing these little birds, but I'm not sure it's worth it. I can feel Sandra's disapproval again. I am not, of course, speaking for her. I'm not respecting her park.

Another enigma on the right is the distinctly 1960s Summer Theatre[1], which is an open air experience. Except I've never seen it open. It seems like a great idea to have a theatre in this park. Shakespeare has visited especially in summer, I hear, but it remains firmly closed at the moment and unsupported.

Sandra, Queen of Roundwood Lodge Cafe.

Oh goodness, I've just read – post-walk – that after the First World War a German Bomber plane was almost fixed to the bandstand in the park as a decoration. Now that would have almost outdone Damien. There used to be a bandstand on the defining hillock, but no more. Now there's just a flat area, which could also easily be for performance, and it overlooks Wembley Stadium with its white halo. 'When the park was built, this looked out on woods and trees,' says Sandra. 'Look, you can see the church steeple in Harrow.'

As we're walking back down towards the cafe, I notice a plaque on one of the oak trees that I've never seen before. It says simply that Lance Hamilton died here in 1998. Who was he? What happened? Even Sandra doesn't know. Google doesn't give an answer.

'Actually, at times of trouble, I have come to sit between these oaks and wept,' says Sandra, 'and I have found the solace of nature here in Roundwood Park. It really has meant so much to me over the years.'

Sandra really is Queen of Roundwood Park.

A Batty Night Out at the Welsh Harp

I discovered last year that there is an annual bat walk at the Welsh Harp – or Brent reservoir, which is 170 hectares of open water, marshes, trees and amazing wildlife – and I immediately wanted to go. The idea that bats were flapping rather wonderfully right next to the A5 enticed me, as well as my imaginings of who was going to be on this walk.

I wasn't disappointed.

Having had cold feet at the last minute, I persuaded my son Marlon – who is as fond of British eccentrics as me – to come along.

And so, at 8.45 p.m. one Wednesday, we find ourselves in the darkness that is the evening on Cool Oak Lane. I spot a large gentleman with binoculars on the bridge and conclude, wrongly, that this must be Roy Beddard, our leader and avid Welsh Harp conservation expert. It isn't. It's Derek, a veteran birder and 'batter' who has been visiting the Welsh Harp since 1960. However, Roy and Derek are a bit of a comedy duo. Derek starts telling us about a birdwatcher he used to know who wore a raincoat and bicycle clips for his batting excursions, even though he drove to the destination. 'Those were the days when you had to balance your

telescope on your knees and no one carried tripods,' he smiles.

There's an initial assessment of the night insects. 'There are a lot around tonight,' says Roy. Which means it should be a good night for bats, because they eat them. Apparently the common pipistrelle (our most common bat) can eat up to 3,000 insects per night. In fact, seven varieties of bat have been seen at the Welsh Harp.

Gradually, a motley crew of twelve turn up. And then, there's the bat detector revelation. I hadn't even considered equipment beyond the humble binoculars. But suddenly there are a gaggle of men in anoraks wielding bat detectors. They turn out to be the key ingredient of the evening. As opposed to the actual bats.

I am – no surprise here – a bat detector virgin, and intend to stay that way. We head off into the darkness and pick up the small group already on a viewing platform. They've already seen a common pipistrelle; the UK's smallest bat, its body is the size of a pound coin. We make our way through the trees and I am certain I can smell wild garlic. Marlon is adamant that I can't, and later explains that it is the man walking behind us who keeps burping up his garlicky evening meal.

As we come out into a clearing, our eyes are keenly trained on the late dusk skies. I hear a sound that I think is a woodpecker; it's a kind of violent knocking. Of course, it isn't a woodpecker; it's a bat detector picking up a noctule, one of the bigger bats.

'I'm on 45,' says Roy to another 'batter'. This is one of the refrains of the evening.

'I'm on 25,' says the other gentleman with a grey beard, the one with the garlicky breath.

They are talking bat frequencies, and the frequency dictates the sort of bat they will pick up. The common pip – 45, the noctule – 25.

At this point, I actually see the shadowy flicker of what I take to be a common pip. Note – I am now down with the bat speak. It is barely detectable against the dark moonlight. That turns out to be my sighting of the evening.

How I long for that evening last year in northern Kerala when the twilight sky was full of huge fruit-eating ones.

We press on down another night-drowned footpath. The woman in front of me hangs on to her overweight partner as though she is here merely as his bat appendage with no apparent will of her own. We stop and stare at tall sycamore trees; they may have bats abounding but we can't see them. We are transfixed by patches of the sky that might suddenly witness a batty visitor, to no avail.

There are plenty of churpings – the common pip – and low knockings – the noctule, but they are mechanical as opposed to natural. There are diversions as the detectors pick up neighbouring crickets and even someone's keys in their pocket. Bats themselves are there, obviously, but not visible.

Roy is a bit of a one, in his baseball cap. Derek wears one as well. The former regales us with a tale of discovery, in compensation for the lack of bats. 'As recently as 1996, a new bat was found in this country,' Roy explains. 'Scientists discovered that there were pipistrelles that operated at 55 rather than 45, and they were another sort of pip, the soprano pip. We get them here too.'

Seemingly not tonight, although a few 'I'm on 55's can be heard amid the '25' and '45's. It's a funny old bat world.

We turn back. There are cars racing up the A5 nearby, a light that is shining far too brightly over the lake and a younger man from Primrose Hill who is just back from kayaking and wildlife-visiting in Uganda.

What on earth is he doing on the Welsh Harp bat walk? 'It is a bit of a poor partner,' he says jokingly. 'I sometimes come birdwatching down here, so I thought I'd pop over. Mostly I come if a rare bird has been seen.'

Ah, hot birds. How far would he go to see hot birds? 'I'd go quite a long way,' he laughs, extending the joke, 'but you have to be careful because there's a lot of scamming that that goes on in the bird world. It's easy to be disappointed.'

Derek accompanies us down the final pathway. Has he been excited by any bird sightings recently?

'It gets harder as time goes on. I used to be excited by seeing oystercatchers, but they're commonplace now. To be honest, I'm into orchids now,' he admits.

He wonders if we've heard the urban myth about parakeets. I'd read they arrived in the thirties, but I'd always assumed they'd started multiplying in the eighties because that is when I first noticed a flock in Syon Park. 'Well, it is said,' he says in hushed tones as though he is imparting a treasured secret, 'that they escaped when they were filming *The Wizard of Oz*.'

The others are waiting at the first viewing platform. We've just missed a fish owl in flight across the lake. Roy is standing still, his detector aloft, and Derek makes an interesting observation. 'Listen, did you hear a kind of raspberry noise? That is the pip eating an insect. They do a little loop round,' he tells us.

Now that is incredible. Experiencing a pip feeding via a frequency. Who would have thought it?

And then he asks a brilliant question. 'Do bats hear in colour?' I've no idea but if they do, does that make them synaesthetes?

I've learnt a lot, I tell them both, but I haven't seen a lot! 'It's my fault,' confesses Roy. 'We should have come half an hour earlier.'

Oh well, only another year to wait.

WALK 25

One Hell of a Somali Woman

What do you do when you don't know any Somalis and you
want to find one to walk with? Preferably a woman. Well, I
kept on looking around and finally I noticed Rhoda Ibrahim
was one of the organisers for SAAFI (Somali Advice and
Forum of Information; founded by British Somali mothers,
they help translate at schools and promote the arts) and
she seems to be responsible for Somali dancers and singers.
Sweetly, she agreed to meet me by the Jubilee Clock one
Saturday morning.

I look around and see a small, curvy woman couched
in layers of a long cream patterned dress and a light pink
scarf. She's smiling. It must be her. I'm hobbling today – too
much tennis and too much dancing – and she is too. Later, I
discover her difficulty walking is down to arthritis. 'I need to
lose weight,' she says honestly. I was just about to suggest a
new Italian café called Fornetti when she says: 'No, let's go
to a Somali café.' How stupid I am. Of course.

I'm so happy to go to this nameless café with her. Somehow
I never think – and probably I'm a bit apprehensive, because
they seem to be mainly peopled by men and you know,
I'm a sheep, I do mainly gravitate to places where I know

people – about going to a Somali café. Anyway, this one hasn't got an official name yet – Lido is coming – instead, bizarrely, writing from the Elm Tree is still there declaring its Fine Ales, which is very far from the case. This is invisible Harlesden raising its head again.

Immediately, one of the regular customers – Ali Naji, a cameraman and film-maker – grins and introduces himself. I'm transported to a travel place in my head, where I'm so much freer, where I speak to strangers, where I forget I'm in London. It turns out that Ali came over from Rotterdam in 2008 because there's such a large Somali population here and so many TV stations – seven Somali TV stations in Brent, apparently – that he could easily find work.

One of the themes of my encounter with Rhoda (and Ali) is the different waves of Somali immigration and what that means. Rhoda came over to Britain as a student when she was twenty in 1989, and then the war broke out at home. She didn't go back, instead she sought asylum here. But that means she's been here over twenty years. '80 per cent of Somalis at home are nomadic. My family was the first generation to come to the city, and I went to University,' she explains. 'My father was very progressive. He wanted his daughter to have an education and have choice.' However, that didn't stop her getting married at sixteen.

Ali and Rhoda both talk about European Somalis. I wasn't familiar with this distinction. But it seems that many of the Somalis who have come to Harlesden in the last ten years are European Somalis, so they've come here from somewhere else in Europe like Holland. Harlesden has the second highest population in London; Tower Hamlets is the first.

Ali is telling me about a short film he's making. 'It's about a young Somali girl who was born here, is independent, has

OCD and has no plans to get married. It's about the conflict of the cultures, West and Somali, and how this affects her life. How sometimes this lack of structure can lead to problems, but that complexity is what the film is about.'

I ask Rhoda how she feels about wearing a scarf over her head and if that tradition has changed. She laughs a little uneasily. 'I've got more conservative as I've got older,' she declares. 'I wear a scarf now because I'm a community worker. When I was a fifteen-year-old girl, we didn't wear scarves, we were free. Somalia was more liberal then.'

Does she feel peer pressure to wear a scarf? 'Yes,' she says vehemently, and later I see this very aspect of 'modern' Islam in action. Rhoda and I have our photo taken together, and another older Somali woman is looking at us. She gives Rhoda a stern look because she hasn't got her scarf over her head. Rhoda immediately capitulates and draws the scarf over her hair.

I wonder why there seems to be such a flux of Somali shops around this little area and Church Road? 'Wembley used to the place for Somalis to shop here,' she smiles, 'but then that area was cleared for redevelopment and they moved here. Central Wembley was always the first place to go in London when a family member came over.'

Rhoda has a complicated life story, but Somaliland, where she's from – in the north – didn't suffer from the civil war. 'It's always been peaceful there,' she explains. In fact, her mother, who moved to Canada with her sister, has gone back home. 'She's happy she can talk to everyone; she's not so isolated.' Rhoda is a single mother to two boys here who are twelve and fifteen. But she's also got a twenty-eight-year-old from her first marriage, who lives in Wembley. And that first husband lives in Britain too. 'It's just what happened at

that time in Somali – you got married early. It lasted three years. I was lucky that I went to University too,' she says. 'We're good friends now.'

The second husband – she met him when she was working with refugees in Somalia – lasted three years as well, and died last year. 'I'd just taken the boys to see their father over there,' she says sadly, 'and then he died suddenly from cancer.'

I ask her if she was ever in love? 'Probably with the first one,' she says, 'but he was from the South and I was from the North and that made it very difficult. We belonged to different clans. I used to say to my friends that I had a mixed marriage and they'd look at me as though I was mad because we were both from Somalia. But that's what it felt like. Clan issues are so big and it all derives from the nomadic issue. They fight to get the best grazing land and the best water holes.'

She talks about how SAAFI has evolved over the years, and how much translating she does to help people with forms for medical and welfare applications. She talks about Somali mothers being over-protective, especially with their sons. 'They don't want them to get involved with drugs or extreme religion,' she says, 'so they stop them doing everything. The girls seem more active about getting jobs – it's the boys we have difficulty with.'

I ask her if she's experienced any conflict with the Afro-Caribbean communities. 'Well, I know it exists,' she says, 'because often the Somalis have arrived more recently and they view us as taking away their flats, etc. People tend to assume I've just come here but I've been here twenty years. That's a common assumption. I am aware that there are hostilities in Harlesden and one of the contributory factors

is that Somalis are a people of one language, one culture and one religion. That makes it harder to integrate.'

It's midday and men start coming in for coffee from the mosque over the road. I've noticed mosques popping up all over the place. 'Yes', she says, 'there are three around Church Road. I actually go to an Afghan one because that's all that was here when I arrived. I only go on Sundays.' Her sons, it turns out, don't go to the mosque.

I ask her why she thinks the woman running one of these shops was so hesitant to tell me where she was from? 'They're afraid of hostility against them,' she says. 'In fact, when the Nairobi killings happened, my sons were very worried that they'd experience negative reactions because the militants were from Somalia, but I told them to just be as they are usually, that they were Somalis and that's who they are.'

Next, we visit some of the neighbouring Somali shops, stocked up with hundreds of coloured scarves, blankets, curtains, and hair products. But what are these bling-bling red glass objects on the counter? She doesn't actually know, but they are incense burners, which take oil. There are mixed spices for tea, then meat, there are sprays to make the room smell better when you have guests, there are little limestone ovens. In fact, there's a labyrinth of little shops – a tailor, a barber's, a coffee shop, a material shop – all inside this doorway.

So I ponder – what does she eat? 'Takeaways,' she grins, and she's serious. 'Let's go and taste some Somali food.' We visit Somstar, which is a restaurant down the road. Plastic tablecloths, water jugs and not much more on show.

'They always bring you bananas first,' she says, 'and you eat them with your meal.' She then orders suqaar, which is

small bits of beef fried with peas, corn and cabbage (but predominantly beef), hilib ari, which is fried lamb, anjero lahoh, which is a kind of stretchy pancake that acts as bread, and baris, which is rice with peas. It's tasty but a bit too meaty for me.

She tells me something quite shocking. '70 per cent of Somali women here are on their own. They're independent and strong,' she says.

Finally we get on to a difficult subject, Female Genital Mutilation. Rhoda herself had this unjustifiable procedure when she was only six and it has obviously affected her entire life. She says that it had painful consequences when she was giving birth to her last son thirteen years ago and that the medical practitioners had no awareness around it.

'I'm glad it's getting much more publicity,' she says. 'I feel angry with mothers sometimes when they want to have their young daughters operated on in this way.'

Just as she's about to go, I start to ask her about her own sex life and how that has suffered. 'Oh well, sex, that's the subject I know the least about,' she counters jovially, but the hurt is not far below the surface.

George the Poet and His Marvellous Mother

Ever since I saw an article in the *Observer* on George the Poet, I've wanted to walk and talk with him. Brought up around Harlesden – the *Observer* said he was from Stonebridge, but in fact he's from the even tougher estate St Raphael's on the Wembley side of the north circular – he's twenty-three, and the second eldest in a Ugandan family who arrived as political refugees in the late eighties. He (and his mother) managed to get him to Cambridge University, then he transformed himself from a rapper to a poet and back again to a rapper, and more recently was signed to Island Records.

But more than that, he's a bold voice for social change. George Mpanga cares very much about the disenfranchised, often ignored members of society – specifically black young people – from areas like the one he grew up in. And he's willing to take on not only the police and the establishment, but also the values that are so often trumpeted by those dodgy rap videos and lyrics. And obviously he gets the complexity because he's a part of it.

I'm excited! I'm old (I started this project when I was middle-aged, now I'm proud to say I'm old) and thrilled

that someone young is daring to step out and up, without being patronising.

George is even on time at the Jubilee Clock. Within a few minutes, he's bumped into a young woman and they embrace. 'I'm so proud of you,' she says quite a few times to him, quietly. I'm already moved. Later, George explains that they are old friends and because he's been at Cambridge they haven't seen each other. It's a moment where his community tells him how important he is to them.

Jan, the photographer for the *Brent and Kilburn Times*[1], has arrived and we were thinking of a photo taken at the clock looking up the High Street. But George has other ideas. And so we're off. 'I used to hang out round here back in the day,' he says. 'I still consider it my neighbourhood.'

I ask him as we're walking how he sees himself in comparison to K Koke. His answer is unexpected because I imagined that they came from very different philosophical places. 'K Koke comes from a much colder place,' he explains. 'I started off from a warmer place, but we share a lot.' What he means is that George had educational advantages; his mother, obviously an extraordinary woman, got him to apply for Queen Elizabeth's, an all boys grammar school in Barnet with some of the best A level results in the country. She also persuaded him to stay when he wanted to get kicked out. And eventually that's how he got to Cambridge, which has given him societal warmth.

We're walking by the former Mean Fiddler (the sign has only just gone down and it's been closed for years) and I'm telling him about the gigs – like Los Lobos and Christy Moore – that I used to review there. George is a little beside himself that he never had the chance to visit this legendary

venue. The next minute, he's grabbing plantains from a shop, obviously enjoying the opportunity to buy some again.

I'm a bit worried that Jan hasn't got lots of time for all this wandering and ask George about the photos. Then we're in the hair shop, Juliet's, and George is buying skin moisturiser. 'It's part of the immigrant experience that doesn't get advertised,' he says passionately, 'all black families have tubs of cocoa butter around. My skin would tear so much more easily without it.'

George then makes it clear why he wants to have the photo done away from the High Street. 'I remember how that series *The Heart of Harlesden* (in 2001) didn't go down well with some of the community,' he says, 'and I was thinking they might not welcome the sight of cameras and notebooks.' Again, I'm surprised. I've never had any problems – well, there was that one incident actually, with Vince Power, where someone assumed I was from 'Elth and Safety – and in fact this makes me realise how relaxed I feel these days out and about in Harlesden with a notebook and a camera. Unlike four years ago.

Also, it strikes me as we sit down on a wall to chat that George actually grew up on St Raph's when Harlesden was at its worst in terms of shootings, stabbings and violence. He was only eight when it was all starting. It must have seriously affected him. 'It really did,' he says, clearly still disturbed by that era. 'There was no choice, there was no room to be any different. If you didn't want to get involved with violence, it was very difficult. I remember having my bike taken, and getting into a fight about it. And then my dad didn't understand that I could be just doing nothing, and this could happen to me. Later, he was robbed as a cab driver and saw the bad side of the area, and got hardened.'

As George got older, the incidents got worse. 'I was going to parties for the usual reasons – to have fun and meet girls,' he says, 'and I ended up seeing someone get stabbed when I was fifteen. It was a rude awakening. I realised that I didn't have any power over my future. Even now I get feelings of paranoia. I get feelings that I might die soon. I was telling a friend this and she went very quiet. I had expected her to agree but she didn't. All that stuff that happened has deeply affected me.'

But you are still willing to step forward and challenge the culture that created it. 'The only way to release this fear is to embrace death,' he says intensely. 'That's the way I can step forward, but it's difficult. It's bittersweet. I also realise that embracing death and incarceration is the way that gang members release their fear and that enables their recklessness. It's the same mechanism, but used for different ends. I'm aware of the importance of being able to have dreams in your life and I was encouraged to have dreams by my mother.'

He also had guardian angels along the way. 'I was sixteen and someone offered me the opportunity to sell drugs. I gave it some serious thought because I didn't have any money. But someone I respected shut this conversation down for me. It was a crucial moment for me. I respected him and so I didn't go ahead. It was the respect that did it. Young men don't have enough older role models around that they respect. It's all well and good, politicians and parents and teachers telling us to behave, but they're not offering an alternative, a way of being able to behave.'

What was it like going to this grammar school and then going back to St Raph's? 'A culture clash,' he says. 'The school gave me a lot in terms of internal rules and under-

standing about how Britain works. But I wanted to get kicked out for a long time, because I wasn't comfortable. I was still a minority. Most of the kids there were Asian. Most of what was really useful I learnt outside the classroom. There was the unspoken agenda. There was this arrogance about the world and how it ran that I started to understand. But with regards to my position, I was between a rock and a hard place. I didn't fit in. It's funny because I was among the so-called privileged, but I didn't see them that way.'

It turns out – another surprise – that George had been considering standing for MP in Brent South now that Sarah Teather has stood down. He had discussed the possibility with his mother, and in the end, decided that being an MP was not the position where his voice could be the most heard.

George is a young man who is constantly debating with himself where he can be the most useful. How he can contribute to his community. How he can help his community stand up for themselves. How he can get the respect to be an influence. What I love is how much he wants to enable social change and how serious he is.

But he's got to have fun too. When he tells me he's been signed by Island Records, he breaks into a giant smile. Island is now run by Darcus Howe's – yes, the great big man himself, rebel broadcaster and writer – son, Darcus Beese, and he came to see George perform at St Pancras Church last year. And that was it. The CD will be out in 2015. And George has already been on Channel 4, Sky, BBC 2's *Late Show*, won awards, met the Queen ...

We go into JJC over the road because George is hungry now and wants some jerk chicken. We're discussing Dawn Butler's return and the departure of Sarah Teather when the

owner, JJ, shows up. He is also King Sounds, who had reggae hits like 'Pilot' and 'Book of Rules' in the seventies and eighties. Funnily enough, I end up introducing the young to the elder. George and JJ don't know each other. Harlesden!

'I've seen you around with your car and girls,' says JJ.

'No, I'm not like that,' says George. 'I'm humble.'

And then we're outside. I was thinking of walking to St Raph's. But George has his car – it is a BMW – so we drive. This is a first. A drive, not a walk. And a first for me, to visit St Raph's. Is there still trouble between Stonebridge young men and those of St Raph's? 'Yes, no one can remember how it started. I used to spend a lot of time down in Harlesden though; I worked at a barber's called Active sweeping up the hair. They'd pay me cash in hand. Yeah, someone was shot at one of the barbers in that time.'

We're passing those empty office blocks just before the north circular. I feel scandalised every time I see them. Why isn't anyone occupying them creatively? Or squatting? 'I pass those all the times, you know,' says George, 'and I never even think about them. I'm fascinated by squatting though. Did that happen because of Thatcher?'

Being older – a lot older – and having lived through punk and hippiedom, I'm half-historian during this encounter. Yes, I squatted – it was legal though – in a brilliant vicarage in Shepherd's Bush where we had mad parties and could afford to really live fully in London. It was before Thatcher, and also of course before they changed the law and also young people have become attached to comfortable living. I tried for years to persuade my son that squatting was a rich way of living.

And so we're sat outside some of the low-rise red brick seventies housing on St Raph's. George is telling me that

when they arrived here in the eighties they were one of two African families and everyone else was Jamaican. 'We were a minority within a minority,' he says, 'like I was later at school. It was another culture clash.'

Is it more relaxed now than when he grew up? 'Well, now there are more Somali families here,' he says, 'and my two younger brothers do seem more relaxed than I was. Sometimes when I do poems about the area, I do wonder if I'm making it worse.'

A curly-haired woman, emanating warmth, walks towards us and invites us in. For some reason – mainly because George hasn't mentioned that we're sitting outside his family house – I think this is his aunt. I explain that I'm interviewing George and ask her if she's his aunt. 'No,' she laughs as she ushers me into their front room, 'I'm his mother.'

Ah, so this is George's inspirational mother.

The lounge is full of photos of the family, like a big celebration of their Ugandan heritage. Above the television is a big sepia photo of all of them, mum and dad plus their four sons.

Mrs Mpanga explains in her graceful way that her husband and herself were political refugees. That the president who had come after Idi Amin – in other words, Milton Obote – was far worse than the infamous dictator. This one was killing and torturing people who were thought to be rebels. Mr and Mrs Mpanga were, at the time, caring for Aids sufferers. She is proud that Uganda was the first African country to treat Aids seriously. 'It is called 'Slim' there because people lose so much weight,' she says.

But they were on the wrong tribal side, and Mrs Mpanga had been communicating with her sister in Kenya about

what was really going on. 'We had to leave,' she says. 'It was too dangerous for us there.'

The Mpangas are Christians and go to All Souls Church in Harlesden. 'I don't go any more, 'says George, 'but I'm very grateful for Christianity. It gave me a black and white way of looking at things when I needed that.'

We start talking about how he got into to Cambridge. It turns out that a teacher at Queen Elizabeth's tried to dissuade him from applying. 'He showed me a negative graph, told me it was unrealistic and that I wouldn't get in,' says George. 'That really took the wind out of my sails. I lost a lot of confidence after that. It was my mum who persuaded me to go for it. She totally believed in me. It's what got me everywhere. This experience taught me one big lesson. You don't get anywhere without self-belief. You only really have yourself to depend on. That's what I'm always trying to take out to other young people.'

How was Cambridge? 'I loved the lectures and I threw myself into the social scene for the first three months, then I realised I didn't fit in. I felt awkward. There really were very few black students. I felt lonely but I started to go out to do gigs at other universities. That's when all of that started happening.'

Poetry came about because rap didn't fit in. George removed the music, and hey presto, he was a poet. Perfect. Another crack that opened up into an opportunity. George may be often an outsider, but it's a creative outsiderdom.

There he was out gigging around the country venting his anger about what was happening in Harlesden. 'I hated the area because all the shootings and violence made me feel powerless,' he explains. 'Something bad happened to someone I knew and it stayed with me. That's how it turned

into social commentary and me wanting to enable social change.'

Before Cambridge, he went to Uganda for five months. 'It was an amazing time. I saw the possibilities of what I could do over there. It seemed like freedom to me, to see so many black people in significant roles; you never see that in the UK. It was liberating. There's no glass ceiling there. All my life, I've been told to tread carefully because I'm black and you never know how people will interpret your actions. There was no treading carefully there.'

George the Poet and his fabulous mother at home.

Sweetland

I'm following Dar, or Danny, into his back room. He's my local newsagent. And it's full to the rafters with boxing gloves in red and blue, punch bags, shin guards, footballs with stars on them, shorts and tops. Yes, in true Harlesden style, this is a newsagent that sells boxing gloves.

Not only that, but they are all hand sewn in Danny's family factory in Sialkot, Pakistan. Sialkot, it turns out, produces the most hand-sewn footballs in the world. As for that name, Danny – in the seventies, an Irish friend started calling him Danny and it stuck. His Pakistani first name, confusingly, is Amjad, and the family name is Dar. The boxing gloves are made by Darco. The family used to sell to the US and Danny reckons Mohammed Ali must have worn some of their gloves.

Danny is such a sweet man, and he runs a shop called Sweetland; that is not a coincidence. His brother Max (Pakistani name Masjud) is sweet as well. Ever-smiling and gentle, both of them. It's a shabby shop but it's their hearts that you notice; they're always friendly and chatty. I first talked to Danny right at the beginning of this project, and now I'm back. Also I first spotted Louis – who lives nearby – in his shop. It's gone full circle.

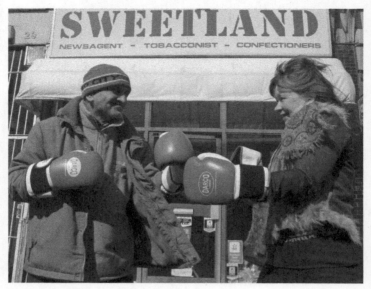

Trying out Darco boxing gloves!

Danny didn't go into the family business. At nineteen he came to Harlesden, moved into a flat on the High Street – now above a halal butcher's – and became a fork lift truck operator at McVitie's.

'I was a bit different to the rest of my family,' he explains as we walk down Park Parade, 'and it was easy to get work here.' That was 1970 and he was very happy with Harlesden. He'd go to the Royal Oak to hear Irish bands on Saturday nights. 'All the shops would close at 6 p.m., so then it was quiet except for the Victoria Wine shop, which was at that time on the corner opposite Sam's. We'd all pop in there.'

This is a man who never leaves his shop – from 6.30 a.m. to 8.30 p.m. – so a constant stream of his regular customers regale him with shocked gasps. Here was Danny in the

street. They couldn't quite believe it. And I couldn't believe just how many of his customers we met.

Danny is small, wears a woolly hat and lots of layers. He's sixty-four now, and walking is difficult for him. He's lost a couple of teeth and his face often crumples into an expression of unending kindness. He asks after an Irish woman's husband who's just come out of hospital. We bump into a Jamaican lady outside Peacocks, and Danny listens intently while she expounds on the painfulness of a corn on her big toe.

Oh, and Danny refers to himself as 'one of the originals'. I love this idea. What he means is that he and Johnny – who runs the hairdressers and tanning shop, Paraskevas – have been on Park Parade the longest. 'People come and go these days,' he says. But Johnny, whose family are from Cyprus, and Danny are both long-stayers. Danny has been here in Harlesden for forty-four years. A miracle.

To walk with Danny is to enter into another era. His version of Harlesden is set in the seventies and eighties. He used to do a double work shift, first at McVitie's and then running a newsagent called Midnight further down Park Parade (the blue sign is still there), opposite the Royal Oak.

He's also frequented most of the local religious establishments over the years. He's a Muslim, of course, but his wife, Lucy, is a Roman Catholic from the Philippines. Hence Danny sometimes goes to churches and sometimes to mosques. 'I'm not very religious, though,' he says. He repeatedly tells me what a good wife Lucy is. 'She always has a meal for me when I get home,' he explains, 'although she works in the City herself.'

He points out that his favourite bags of chips came from Bigger Bites, but that he can't eat chips any more. 'I've had

a couple of heart attacks and a stroke,' he explains, 'so I can't.'

He last went back to Sialkot seventeen years ago. His mum, eighty-six, is still there in the family house. 'Max's wife is there, his daughter too, and his son now runs the sports factory,' he says. 'But when my grandfather started that factory 100 years ago, they had 200 employees; now there are only a few left.'

And then he tells me that in the seventies and eighties there used to be an annual Irish festival in Roundwood Park. 'It was amazing,' he says. 'Bigger than Carnival at that time, with brilliant bands.'

He points out that Peacocks was Woolworths then. 'We had a Macdonalds, too, and they closed that down. People weren't behaving themselves,' he says.

From time to time, Danny mutters, 'Oh my god,' and I start to realise that he's in a lot of physical pain. I suggest we go back. Later, he admits that he was feeling dizzy and couldn't see properly. Poor Danny – this sounds awful.

Now we're back in the mysterious ever-expanding back room and Danny is explaining that they sell to all the boxing gyms around, including the famous All Stars in Harrow Road. 'They're even promoting boxing in schools now,' he says, 'and we sell to Newman Catholic College up the road. I go in and check stocks.'

For the World Cup in Brazil, Danny has ordered lots of footballs with different flags on them. 'We're getting them to give to the community schools around here,' he says. 'And all the local businesses are going to have ones too.'

I notice a pile of leather belts, whereupon Danny starts undoing zippers on his multi-layered tops to reveal one of these very belts which seems to be holding his body together.

It is not in the belt position but more around his ribs. 'It helps to keep me upright,' he explains. It turns out that as soon as he hung these belts in the shop, they started selling. 'One woman bought six of them.' He smiles at this incredible belt success.

Ah, but there is another back room conundrum – bags and bags of knitting wool. What on earth is he doing with all that wool? Apparently – wait for this – it's been there for thirty years going back to the time when Danny opened briefly as a ladies' fashion emporium.

Surely, the time has come to do a cheap deal on wool ...

Not everything has always been so sweet for Danny. He's had to survive some brutal encounters in his shops. This happened firstly at Midnight, which was unusual in those days in that it stayed open late. 'I was in the shop alone,' he says, 'and three guys came in, they beat me up. I was covered in blood. They stole money and cigarettes. It was strange because I'd never felt scared. I knew everyone around there.'

And later, it happened at Sweetland. 'There were three men but they stayed outside. Two girls came in with broken glass bottles, they stabbed me with them all over my body. They were trying to steal the till and I wouldn't let them. A crowd gathered outside and one man persuaded me to let it go. Afterwards, he told me that the young men all had knives. They were caught afterwards because someone recognised them, but only the girls went to prison as the young men had stayed outside and the police advised me that it would be difficult to convict them. People warned me not to go ahead with charges against the girls but I did. It was the right thing to do. I had it all recorded on CCTV, too.'

The best thing was how the community helped Danny out. 'Johnny cleared up the glass from the front windows for me and ordered new glass. I got a lot of help from people on Park Parade. That's what we're here for, to help each other.'

Danny has had a hard life but he retains this infinite sweetness. If you saw him in the street, you wouldn't notice him, but he has such a big soul ...

Harlesden and the Ripples Outwards

I walk down my road one morning in August with a deep sense of comfort. I know my neighbours here – from Gabriella and Francisco, who provide a second home for my cat, to Patrick next door, who put my side door back together after police had knocked it down in order to find a disappeared burglar – better than I've ever known any elsewhere, including Portobello Road.

And after four years of walks through my neighbourhood – one that I felt slightly apprehensive about at the beginning – I find myself at ease in its wider company. These Harlesden streets are no longer alien. I often find myself chatting to Danny at Sweetland or Johnny outside his hairdressing salon. I think it's inspired and funny that they call themselves Park Parade 'originals'. I truly feel a valued member of this community now.

Walking has been so much more than walking; it has been meeting, arguing, unravelling bits of information and, most importantly, being thrilled by all the characters that I've met along the way. I am often asked where I found these remarkable people. Well, often while I was looking for answers to other questions, in the best random way.

And sometimes I searched for them, like elusive, succulent prey. I can wholeheartedly recommend walking and talking as a way of getting to know your community and what lies underneath the surface. All you need is the willingness, an open heart and the desire to engage.

Curiosity and being aware of my own lack of knowledge has somehow helped. Within my ignorance appeared the questions that led to the gold, to who that person is and what their story has been so far. It has led to being unexpectedly invited in to meet George the Poet's Ugandan super-mum surrounded by celebratory photos of their close-knit family, to spending time in Danny's stockroom bemused by packets of wool from thirty years ago and to Rhoda Ibrahim telling me about what outrageously damaging effects FGM has had on her life. It has been an almighty privilege.

And of course, this richness is not just in Harlesden. The rest of London – the likes of Portobello, Brixton and Dalston – has plenty to reveal. So has Britain, for that matter. There are so many diverse communities out there. When I go to see my mum, I can feel myself being drawn to Bradford – the history, the individual stories, the surprises. My feet find themselves wanting to wander across other urban landscapes to discover more.

Today, as I meander down Ancona Road, I'm aware of how much more I could discover here. I note that the concrete poetry has lost the layer of plaster that had 'love' written on it. Sadly, I never did get to meet Leah, the woman these words were dedicated to. KT Tunstall's old house is over the road; she left before I could pin her down. Neither have I got to a service at the Rebirth Tabernacle, but I have become aware that one of the unrecognised aspects of Harlesden is

the sheer and never-ending eclecticism of its churches; from the Harlesden Church of God 7th Day to the Fonte de Vida Brasilera – I have more services to visit.

In answer to those Robert Macfarlane questions – what do I know when I am in this place that I can know nowhere else? And, vainly, what does this place know of me that I cannot know of myself? – there is definitely something different in me from these four years of walking. I love that I now have knowledge that I didn't have before. And it's not flat, one-dimensional information. I walk with a warm, fleshy feeling, almost as though I'm walking with lots of different companions at my side. I may not have been to the Rebirth Tabernacle but I know Faisal went there as a child, and that makes me quietly glow inside. It happens all over Harlesden. I have new memories, almost, memories that are not mine but have become mine.

There's also a hope and faith in me. I pass Furness Pocket Park in wonder at the purple lavender planting and the noble white and blue agapanthuses. This was a disgusting little park, unfailingly full of dog shit. Over eighteen months, I witnessed the railings go down and then shrubs and flowers appearing. Finally, I saw several women putting up a bejewelled mosaic of golden sunflowers and orange lilies. I couldn't help myself – I went in and asked them what was going on. This was all down to a residents' group, Kensal Green Streets. It's not perfect, there is still some dog shit and fag ends, but this is Harlesden.

There are two new shops over the Harrow Road – Glamour Look Beauty Salon and Ital Cuts. More hairdressers and barbers. Jet Set has a new sign but the same battered old brown door. I stand for a moment and take in the industrial bleakness and beauty that is Willesden Junction, then make

my way down to Little Brazil, which is still going strong in Station Road.

Le Junction has put its modern signage over the remnants of the Amber Grill and Willesden Junction Hotel. These layers of history fascinate me in this form. Down the road, a wooden Chinese restaurant sign still lingers next to a flashy one announcing the new Station cafe. They're like contemporary history collages. Then there are also cherry trees, a wider pavement and impressive contemporary benches, all courtesy of Harlesden Town Team's vision and Transport for London's budget.

I pop into All Souls Church, as the door is open. Built in 1879 and based grandly on Ely Cathedral, the interior is all white, a contrast to the battered exterior. While I'm admiring the size and the hexagonal shape, I realise there is a tiny mass going on in the old chapel behind the modern screen at the front. A few Afro-Caribbean women sit in thrall to the words being read from the bible. It's an old-fashioned scene, one that I just happened on by chance. It's the sort of Harlesden moment I am still dazzled by. I love that I would never have known if I hadn't ventured in.

Outside, there's a kind of giddiness about how fast Harlesden alters its appearance. Shop signs go up and down, shutters come down and go back up, there's a hustle and bustle to its personality. Dora's Delights became Akbar's Jewel In The Crown, which has now become simply Waves. Ali Baba has become Lahori Bites. Like a market, forever buzzing with new activities. Like a river, it's forever changing yet always the same.

Harlesden hasn't been gentrified yet, but regeneration is here with all its road diggers and inconvenience. I see Leroy in the Star Express, and his head is hanging heavily because

everyone is complaining about the noise and the roads in chaos. There's a mass blindness about a better future and our unofficial king, the chair of Harlesden Town Team, is shouldering the blame.

Leroy had a dream four years ago, and it was not just a bistro; it was that Harlesden could look so much better, and therefore would become so much more of a cohesive community. 'I was brought up here in the sixties and seventies,' he sighs. 'I want to bring back the pride in our community. The changes in traffic and roads are all happening, but it's slow and at the moment no one can see the end results. I'd like us to celebrate all our different cultures more and stop living in such a separate way. I want us to organise an annual festival that brings all the cultures together.'

And as for the bistro, the art gallery and the old Harlesden Hub idea? 'We've become more pragmatic,' he says. 'We've had a pop up café at Atlas Cafe, and boys from Newman Catholic College as waiters. We want to turn the Library into an art gallery and, as you know, Serena is working with Newman Catholic College now. Nothing is static. Everything is moving. We're using the resources that already exist. Now we're just thinking about new benches and dedicating them to local people. There might be a Leroy and Louis bench at the Jubilee Clock when it's put back into position.'

Are his parents proud now? 'Well, they're coming down this week,' he grins, 'so we'll see. I think they will be surprised in a good way by the changes.'

And how do you manage regeneration so that it's not exclusive? 'I think Lambeth have done a good job with Brixton,' he says. 'They involved the community in the decision-making so they didn't exclude shops for people who are on tight budgets. You have to mix it all up.'

Down the High Street, pedestrianisation is in full throttle, which is pretty unbearable. And yet, there is so much of its future blossoming there. Popsie – white beard, natty black hat – is re-opening his reggae shop and building a studio there too. Blue Mountain Peak is thriving as ever. Hair shops are still opening everywhere. There's a new shiny Harlesden Town Garden off St Mary's Road with a basketball court, a new children's playground, and raised vegetable beds – it's a community endeavour.

I see a door ajar at the Citadel – I initially had thought it was a squat on my walk with Faisal – and I wander in. Rough and ready, there is a group of men and women looking a little worse for wear, eating breakfast. I ask a woman sitting nearby what's going on. She's called Joan and oozes humour plus attitude in that fulsome Harlesden way. There's naughtiness in her haughtiness. 'This is a breakfast club,' she says, looking down her nose at me, 'completely free to anyone on Thursday mornings. The Citadel is an Afro-Caribbean church and we have services at other times as well.'

There is a stage full of conga drums, a keyboard and guitars. It makes me want to come back for more. That's Harlesden, always calling me back for more.

> If you want to build a ship, don't drum up people together
> to collect wood and don't assign them tasks and work, but
> rather teach them to long for the sea.
>
> Antoine de Saint-Exupéry

I am still longing for more encounters on these scruffy pavements.

Notes

Introduction

1. This project was originally a blog called 'Not On Safari In Harlesden', which was a riposte to the out and out racism I'd found about Harlesden on the White Pride World Wide Forum by someone who signed off as 'Mine and GF's Safari In Harlesden'.
2. Which I thought had closed but has actually moved up Craven Park Road.

Walk 2

1. The Misty Moon is now closed and is re-opening under the Antic group. Happily, they are going to retain the cinema and even use the old balcony.

Walk 3

1. Even more recently, this has changed into Le Junction, a shabby chic pub with pan-fried sea bass on the menu and micro-brewery beer in the fridges.

Walk 4

1. The well, its miraculous powers of healing and
2. the cult of the black virgin are all cast into doubt by the research of Malcolm Barrès-Baker and others, who are skeptical. Barrès-Baker says he doesn't believe the image of the virgin was black and ascribes it as an invention by a Victorian antiquary with something of a fascination for Black Madonnas.
3. The vicar, David Clues, has now moved to Brighton.

Walk 5

1. This sign has now been removed in renovations that have taken place at the Royal Oak.

Walk 6

1. Which went into liquidation in 2013.
2. Now black.
3. Now ten grandchildren and two great grandchildren.
4. Died in 2014, sadly.

Walk 8

1. At the moment he is the Town Champion manqué, as he and his family are living in LA for a couple of years while he makes documentaries there.

Walk 9

1. Since then, Monique has published *With The Kisses Of*

His Mouth (2011), *Archipelago* (2012), which won the OCM BOCAS Prize in Trinidad in 2013, and *The House of Ashes* (2014), all with Simon and Schuster.

2. More recently, she has moved east to Mile End.
3. I haven't seen Mr Campbell lately; I'm not sure what's happened to him.
4. The Jubilee Clock has been temporarily removed for renovation and will re-appear in a different position because of the new design plan in 2015.
5. This Trinidad Roti shop has moved to Craven Park Road.

Walk 10

1. Serena Balfour now has a charity called the US Charitable Trust, which is doing great work with young people in Harlesden to support them in obtaining training and employment. She is particularly working with Newman Catholic College.
2. I have noticed lately that the tatty banner for the Dominion Church of Christ has disappeared.
3. Not Another Drop was the effective initiative started in 2001 by mothers in response to the growth of gun and knife crime in Harlesden. They had peace marches and a poster declaring 'Young, Gifted and Dead'.

Walk 12

1. Molly Sayle died in 2013.
2. The Shawl has recently been refurbished.
3. Os Amigos is now O Bombeiro.

Walk 13

1. Now also Wisconsin as well.

Walk 14

1. They've been painted out recently.
2. Now closed.
3. Also now closed.

Walk 15

1. Willesden Junction has had major work done since this walk; new platforms, lighting and underground passageways have all been added.
2. Afterwards, Ian contacts me to say that those windows are actually from 1909.

Walk 16

1. My mother is now happily ensconced in a residential home in Ilkley, Yorkshire. Tellingly, she calls it 'the hotel'.
2. Which have recently been demolished.
3. No longer there.
4. Now renamed Harte's Irish Meat Market. Not sure Robert would think that it's an improvement!

Walk 22

1. Harlesden City Challenge was money given by the government in the early nineties for regeneration.
2. I do ask Kevin Harrison and he explains the joke. 'These

are people struggling together to put up a yellow and green spotty joke-corporate flag. The humour is that it's like a Soviet Realist sculpture, but in this one the workers are struggling to put to up a funny thing.' And he also explains that he did do some school visits so that it wouldn't seem that it had just 'landed', adding that it probably needs some 'TLC now'.

3. I manage to find Guy Paterson, too, who says it was meant to last ten years so is doing well if it has survived. He also mentions a painted piece by Julia Bird on a roundabout in Park Royal that he doubts is still there. 'My imagery was taken from the local library archives and arranged in such a way that it's reminiscent of a scrapbook. Geraldine's part is more symbolic and the idea was that shapes from her disc would interact with the images etched on the pavement. As the sun moved constantly, so the sculpture would change.' Ah ha, so they did collaborate more than we had imagined and there was a 'sun disc' at the heart of it. Sadly, it doesn't quite translate in actuality.

4. Guy Paterson mentions that this sculpture was probably by someone called Arik.

Walk 23

1. The Summer Theatre was demolished in 2013. It had been closed for thirty years.

Walk 26

1. For the past couple of years, I've been writing an abridged version of my walks for the *Brent and Kilburn Times*.